Master Paintings

in The Art Institute of Chicago

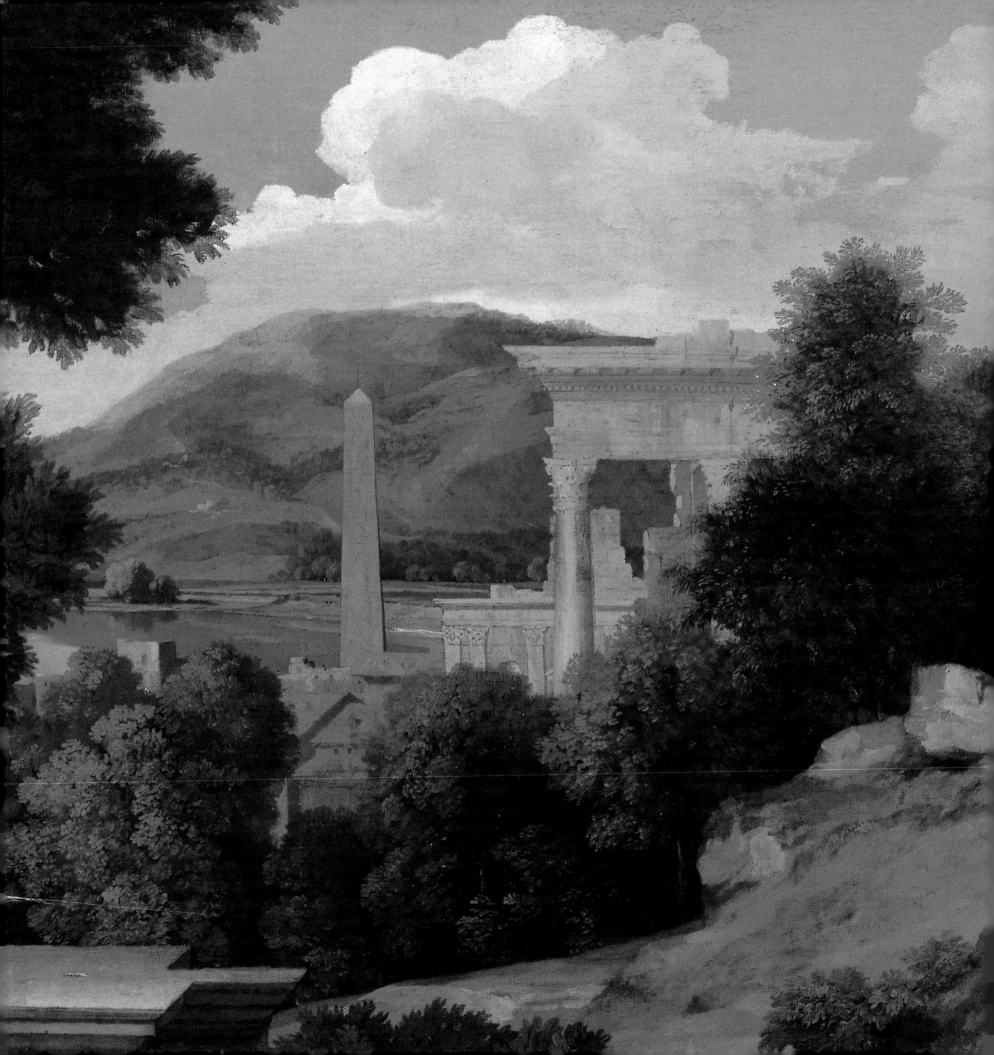

Master Paintings

in The Art Institute of Chicago

Selected by

James N. Wood, DIRECTOR AND PRESIDENT

The Art Institute of Chicago

Produced by the Publications Department,
The Art Institute of Chicago, Susan F. Rossen,
Executive Director

Edited by Laura J. Kozitka and Susan F. Rossen

Production by Sarah E. Guernsey, Associate
Production Manager

Photo edited by Stacey A. Hendricks

Photography by the Department of Imaging,
Alan B. Newman, Executive Director

Designed and typeset by Joan Sommers Design,
Chicago

Printed and bound by Arnoldo Mondadori Editore,
S.p.A., Verona, Italy

Second Edition

Published by The Art Institute of Chicago, 111 South
Michigan Avenue, Chicago, Illinois 60603-6110

Distributed by Hudson Hills Press, Inc., 122 East 25th
Street, 5th floor, New York, New York 10010-2936
Editor and publisher: Paul Anbinder
Distributed in the United States, its territories and
possessions, and Canada through National Book
Network. Distributed in the United Kingdom, Eire,
and Europe through Art Books International Ltd.

Library of Congress Catalog Card Number: 99-62276

ISBN 0-86559-175-x

Frontispiece: Nicolas Poussin, *Landscape with Saint
John on Patmos* (detail), 1640 (p. 31)

Contents

Acknowledgments

This second, revised edition of *Master Paintings in The Art Institute of Chicago*, like its predecessor, presents not only many of the Art Institute's outstanding European and American paintings but also an overview of the styles and eras represented in the museum. This edition was almost as challenging to achieve as the first, which appeared in 1988. Between that publication and this one, the collections of the Art Institute have grown dramatically in breadth and depth. Several reorganizations and rehangings of the galleries have also resulted in discoveries within the museum's historic holdings. While it is impossible to produce a definitive list of the 149 greatest paintings in our collection, we hope that the process by which we decided on our list, including the additions and deletions to this edition, has resulted in a balanced view of the museum's long-acknowledged master paintings and of our recent acquisition activities. In the end, about one-fifth of the works featured here entered the museum's collections in the past twelve years. We have also updated, revised, and sometimes rewritten the entries about works that appear in both editions.

First, I would like to acknowledge the role of Teri J. Edelstein, former Deputy Director, who played a major role in shaping the final selection of the works featured here. A number of individuals have supported this project: In the European Painting Department, I thank Gloria Groom, David and Mary Winton Green Curator of Nineteenth-Century Painting, and Martha Wolff, Curator of Painting before 1750, both of whom helped determine the images and reviewed both the revised and new texts. I also wish to thank Douglas W. Druick, Searle Curator; Adrienne Jeske, Manager of Collection and Research Assistant; and Barbara Mirecki, Exhibition Coordinator. In the Department of American Arts, I am grateful to Andrew J. Walker, Assistant Curator, for his involvement with choosing works and revising entries. I also thank Judith A. Barter, Field-McCormick Curator, and Suzanne F. Gould, Curatorial Documentation Assistant. To be acknowledged in the Department of Twentieth-Century Painting and Sculpture for her assistance in selecting objects and reviewing texts is Stephanie D'Alessandro, Andrew W. Mellon Postdoctoral Curatorial Fellow. I am also grateful to Jeremy Strick, former Frances and Thomas Dittmer Curator, and James E. Rondeau and Daniel Schulman, Associate Curators. Jane H. Clarke, Associate Director, Department of Museum Education, and Britt Salvesen, Associate Editor, Publications Department, also reviewed the entries.

Special thanks are due to Sally Ruth May, who wrote the entries for the works new to this volume. The individuals responsible for reprinted entries, which originally appeared in the first edition, are: Catherine Bock-Weiss, Courtney Donnell, Thomas Frederickson, Jean Goldman, Mary Gray, Ann Morgan, Dennis Nawrocki, Terry Ann R. Neff, Susan F. Rossen, Steve Sennott, Thomas L. Sloan, Malcolm Warner, Lynne Warren, Martha Wolff, and James Yood.

In the Publications Department, I wish to thank Laura J. Kozitka, Editorial Assistant, and Susan F. Rossen, Executive Director, for organizing, editing, and preparing the book's text. Associate Production Manager Sarah E. Guernsey was responsible for its production. Photo editor Stacey A. Hendricks obtained the photo rights. The elegant redesign is that of Joan Sommers Design, Chicago. Photography was provided by the Department of Imaging Services; I am grateful to Alan B. Newman, Executive Director; Christopher Gallagher, Associate Director; Sydney Orr, Archival Coordinator; Gregory Williams, Photographer; and Iris Wong, New Photo Coordinator. Finally, I extend my gratitude to Paul Anbinder, of Hudson Hills Press, New York, for his distribution of this title.

James N. Wood, DIRECTOR AND PRESIDENT

Introduction

In the years after the Great Fire of 1871, Chicago's commerce and industry were booming. While there was no shortage of money or entertainment in the city, many citizens recognized a lack of cultural institutions comparable to those in New York and Boston. Several prominent Chicagoans had a vision of the city and its needs: namely, libraries, a symphony, a university, a museum of science, and an art museum. A group of these citizens came together in 1878 to form a board of trustees for the floundering Academy of Design, which had been established in 1866. Within a year, debts completed the demise of the institution, but out of that failure came the Chicago Academy of Fine Arts, which accomplished "the founding and maintenance of schools of art and design, the formation and exhibition of collections of objects of art, and the cultivation and extension of the arts by any appropriate means." To help establish the city as a major cultural center, William M. R. French (brother of sculptor Daniel Chester French) was selected as the institution's first director.

In December 1882, the Academy changed its name to The Art Institute of Chicago, and banker Charles L. Hutchinson was elected the first president of the Board of Trustees. Hutchinson's standing in the community, generosity, and vision established a model for the future leadership of the Art Institute. In 1887 the Art Institute moved from rented rooms on the southwest corner of State and Monroe into a building designed by the Chicago firm Burnham and Root. This Romanesque structure, located on the southwest corner of Michigan Avenue and Van Buren Street, housed school studios, lecture halls, galleries for the Society of Decorative Arts (later the Antiquarian Society), and a display of plaster casts presenting a "comprehensive illustration of the whole history of sculpture," which formed the core of the museum's collections at that time.

In 1888 the Art Institute hosted the first "Annual Exhibition of American Art," the beginning of a series of annual (later biennial) shows for the work of living American artists. Among the exceptional paintings that entered the permanent collection after having been in an "American Exhibition" are Tanner's *Two Disciples at the Tomb* (p. 107), Wood's *American Gothic* (p. 131), Hopper's *Nighthawks* (p. 140), de Kooning's *Excavation* (p. 148), and Warhol's *Mao* (p. 158).

The Art Institute soon outgrew its quarters. As chairman of the Committee of Fine Arts for the 1893 World's Columbian Exposition, Hutchinson arranged for the Art Institute and the Exposition to jointly finance a building that would serve as the hall for the World's Congresses during the fair and then become the new Art Institute afterward. Designed by the Boston firm Shepley, Rutan and Coolidge, the building, on Michigan Avenue between Jackson and Monroe streets, was completed in May 1893, in time for the opening of the fair. In December the Art Institute opened in this Beaux-Arts-style building, which it continues to occupy.

While the Art Institute's collection of plaster casts was one of the largest of its type in the country, from the beginning it was intended that the museum collect actual masterpieces in all periods and styles. Lacking funds, the institution had to rely upon gifts and loans of art and money from private collectors and patrons. Fortunately, Chicago collectors active in the late nineteenth century were blessed with the means and the taste to assemble some of the finest private collections in the United States at that time. In 1895 Hutchinson, Martin A. Ryerson, and other private donors seized the opportunity to make a purchase specifically for the museum. Thirteen works by Dutch masters were acquired from the collection of Prince Anatole Demidoff, including Meindert Hobbema's *Watermill with the Great Red Roof* (p. 33). A second seminal acquisition was made just over a decade later, in 1906. Convinced by the enthusiasm of artist Mary Cassatt (see p. 100) for the central portion of an early altarpiece by El Greco that had come on the market, Hutchinson and Ryerson arranged the purchase of *The Assumption*

of the Virgin (p. 22) with private contributions. A gift in 1915 from Nancy Atwood Sprague allowed the temporary donors to be reimbursed. El Greco's *Assumption* is still considered by many to be the greatest single work in the museum.

The Friends of American Art was founded in 1910 with the goal of purchasing the work of living American artists. Soon, however, the organization was acquiring works of all styles from all periods. Purchases include Stuart's *Major-General Henry Dearborn* (p. 80), Cole's *Distant View of Niagara Falls* (p. 82), Homer's *Croquet Scene* (p. 87), and Eakins's *Mary Adeline Williams* (p. 102).

The Art Institute continued its support of contemporary art when, in 1913, it hosted the landmark "International Exhibition of Modern Art," known as the Armory Show. It inspired Chicagoan Arthur Jerome Eddy (see p. 101) to buy works for what was to become a pioneering collection, part of which was given to the museum in 1931. Included in Eddy's bequest was Vasily Kandinsky's *Painting with Green Center* (p. 117). The Art Institute's commitment to modern art intensified in the 1920s. In 1921 Joseph Winterbotham, a Chicago businessman, donated $50,000 to be invested and used as capital for the purchase of European paintings. The unique stipulation of the Winterbotham plan was that only thirty-five paintings should be purchased; once this number was reached, any painting could be sold or exchanged to acquire a work of superior quality or significance. This farsighted gift has resulted in the acquisition of some of the museum's most important late nineteenth- and early twentieth-century works, including van Gogh's *Self-Portrait* (p. 62), Léger's *Railway Crossing* (Preliminary Version) (p. 122), Delaunay's *Champs de Mars: The Red Tower* (p. 112), Chagall's *Praying Jew* (p. 126), Feininger's *Carnival in Arcueil* (p. 113), Magritte's *Time Transfixed* (p. 138), Balthus's *Solitaire* (p. 141), and Freud's *Sunny Morning—Eight Legs* (p. 165).

In 1922 one of the first major bequests from a private collector entered the museum. Mr. and Mrs. Potter Palmer began their collection in the 1880s with works by living American artists, and their interests remained resolutely modern. Mrs. Palmer's attention turned to French painting and the works of Jean Baptiste Corot, Eugène Delacroix, and others; eventually, she discovered the Impressionists. On annual trips to France between 1888 and 1895, she acquired the majority of the Impressionist works in her collection. The Palmers loaned many works to the Art Institute; after Mrs. Palmer's death in 1916, the museum selected a group of paintings, according to the generous terms of her will. This gift, which helped to establish the Art Institute's preeminence in nineteenth-century French art, included Corot's *Interrupted Reading* (p. 52) and Pierre Auguste Renoir's *Acrobats at the Cirque Fernando (Francisca and Angelina Wartenberg)* (p. 57).

The Helen Birch Bartlett Memorial Collection was given to the Art Institute late in 1926 by Frederic Clay Bartlett in memory of his second wife. It contained such works as Georges Pierre Seurat's *Sunday on La Grande Jatte—1884* (p. 63), Pablo Picasso's *Old Guitarist* (p. 108), and Amedeo Modigliani's *Jacques and Berthe Lipchitz* (p. 119). A few years later, Bartlett added such masterpieces as Vincent van Gogh's *Bedroom* (p. 64), Henri Marie Raymond de Toulouse-Lautrec's *At the Moulin Rouge* (p. 71), and Paul Cézanne's *Basket of Apples* (p. 69). With this extraordinary group of paintings mounted in a single room, the Art Institute became the first American museum to feature a gallery of Post-Impressionist art, three years before the opening of The Museum of Modern Art, New York, in 1929. Another benefactor who greatly augmented the museum's collection of nineteenth-century French art was Mrs. Lewis Larned Coburn, whose 1933 bequest included Hilaire Germain Edgar Degas's *Uncle and Niece (Henri Degas and His Niece Lucie Degas)* and *The Millinery Shop* (pp. 51, 56), Edouard Manet's *Reader* (p. 58), and Paul Gauguin's *Arlesiennes (Mistral)* (p. 65).

Also in 1933, the Art Institute received the bequest of Mr. and Mrs. Martin A. Ryerson. Their collection ranks as the greatest gift ever to enter the museum. Unlike other private collections, that of the Ryersons reflected the breadth of all of Western art. The bequest included textiles, European decorative arts and sculpture, prints and drawings, and over 227 European and American paintings. Among them are a suite of panels by Giovanni di Paolo (see pp. 14–15), Hey's *Annunciation* (p. 18), Monet's *Arrival of the Normandy Train, Gare Saint-Lazare* (p. 55), and Homer's *Herring Net* (p. 93).

Charles H. and Mary F. S. Worcester built their collection to correspond to the needs of the Art Institute's holdings. Among the works by German and Italian masters the Worcesters gave to the museum between 1925 and 1947 are Giovanni Battista Moroni's *Gian Lodovico Madruzzo* (p. 21), Bartolomeo Manfredi's *Cupid Chastised* (p. 26), and Giovanni Battista Piazzetta's *Pastoral Scene* (p. 35). The fund established by the Worcesters has resulted in such

purchases as Frans Snyders's *Still Life with Dead Game, Fruits, and Vegetables in a Market* (p. 25), and Gustave Caillebotte's *Paris Street; Rainy Day* (p. 54).

Since the founding of the museum, paintings had been hung according to the collector who had loaned or given them regardless of historical or stylistic considerations, an approach that emphasized the role of the individual patron. In 1933 and 1934, the Art Institute hosted two large-scale exhibitions that changed this policy. Organized by director Robert B. Harshe and consisting of works from the Art Institute and lent by private and public collections from around the world, the shows were held in concert with the "Century of Progress" exposition in Chicago. They proved to be the museum's first real international success, attracting over seven hundred thousand visitors. Their lasting significance for the Art Institute, however, lay in the purely geographical and chronological manner in which the works of art were grouped in the galleries. Although he was director during the decade when many of the most important collections came to the museum, and although he played a critical role in assuring their arrival, Harshe's redistribution demonstrated the effectiveness of an historical arrangement of the museum's holdings and ended the era of the Art Institute as an assembly of private collections.

In 1940 a new auxiliary organization, the Society for Contemporary American Art, was formed in response to the success of the Winterbotham Fund, which acquired only works by foreign artists, and to the demise of the Friends of American Art. The organization's original intent was to purchase only contemporary American paintings for the permanent collection; in 1968 the group voted to include European art in its interests and changed its name to the Society for Contemporary Art. Among the paintings it has acquired for the museum are Jackson Pollock's *Greyed Rainbow* (p. 149) and Leon Golub's *Interrogation II* (p. 160). Another important source for the Art Institute's collections has been right within its walls: the School of the Art Institute. Among the artists who attended the School, maintained a close relationship with the museum, and whose art later assumed a prominent place in the permanent collection are O'Keeffe (see p. 129), Albright (see p. 130), Wood (see p. 131), and Golub (see p. 160).

For the first seventy-five years of the Art Institute's existence, the director of the museum also acted as a curator of paintings, reflecting the primacy of the paintings collection. After joining the museum staff in 1927, Daniel Catton Rich was named director in 1938. Rich's distinguished tenure included outstanding scholarship (his monograph on Seurat's *Grande Jatte* was one of the first books ever devoted to the study of a single work), important exhibitions (O'Keeffe, 1943; Cézanne, 1952), and significant acquisitions (he was primarily responsible for forming the Coburn and Worcester collections). In the 1950s, the growth of the museum's collections, increasing specialization in the art world, and greater interest in modern art led to a number of changes. In 1954 Frederick A. Sweet and Katharine Kuh were appointed Curator of American Painting and Sculpture and Curator of Modern Painting and Sculpture, respectively. Kuh acquired for the museum such important works as Picasso's *Mother and Child* (p. 125), Picabia's *Edtaonisl (Clergyman)* (p. 116), Matisse's *Bathers by a River* (p. 120), and Beckmann's *Self-Portrait* (p. 137). By the end of the 1960s, an autonomous Department of Twentieth-Century Painting and Sculpture had been formed. The evolution of the paintings collection into three branches was completed in 1975 with the formation of a Department of American Arts. The tripartite division—European Painting, American Arts, and Twentieth-Century Painting and Sculpture—continues today and is reflected in the organization of this book.

These departments carry on the tradition of collecting the finest paintings available for the Art Institute, sustained by the generosity of a new generation of collectors and donors. Nineteen of the thirty-four works added to this new edition of *Master Paintings in The Art Institute of Chicago* entered the collection since the first edition was published in 1988. Of these, twelve belong to the Department of Twentieth-Century Painting and Sculpture. In 1997 the Art Institute received a major gift of contemporary art from the Lannan Foundation, which made the museum's already important modern collection a major center for the art of our time. Included here from that acquisition are Clyfford Still's *Untitled* (p. 154), Gerhard Richter's *Woman Descending the Staircase* (p. 155), and Chuck Close's *Alex* (p. 163). In addition to the Lannan Foundation gift, this department has benefited enormously from the generosity of such donors as Lindy and Edwin Bergman and Joseph Randall Shapiro (see Matta's *Earth is a Man*, p. 139). The museum has made a concerted effort, over this past decade, to extend its representation of the achievements of African American artists with a number

of significant additions, including Johnson's *Mrs. Andrew Bedford Bankson and Son, Gunning Bedford Bankson* (p. 78), Beauford Delaney's *Self-Portrait* (p. 142), Lawrence's *Wedding* (p. 146), and Marshall's *Many Mansions* (p. 164). Of the four new acquisitions from the Department of European Painting in this book, two add significantly to our nineteenth-century European holdings because they are German, not French: Carl Blechen's *Interior of the Palmhouse on the Pfaueninsel, near Potsdam* (p. 45) and Arnold Böcklin's *In the Sea* (p. 60). Recent acquisitions in American art are represented here by a still life—Raphaelle Peale's *Still Life—Strawberries, Nuts &c.* (p. 81), a portrait—the aforementioned work by Joshua Johnson (p. 78)—and a landscape, Albert Bierstadt's *Mountain Brook* (p. 85).

The works contained in *Master Paintings* reflect the vision and ambition—shaped and maintained by Chicago collectors and museum curators, directors, and trustees—that have helped the Art Institute grow, since its founding more than a century ago, from an outpost of culture on the midwestern prairie to one of the world's great museums.

James N. Wood, DIRECTOR AND PRESIDENT

EUROPEAN PAINTINGS

Bernardo Martorell

Spanish; c. 1400–1452

Saint George Killing the Dragon, 1430/35
Tempera on panel
155.3 x 98 cm (61 ⅛ x 38 ⁹⁄₁₆ in.)
Gift of Mrs. Richard E. Danielson and
Mrs. Chauncey McCormick, 1933.786

As a model of Christian knighthood, Saint George was a very popular figure in the late Middle Ages. The most frequently represented scene from his legend was the episode in which he saved a town threatened by a dragon, at the same time rescuing the beautiful princess who was to be sacrificed to the beast. Bernardo Martorell, the greatest Catalan painter of the first half of the fifteenth century, included a wealth of details in his version of the scene: animal and human bones litter the foreground; lizards—or perhaps baby dragons—crawl around the crevice in which the dragon lives; the princess's parents and throngs of onlookers crowd the town's battlements to view the action; neatly cultivated fields provide a sense of orderliness in contrast with the chaos of the slaying.

Saint George Killing the Dragon was the central panel of an altarpiece devoted to the saint and was originally surrounded by four smaller panels (Paris, Musée du Louvre). Martorell's panel incorporates Flemish, French, and Northern Italian currents of the International Gothic Style; this eclecticism reflects the receptiveness of Catalonia, the region of Spain on the Mediterranean bordering France, to outside influences. Spanish paintings often feature raised stucco decoration, which Martorell applied here with wonderful inventiveness to model the armor and halo of Saint George and the scaly body of the dragon. Yet the panel's rich narrative detail is unusual for a Spanish altarpiece, since, more typically, the central figure in an altarpiece was depicted in a rigid, frontal manner.

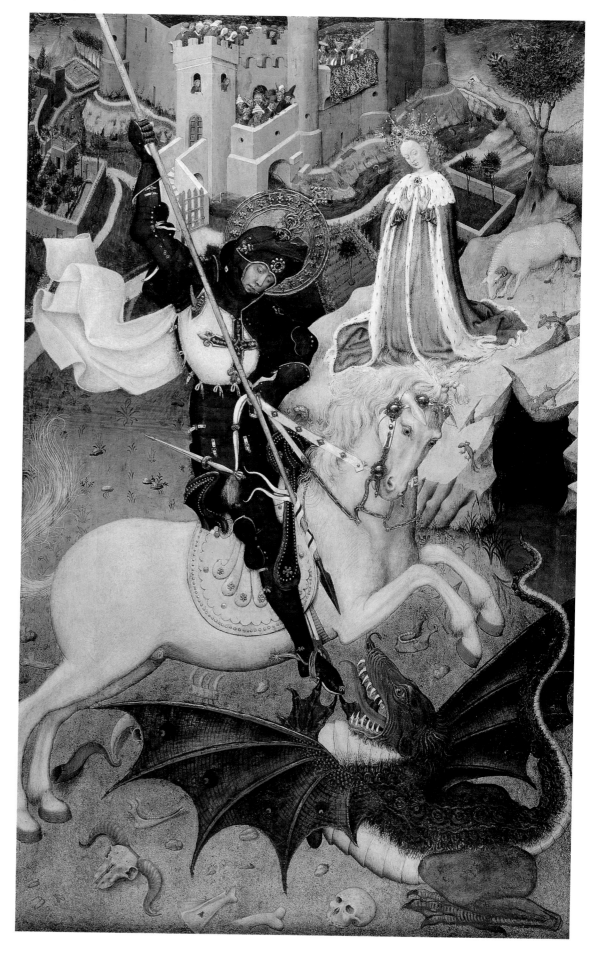

13

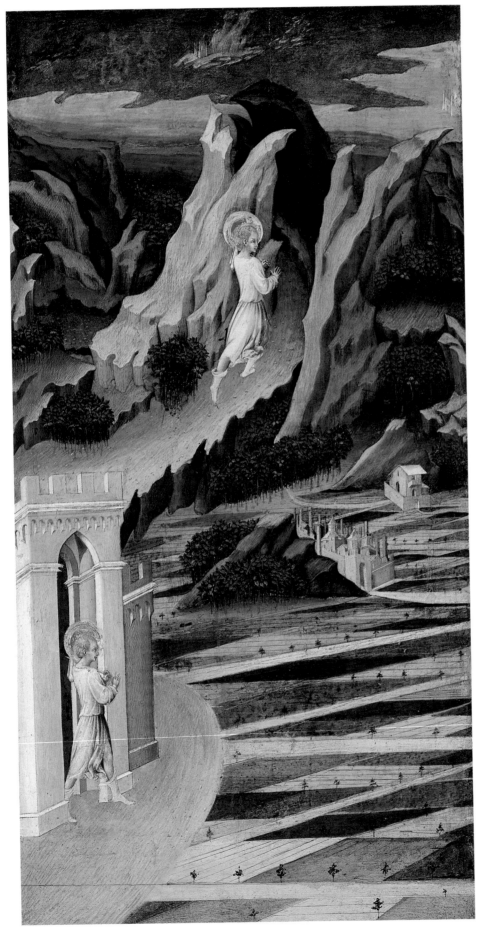

Giovanni di Paolo
Italian (active Siena); active c. 1417–82

Saint John the Baptist Entering the Wilderness, 1455/60
Tempera on panel
68.5 x 36.2 cm (27 x 14 ¼ in.); painted surface:
66.3 x 34 cm (26 ¹⁄₁₆ x 13 ⁷⁄₁₆ in.)
Mr. and Mrs. Martin A. Ryerson Collection, 1933.1010

The Beheading of Saint John the Baptist, 1455/60
Tempera on panel
68.6 x 39.1 cm (27 x 15 ⅜ in.); painted surface:
66.3 x 36.6 cm (26 ¹⁄₁₆ x 14 ⁷⁄₁₆ in.)
Mr. and Mrs. Martin A. Ryerson Collection, 1933.1014

Giovanni di Paolo was perhaps the most impor-
tant painter working in Siena in the fifteenth
century. The combination of emotion and
decorative poetry in his work is an individual
extension of the great tradition of fourteenth-
century Sienese painting. *Saint John the Baptist
Entering the Wilderness* and *The Beheading of
Saint John the Baptist* are two of twelve scenes
Giovanni depicted from the life of the saint.

Eleven of the original twelve panels survive:
six in the Art Institute and the remainder scat-
tered in various European and American collec-
tions. From the shape and condition of the
panels, it is clear that they were arranged in two
large, movable wings. Four panels with arched
tops were placed in an upper row; the other
eight panels were arranged below them in pairs.
Thus, four vertical rows of panels were divided
horizontally into three registers. The function
of these wings is not clear: they may have been
framed in a niche with a sculpted figure of John
the Baptist, or they may have formed the doors
of some sort of reliquary cupboard containing a
sacred relic or effigy of the saint.

John the Baptist was the cousin of Jesus and
the last in a long line of prophets who, according
to the Gospel account, foretold Christ's coming.
With a wonderful feeling for detail and for the

unfolding of the story, Giovanni represented John's birth to the elderly Elizabeth, his departure for a hermit's life in the wilderness, his prophesy of Christ's coming, his baptism of Jesus, and his beheading as a result of the scheming of Queen Herodias and her daughter Salome (see also p. 30). These scenes are enacted in complex settings that exploit the tall, slender proportions of the panels and accentuate the elegant poses of the figures. In *The Beheading of Saint John the Baptist*, exaggerated effects such as the elongated neck and spurting blood of the decapitated prophet add a sense of intensity to an otherwise cool, placid scene. To unite the narrative, the artist made masterful use of repeated figures and settings throughout the series of panels. Thus, the geometrically patterned fields and jagged mountains of *Saint John the Baptist Entering the Wilderness* extend across two other panels from the same wing, and the elegant little prison in which John is confined in *The Beheading of Saint John the Baptist* is repeated in another of the Art Institute's panels. The most extensive narrative cycle produced by Giovanni, this series also marks a high point of narrative painting on panel in fifteenth-century Siena.

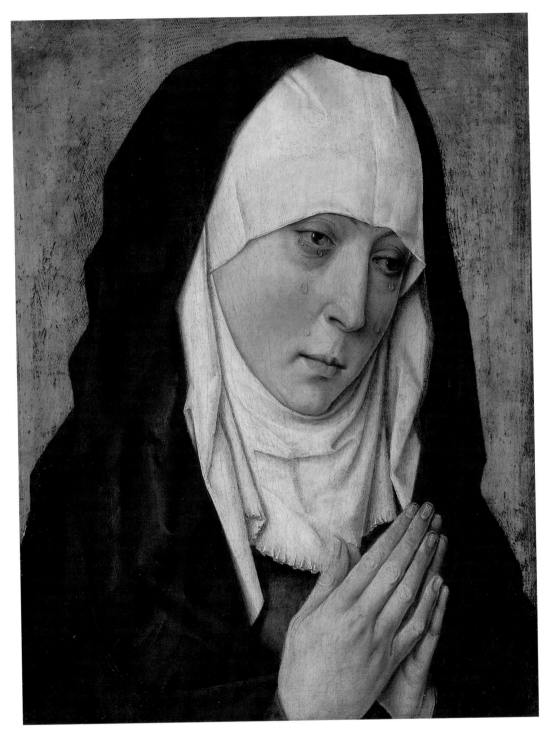

Dieric Bouts
Netherlandish; c. 1415–1475

Mater Dolorosa, 1470/75
Oil on panel
38.8 x 30.4 cm (15 ¼ x 12 in.)
Chester D. Tripp Endowment, Chester D. Tripp
Restricted Gift Fund; and through prior acquisi-
tion of Max and Leola Epstein, 1986.998

In northern Europe, the fifteenth century was a
time of transition from the Middle Ages to the
Renaissance. During this period, innovative
Netherlandish painters, such as Dieric Bouts,
created new, movingly human devotional im-
ages by combining traditional forms expressive
of medieval piety with sensitive observation of
the natural world. One such devotional image
was Bouts's formulation of a sorrowing
Madonna paired with a frontal image of Christ
crowned with thorns to form a diptych, or a
small, private altarpiece. This composition
struck a particularly responsive chord in its
own time, to judge by the many contemporary
copies made after it.

 The Art Institute's *Mater Dolorosa* (consti-
tuting the half of the diptych depicting the
Madonna) is acknowledged to be the finest
surviving example of Bouts's renowned image.
The focus on the head and hands of the Virgin
against a simple, gold background gives the
painting the detached and timeless quality of an
icon; this aspect would have been intensified by
the lost image of Christ, with which it was origi-
nally paired. With her gently elongated features
swathed in simple and somber drapery, the
Virgin is removed from a specific time and
place. It is the physical manifestations of her
emotional state—her eyes brimming over with
tears and her tender, bsorbed gaze as she con-
templates her son's sufferings—that are the
painting's subject. These details were intended
to elicit a responsive flow of emotion from the
viewer, evidence of the eagerness for a direct
and personal experience of God that character-
ized the Renaissance and led to the turmoil of
the Reformation.

Rogier van der Weyden and Workshop

Flemish; 1399/1400–1464

Jean Gros, c. 1460
Oil on panel
38.6 x 28.6 cm (15 3/16 x 11 1/4 in.)
Mr. and Mrs. Martin A. Ryerson Collection,
1933.1051

Rogier van der Weyden was one of the most influential artists of the fifteenth century. He settled in Brussels, where he was named official town painter in 1436 and maintained a busy workshop. He executed altarpieces and portraits for religious institutions, court functionaries, and the powerful dukes of Burgundy, a province in what is now France, who ruled the Netherlands during most of the fifteenth century.

The coat of arms, motto, and family symbol of a pulley painted on the back of the Art Institute's portrait identify the sitter as Jean Gros, an official of the Burgundian court. This portrait depicts him at the outset of a successful career, during which he amassed a large fortune and led an aristocratic life. Rogier presented the half-length figure against a plain, dark background, which accentuates the sitter's refined features and the prayerful gesture of his slender, elegant hands. This gesture indicates that the panel was once part of a diptych, a portable altarpiece, usually hinged, used for private devotion: Gros's devout, abstracted gaze was in fact directed at a second panel bearing the image of the Madonna and Child, which has been identified with a painting now in the Musée des beaux-arts, Tournai, France.

This type of diptych, which was intended for continuous prayer and to record the donor's features, was probably first made for princes around 1400, but Rogier revitalized the form, giving a striking focus and elegance to examples he produced for members of the Burgundian court.

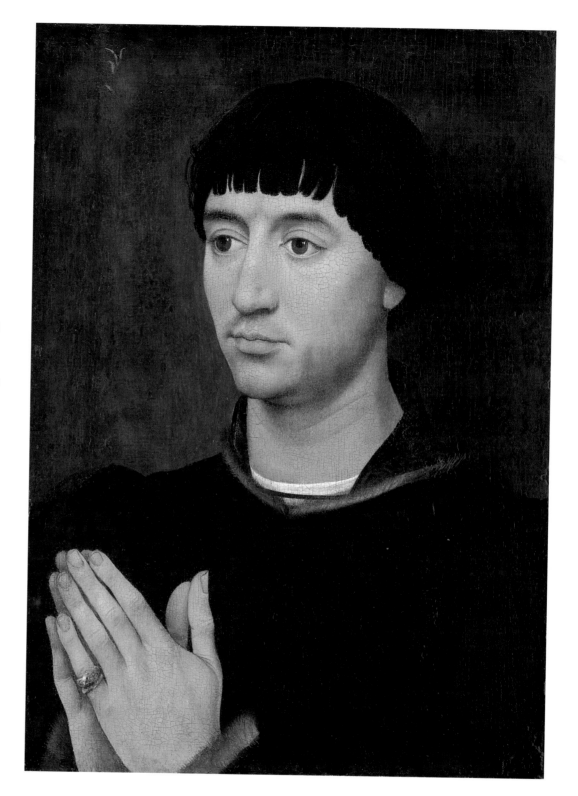

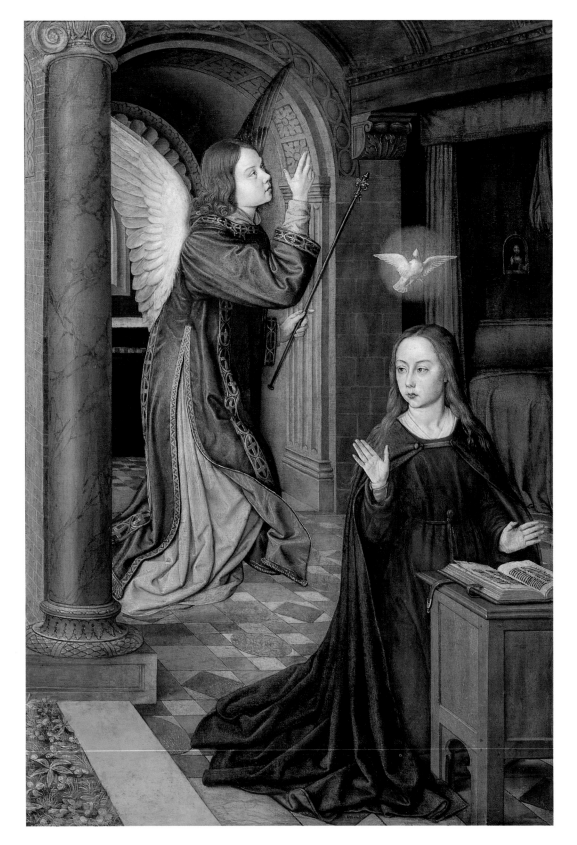

Jean Hey (The Master of Moulins)

French; active c. 1490–1510

The Annunciation, c. 1500
Oil on panel
73.7 x 50.8 cm (29 x 20 in.)
Mr. and Mrs. Martin A. Ryerson Collection,
1933.1062

The Netherlandish painter Jean Hey was employed by the regents of France, Pierre de Bourbon and Anne de Beaujeu, at their court in Moulins. While reliant on themes of the late Middle Ages, his art nevertheless displays a self-consciousness and an interest in antiquity that characterized the emerging Renaissance. In this painting, the archangel Gabriel tells Mary the news of Christ's coming birth; the setting is a richly carved and vaulted chamber with stone ornamentation recalling the architectural vocabulary of the ancient world. The placid expressions of Gabriel and Mary and their controlled gestures link them to Hey's portraits of French princes and princesses. At the same time, Hey's Flemish training is evident in the careful rendering of Gabriel's silk robes and in his use of shadow.

 The Annunciation is not an independent work. Rather, it seems to have formed the right end of a long panel with scenes honoring the Virgin Mary, including depictions of her parents, Joachim and Anne (London, National Gallery), and a central section of the Virgin and Child enthroned (now lost). This form explains an awkwardness in the composition of the Art Institute's panel: Hey compressed the action so that Mary looks and gestures modestly toward what would have been the focus of the altarpiece, the image of herself and Jesus enthroned. The glowing colors, complex light effects, and elegantly observed figures of *The Annunciation* and other works by Hey make him the finest painter working at the end of the fifteenth century in France.

Correggio (Antonio Allegri)
Italian; c. 1494–1534

Virgin and Child with the Young Saint John the Baptist, c. 1515
Oil on panel
64.2 x 50.2 cm (25 ¼ x 19 ¾ in.)
Clyde M. Carr Fund, 1965.688

Correggio lived and worked in the provincial city of Parma, executing a body of work that is remarkable for its inventiveness and sophistication, given his remoteness from the great artistic centers of Renaissance Italy. This small panel, executed when Correggio was only about twenty years of age, was intended for use as a private devotional object.

The handling of the light, color, and form reveal an artist searching for his own personal manner. The somewhat angular drapery, gold ornament, brightly contrasting colors, and strong overall lighting refer back to the art of the preceding generation of northern Italian artists. On the other hand, the pyramidal structure of the figures and the softness and fullness of the forms show the influence of the High Renaissance styles of artists such as Leonardo and Raphael. Correggio's own sensibility can be seen in the tenderness of the figures for one another—conveyed through glance and gesture—the gentle sensuousness of the forms, and the overall poetic mood.

Adding to the charm of the panel is the exquisite painting of the details and the landscape beyond. The expressive and idyllic quality of this panel would become more pronounced in Correggio's mature work.

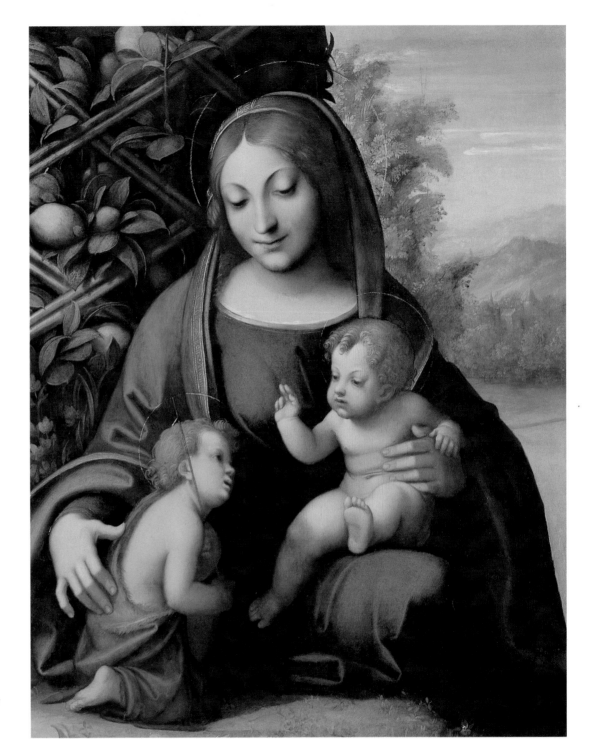

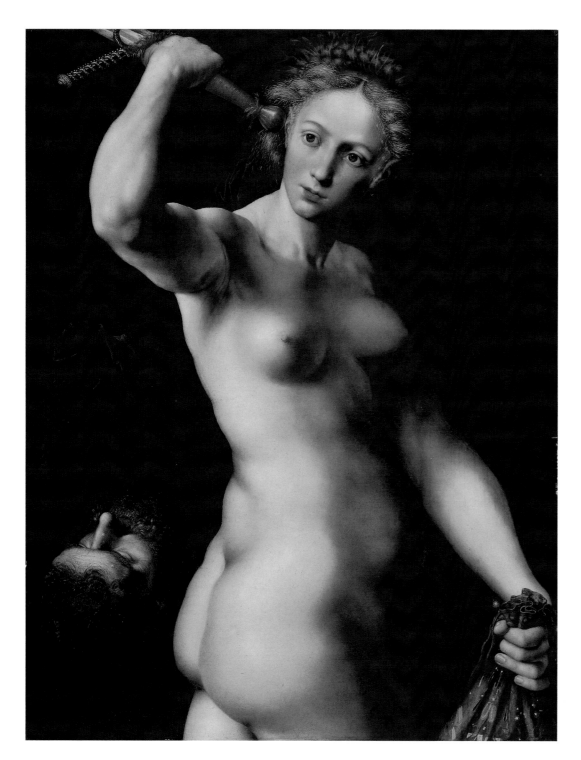

Jan Sanders van Hemessen
Netherlandish; c. 1500–c. 1575

Judith, c.1540
Oil on panel
99.8 x 77.2 cm (39 ¼ x 30 ⁷⁄₁₆ in.)
Wirt D. Walker Fund, 1956.1109

Judith was considered one of the most heroic women of the Old Testament. According to the biblical story, when her city was besieged by the Assyrian army, the beautiful young woman gained access to the quarters of the Assyrian general Holofernes. After gaining his confidence and getting him drunk, she took his sword and cut off his head, thereby saving the Jewish people. Although Judith was often shown richly and exotically clothed, Jan Sanders van Hemessen chose to present her as a monumental nude figure, aggressively brandishing her sword even after severing Holofernes's head.

Van Hemessen was one of the chief proponents of a style, popular in the Netherlands in the first half of the sixteenth century, that was deeply indebted to the sculptural forms of classical art as well as of the art of Michelangelo and Raphael. Judith's muscular body and its elaborate, twisting pose reflect these influences. Yet the use of the nude figure here also suggests a certain ambivalence on the part of van Hemessen and his audience toward the seductive wiles Judith may have employed to disarm Holofernes. In his work, van Hemessen combined monumental figures with precisely rendered textures, as in the hair and beard of Holofernes, Judith's gauzy headdress, and her brocaded bag. The interplay between the straining pose of his figure, the dramatic lighting, and the fastidiously recorded surfaces serve to heighten the power of this composition.

Giovanni Battista Moroni

Italian; 1520/24–1578

Gian Lodovico Madruzzo, 1551/52
Oil on canvas
199.8 x 116 cm (78 ⅝ x 45 ⅝ in.)
Charles H. and Mary F. S. Worcester Collection,
1929.912

Giovanni Battista Moroni was one of the great portrait painters of the sixteenth century. He spent much of his career depicting the distinguished citizens of his native Bergamo, Italy. The young man in the Art Institute's portrait—from the well-known Madruzzo family—became a cardinal and achieved fame for his funeral sermon for Charles V at the Diet of Augsburg. He succeeded his uncle, Cardinal Cristoforo Madruzzo, as Prince-Bishop of Trent in 1567.

Moroni's portraits are characterized by a naturalism tempered by restraint. While he sought to present objective likenesses of his sitters, he kept them at a certain psychological distance through the austerity of his compositions and colors. As in many of Moroni's full-length portraits, the figure of Gian Lodovico is posed easily in a simply constructed, narrow space. The severe composition is enlivened by the contrast of the flat, architectural forms and terrazzo floor patterns with the curved, hanging drapery and undulating hem of the subject's ecclesiastical garment. Madruzzo's aristocratic status is signaled by the choice of this full-length format, traditionally reserved for images of emperors and princes, and by the inclusion of his hunting dog, a symbol of privilege. Madruzzo's steady, yet reserved, gaze aptly suggests his ease in this role.

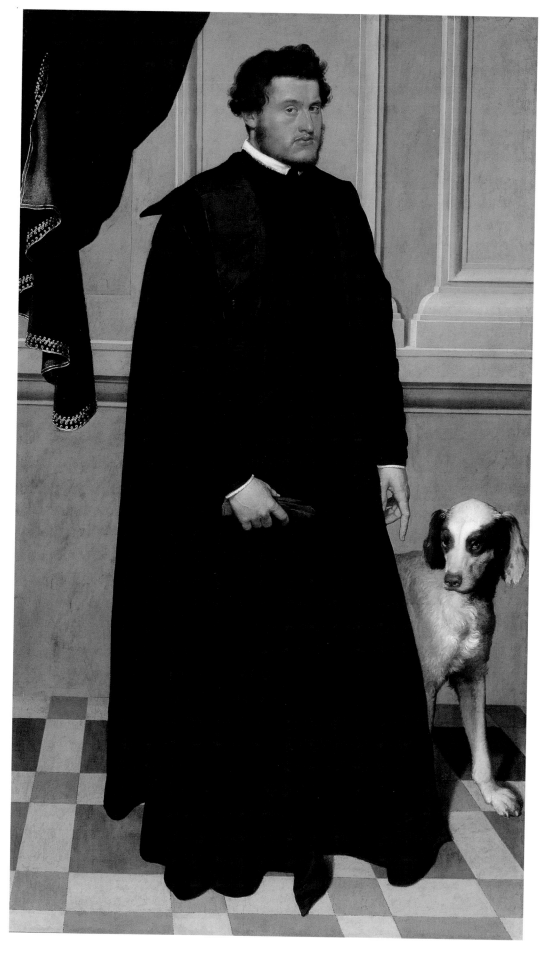

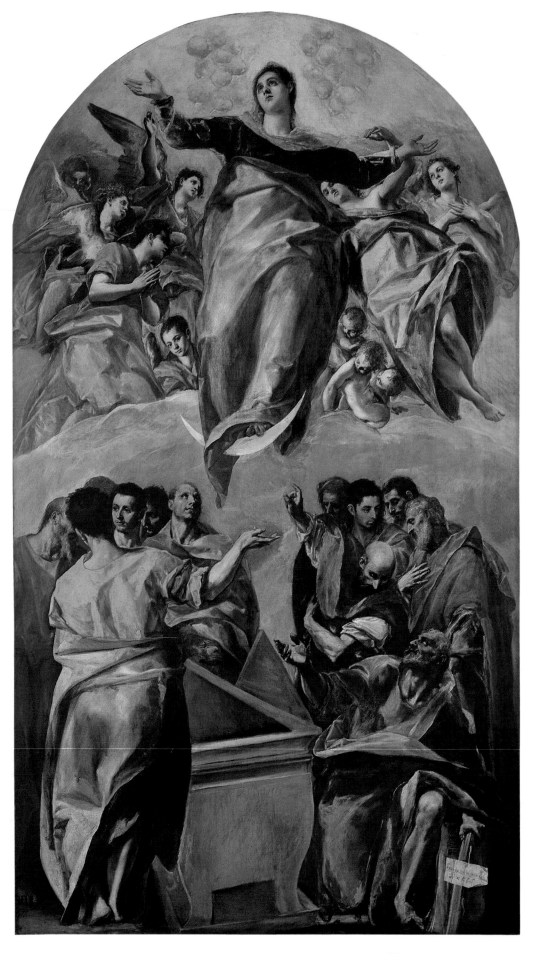

El Greco (Domenico Theotocopuli)

Spanish, born Greece; 1541–1614

The Assumption of the Virgin, 1577
Oil on canvas
401.4 x 228.7 cm (158 x 90 in.)
Gift of Nancy Atwood Sprague in memory of
Albert Arnold Sprague, 1906.99

The work of the great Mannerist painter El
Greco is a supremely effective synthesis of the
traditions of his native Greece, the art of the
Renaissance masters of Italy (he spent nearly a
decade in Venice and Rome), and the deep
spiritualism of the late Counter-Reformation,
which was particularly strong in Spain, where
the artist finally settled.

 The Assumption of the Virgin, undoubtedly
the Art Institute's most important Old Master
painting, was part of El Greco's first major com-
mission in Toledo, the city in which he resided.
One of nine paintings for the high altar of the
church of Santo Domingo el Antiguo, this mon-
umental canvas is a work of stirring drama and
impassioned religious feeling. The composition
is divided into two zones: the earthly sphere of
the apostles and the celestial sphere of angels,
who welcome and celebrate the Virgin as she
rises from her grave upon a crescent moon (a
symbol of her purity). Into a tall vertical format,
El Greco compressed many figures, whose faces
and gestures express a range of emotions —
confusion, disbelief, excitement, peace, awe.
Their elongated bodies, covered with ample,
beautifully rendered draperies painted in high-
keyed colors, are so filled with energy and feel-
ing that the composition seems to burst from
the frame. Here, and in many other works, El
Greco used broad, free brushwork, flickering
hues, rich color harmonies, brilliant illumina-
tion, and bold figural arrangements to arouse
mystic fervor in the viewer and impart the deep
sense of faith that he himself felt.

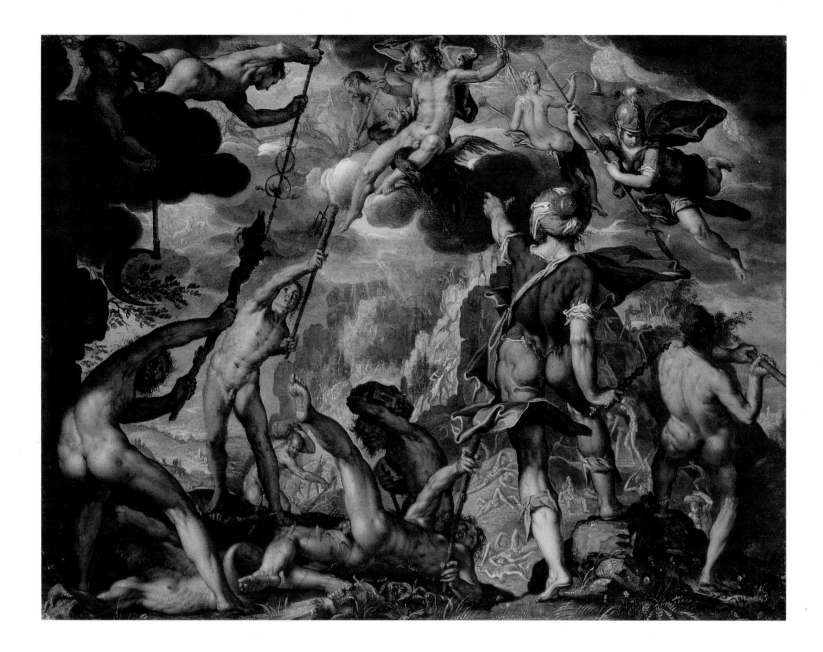

Joachim Antonisz. Wtewael

Dutch; c. 1566–1638

The Battle between the Gods and the Titans, c. 1600
Oil on copper
15.6 x 20.3 cm (6 ⅛ x 8 in.)
Through prior acquisition of the George F. Harding Fund, 1986.426

The two decades after 1585 saw a flowering in Holland of the refined, courtly style known as late Mannerism, an international movement growing out of earlier developments in the courts of Florence, Rome, and the Holy Roman Empire. Joachim Wtewael was probably the most accomplished painter of the Dutch Mannerists. After several years of study in Italy and France, he established himself as an artist in his native Utrecht in 1592. In addition to large canvases, Wtewael executed a number of exquisite cabinet pictures on copper or wood aimed at the sophisticated collectors who were the chief audience for works of this style.

In the foreground of Wtewael's small work on copper at the Art Institute, the doomed ancient race of Titans struggles with crude clubs and rocks against the gods of Olympus, who recline in relative security in the heavens. The gods are identified by the attributes that they brandish against the Titans: Zeus's thunderbolts, Neptune's trident, and Mercury's caduceus (a winged staff entwined by serpents). The action and drama of the battle, recounted in *Metamorphoses*, the ancient Roman text by Ovid, provided Wtewael with an opportunity for a bravura, self-conscious display of skill. This display, combined with the painting's exquisite finish, dramatic poses, and manipulation of space, makes *The Battle between the Gods and the Titans* emblematic of the late Mannerist style.

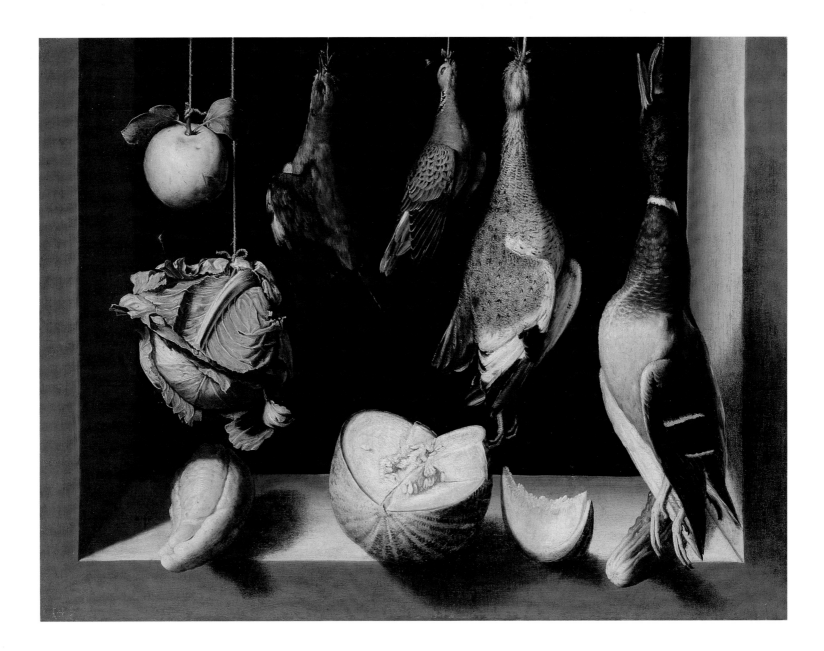

Juan Sánchez Cotán

Spanish; 1561(?)–1627

Still Life with Game Fowl, c. 1602
Oil on canvas
67.6 x 88.3 cm (26 ⅝ x 34 ¾ in.)
Gift of Mr. and Mrs. Leigh B. Block, 1955.1203

The Art Institute's *Still Life with Game Fowl* by Juan Sánchez Cotán is the museum's earliest European still-life painting. The rise of still life as an independent subject occurred in the sixteenth century, when artists began to specialize in such categories as landscape, portraiture, and scenes of daily life. Some, like Cotán, became interested in displaying their skill at depicting

inanimate objects. Cotán's focus changed in 1603, however, when he left the Spanish city of Toledo and a successful artistic career of some twenty years to become a lay brother of the Carthusian order at the Charterhouse of Granada. Accordingly, he changed his focus from still lifes to religious images.

The Art Institute's example by this Spanish artist dates from the period just before he left Toledo. It follows the format of all of Cotán's still lifes: precisely rendered forms are displayed in a shallow, windowlike space. In some canvases, he depicted few objects; in others, such as the Art Institute's, Cotán filled the space with them. Cotán organized this compo-

sition with extreme rigor. The perfect symmetry with which the objects are positioned is echoed in the precise geometry of their shapes: the apple, cabbage, and melon are spherical; the birds are conical. A strong, raking light creates a lively play of light and shadow over each form. This design is further enlivened by a subtle compositional device—the hanging objects are arranged not perpendicular to the bottom edge of the painting, but on a barely perceptible diagonal. In these ways, Cotán was able to infuse simple objects in a simple setting with great presence and drama.

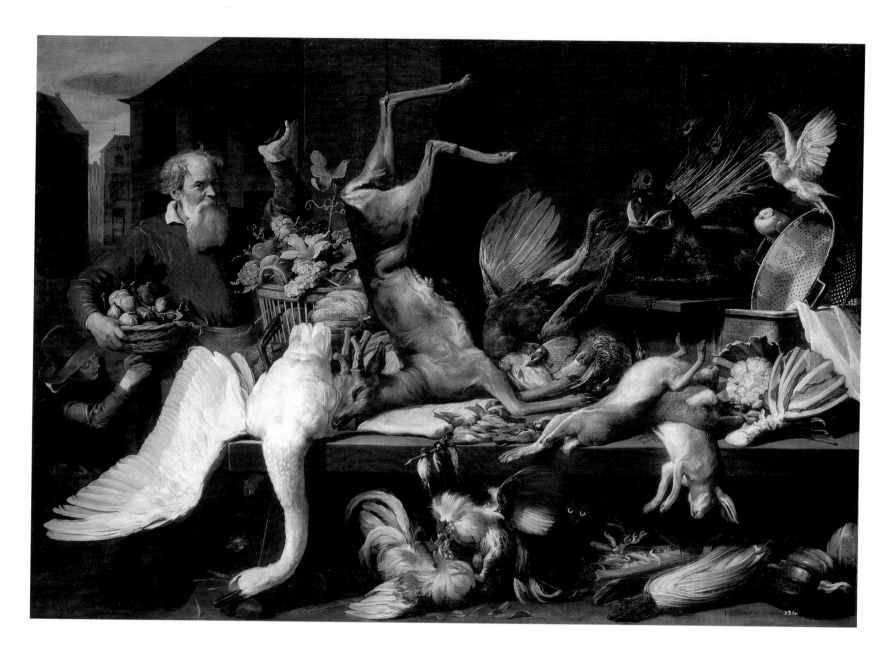

Frans Snyders
Flemish; 1579–1657

*Still Life with Dead Game, Fruits, and
Vegetables in a Market*, 1614
Oil on canvas
212.1 x 308.6 cm (83 ½ x 121 ¼ in.)
Charles H. and Mary F. S. Worcester Collection,
1981.182

Antwerp, with its long tradition of trade, especially in luxury items, was an active artistic center in the seventeenth century. A number of artists, including Peter Paul Rubens (see p. 28), made the first half of the century a golden age of painting in Antwerp. Among them was Frans Snyders, who brought a new level of drama to still life. His almost life-sized compositions depicting living and dead creatures in a market setting seem to have been stimulated by collaboration with Rubens in 1613. However, by 1614, beginning with the Art Institute's painting, the theme of the overflowing market scene became his specialty.

In *Still Life with Dead Game, Fruits, and Vegetables in a Market*, the effect of the market stall is built up through a series of opposing diagonals and contrasting groups of animals, which give the painting a pulsing vitality. A dead peacock's rich plumage contrasts with the flight of the dove at the right. The languid lines of a hanging deer and swan are set off by the frenzied motion of roosters fighting below them. The drama is intensified by a cat that waits with glowing eyes to pounce on the weaker of the two birds. Meanwhile, an old stallkeeper, who, by his gesture and glance, helps place the viewer in the picture, has his pocket picked by a darting boy.

Snyders's large-scale compositions were very much in demand to decorate Flemish town houses and foreign hunting lodges, and established a type of Flemish still-life painting that would remain popular throughout the seventeenth century.

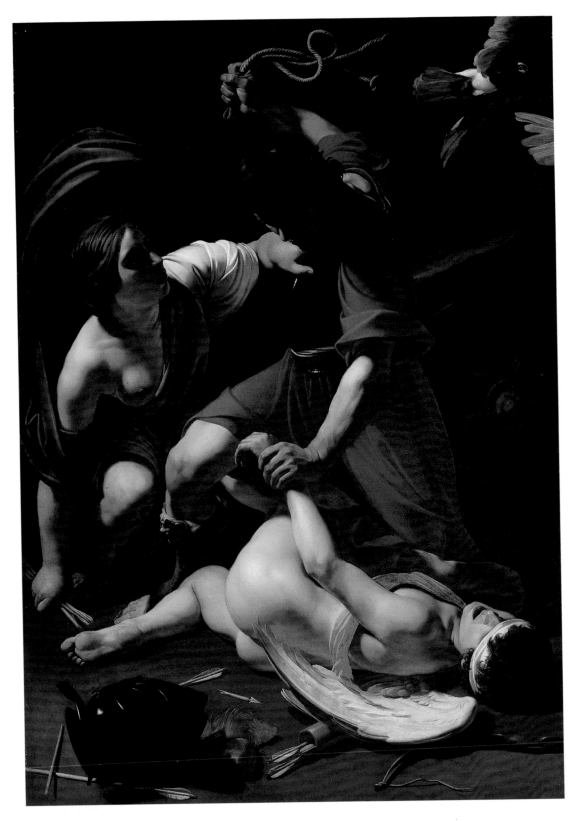

Bartolomeo Manfredi
Italian; c. 1580–c. 1620

Cupid Chastised, 1605/10
Oil on canvas
175.3 x 130.6 cm (69 x 51 ⅜ in.)
Charles H. and Mary F. S. Worcester Collection,
1947.58

Following the example of the revolutionary
early Baroque artist Caravaggio, Bartolomeo
Manfredi chose not to interpret the stories of
the Bible and classical mythology as idealized
subjects enacted by heroic protagonists.
Caravaggio had shown Manfredi and an entire
generation of European artists that such lofty
themes could be transformed into everyday
events experienced by ordinary people. Using
dramatic light effects and depicting the action
as close to the viewer as possible, these artists
were able to convey the meaning of such stories
with great immediacy and power.

Cupid Chastised depicts a moment of high
drama: Mars, the god of war, beats Cupid for
having caused his affair with Venus, which ex-
posed him to the derision and outrage of the
other gods; the goddess of love attempts in vain
to intervene. Surrounded by darkness, the three
figures are lit by a beam of light that breaks
across faces, torsos, limbs, and drapery, intensi-
fying the dynamism and impact of the composi-
tion. The sheer physicality of the figures — the
crouching Venus, whose broad, almost coarse,
face is far from any classical ideal; the powerful
Mars, whose musculature and brilliant red
drapery seem to pulsate with rage; and Cupid,
whose naked flesh and prone position render
him so vulnerable — makes vivid and palpable
the terrible violence of the scene. On one level a
tale of domestic discord, the story also symbol-
izes the eternal conflict between love and war,
and the helplessness of love in the face of wrath.

Francisco de Zurbarán
Spanish; 1598–1664

The Crucifixion, 1627
Oil on canvas
290.3 x 165.5 cm (114 ⁵/₁₆ x 65 ³/₁₆ in.)
Robert A. Waller Memorial Fund, 1954.15

The religious strife in sixteenth-century Europe between Catholics and Protestants prompted intense campaigns on the part of all factions to recruit believers. Recognizing the educational and inspirational value of visual images, the Catholic Church of the Counter-Reformation era encouraged artists to work in a style of easy readability and dramatic fervor.

In 1627 Francisco de Zurbarán, then living and working in the provincial Spanish town of Llerena, painted this *Crucifixion* for the monastery of San Pablo el Reale in prosperous Seville. In the dimly lit sacristy where it was installed, the image of Christ awed the faithful. Later commentators noted that it appeared to be a sculpture rather than a painting. Emerging from a dark background, the austere figure has been both idealized, in its quiet, graceful beauty and elegant rendering, and humanized by the individualized face and insistent realism. Strong light picks out anatomical detail, the delicate folds of the white loincloth, and a curled scrap of paper on which the artist's name and the date of the painting are inscribed.

Zurbarán envisioned the crucified Christ suspended outside of time and place. Conforming to Counter-Reformation dictates, the event occurs not in a crowd but in isolation. Painted with extreme simplicity in a limited color range, *The Crucifixion* conveys intense religious feeling and inspires a deeply meditative response.

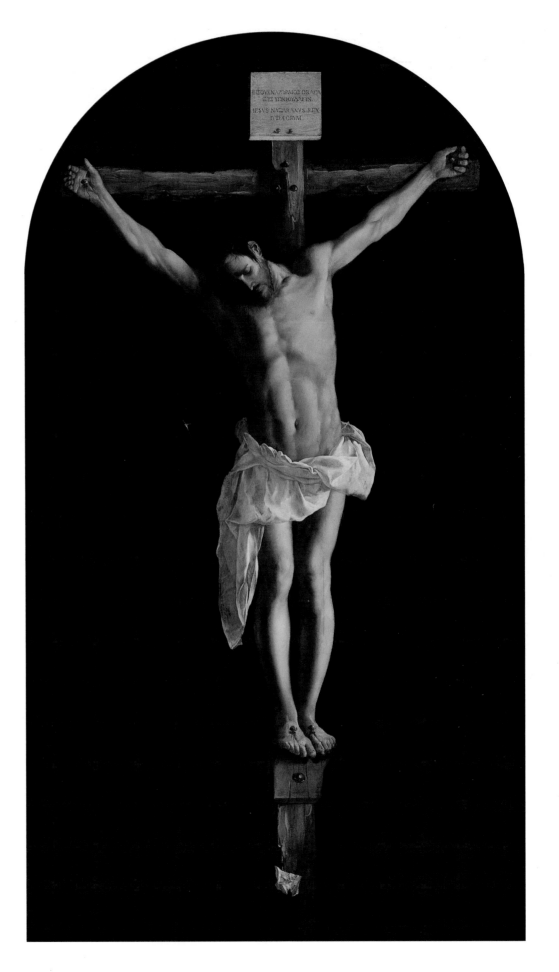

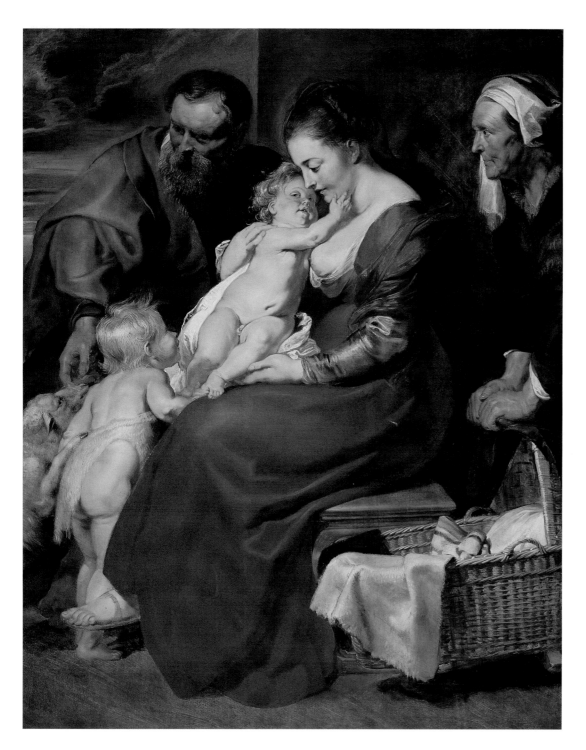

Peter Paul Rubens
Flemish; 1577–1640

The Holy Family with Saints Elizabeth and John the Baptist, c. 1615
Oil on panel
114.5 x 91.5 cm (45⅛ x 36 in.)
Major Acquisitions Fund, 1967.229

By the beginning of the seventeenth century, it was the custom for young Flemish painters to complete their education in Italy. Peter Paul Rubens, who went to Italy in 1600, was exceptional in the length of time he stayed there (eight years) and in the degree to which he assimilated what he saw. He absorbed the art of the great Renaissance painters in Rome and Venice, as well as the most recent advances in early Baroque painting in Rome, and then dominated the artistic scene when he returned to his native Antwerp. The paintings he completed after his return, with their flashing light and dramatic movement, show the influence of Caravaggio's revolutionary work, but his style soon became more classical. A series of paintings of the Madonna and the Holy Family, undertaken between 1610 and 1620—of which this work is a fine example—reflect this development in their balanced compositions, clearly defined forms, and crisply rendered surfaces.

The figure of the Madonna dominates *The Holy Family with Saints Elizabeth and John the Baptist* through the brilliant red of her dress, the emphatic curves of her body, and the solid and contained profile view in which she is presented. The bold, diagonal movement of the two infants—John the Baptist eagerly leans toward Jesus, who twists away from him—provides a counterbalance to the Madonna's solid form. Joseph and Elizabeth frame this pyramidal group, as aged and more passive protectors.

Rembrandt Harmensz. van Rijn

Dutch; 1606–1669

Old Man with a Gold Chain, c. 1631
Oil on panel
83.1 x 75.7 cm (32 ¾ x 29 ¾ in.)
Mr. and Mrs. W. W. Kimball Collection,
1922.4467

Rembrandt van Rijn was very much a product of the Protestant, city-dwelling culture of seventeenth-century Holland. Yet he stands apart from other Dutch artists of his time because of the deep humanity and individuality that he brought to his paintings of religious and historical subjects, and because of the rich and suggestive treatment of color and light that he developed over his long career. Although it is an early work, probably executed just after Rembrandt left his hometown of Leiden in 1631 to become a fashionable portrait painter in Amsterdam, *Old Man with a Gold Chain* treats a subject that was to occupy him for the rest of his life — a character penetratingly observed through dramatic contrast of light and shade and through fanciful costume.

Old Man with a Gold Chain is not a portrait as such. The sitter was a favorite model of Rembrandt, so much so that he has been considered, without any evidence, to be the artist's father. He appears in many biblical scenes, but the subject here is the implied character of the model himself. The proud, old man is ennobled by the chain of office, a soldier's steel gorget, and a plumed beret. Rembrandt used the silhouette of the bulky figure against the light background to convey a sense of the subject's active watchfulness and stability. At the same time, there is a flourish to the figure, in the twist of the body and in the flamboyant outline of the hat, which reveals the ambition of the youthful artist as much as the character of the sitter.

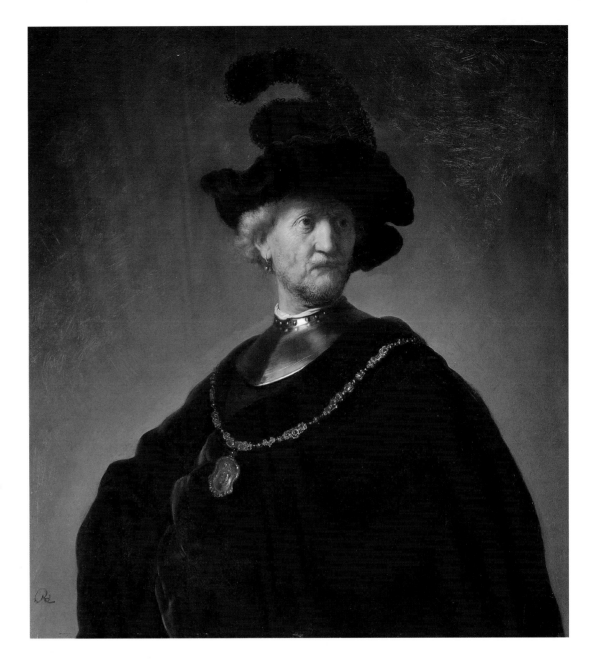

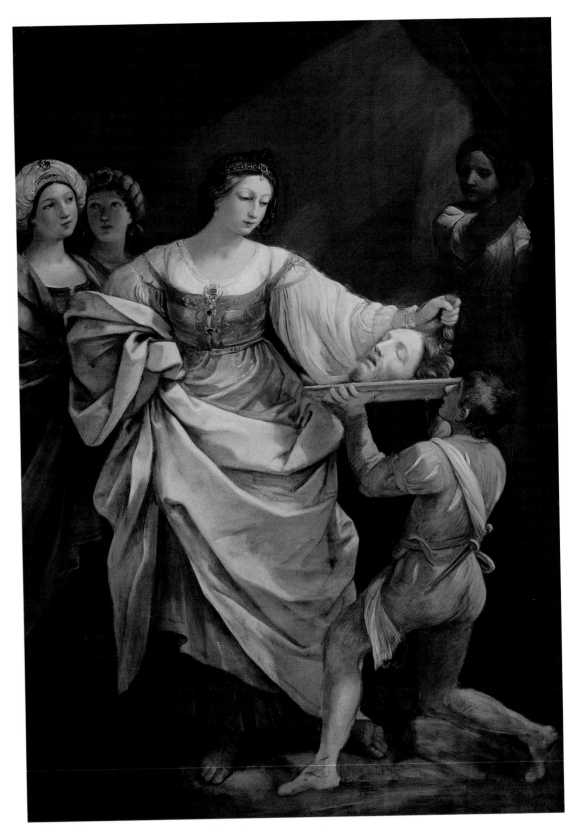

Guido Reni
Italian; 1575–1642

Salome with the Head of Saint John the Baptist, 1639–40
Oil on canvas
248.5 x 224.8 cm (97 ¾ x 88 ½ in.)
Louise B. and Frank H. Woods Purchase Fund, 1960.3

The elegant figures that fill this large canvas enact one of the New Testament's most macabre stories, the death of Saint John the Baptist. The imprisoned prophet had earned the wrath of Herodias because he had reprimanded her new husband, Herod, for having married her, his sister-in-law. A dance presented by Herodias's daughter, the beautiful Salome, so pleased Herod that he offered her whatever she wanted. Prompted by her vengeful mother, she asked for the head of Saint John. In this striking composition, Guido Reni chose to depict the moment when the decapitated head is presented to Salome.

Salome is a prime example of Reni's late manner. He achieved fame in Rome early in his career, working in a dramatic Baroque style for popes and princes, but subsequently settled in his native Bologna. In the Art Institute's painting, as in other works from the end of his life, Reni lightened his palette, restricting himself to a narrow range of cool illumination and color. The broad handling of the forms and paring down of unnecessary details of costume and setting add to the monumental, contemplative quality of the painting.

The central, unresolved issue of Reni's late work is whether or not a painting was completed. *Salome* is extremely sketchy in the definition of areas such as the legs of the page and the feet of Salome — so much so that these parts may have been left unfinished.

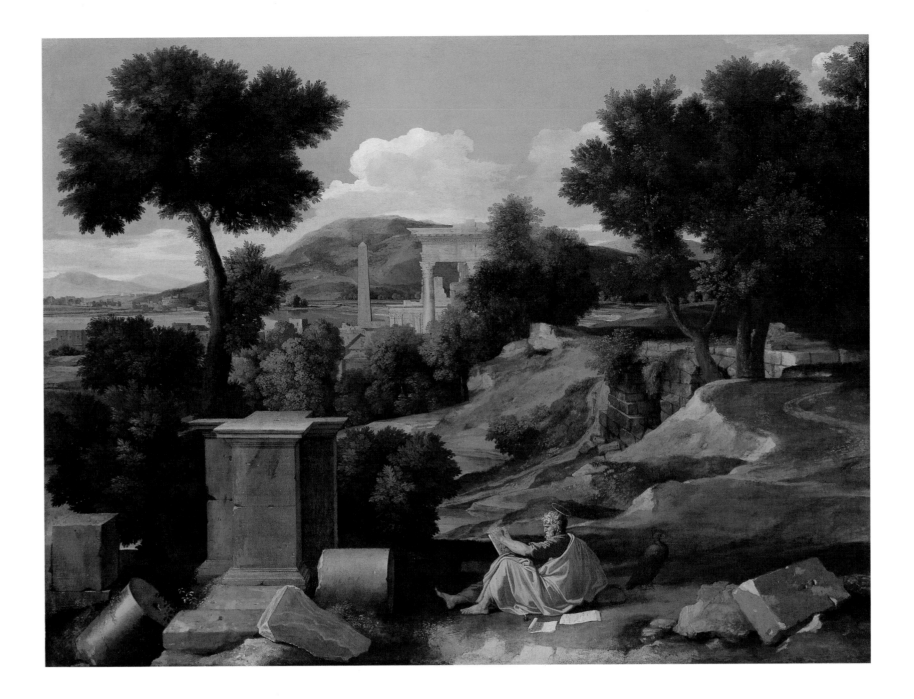

Nicolas Poussin
French; 1594–1665

Landscape with Saint John on Patmos, 1640
Oil on canvas
100.3 x 136.4 cm (39 ½ x 53 ⅝ in.)
A. A. Munger Collection, 1930.500

The art of Nicolas Poussin, more than that of any other seventeenth-century artist, has become synonymous with the ideals of classicism. Although French in origin and training, Poussin spent almost his entire career in Rome painting classically inspired works for a group of highly educated connoisseurs.

This serene and solemn landscape, replete with references to Greco-Roman civilization, seems a perfect setting to inspire Saint John as he writes the biblical book of Revelations. The draped figure reclines beside his symbol, the eagle. The group of ancient ruins in this composition includes an obelisk, a temple, and column fragments, which symbolize the vanished glory of antiquity and its importance as the world in which the new faith took root.

The painting formed a pair with *Landscape with Saint Matthew* (Berlin, Gemäldegalerie), and was possibly part of a projected series on the four evangelists. In these and other works, Poussin carefully constructed an idealized landscape, reshaping and adjusting natural and man-made forms according to geometric principles, and arranging them parallel to the picture plane to reinforce the measured order of the scene. Here, even Saint John is seated in profile, in total concert with the classical landscape that surrounds him.

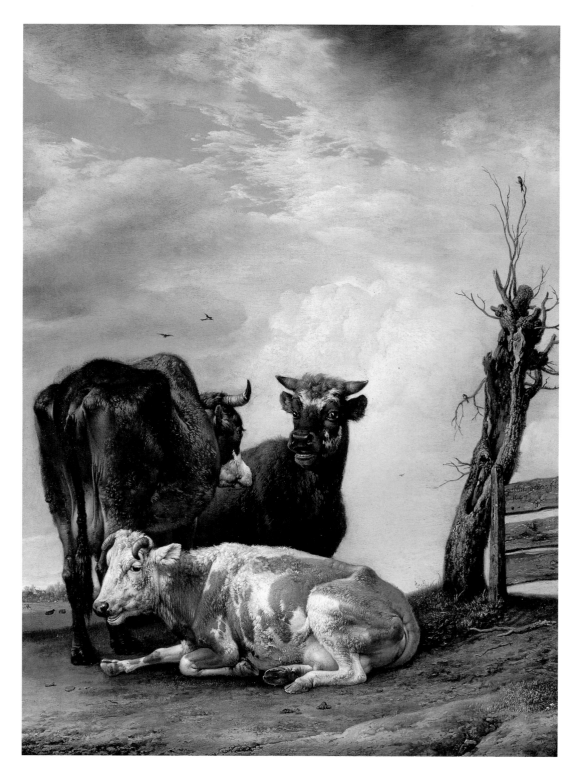

Paulus Potter
Dutch; 1625–1654

Two Cows and a Young Bull beside a Fence in a Meadow, 1647
Oil on panel
49.5 x 37.2 cm (19 ½ x 14 ¾ in.)
In loving memory of Harold T. Martin from Eloise T. Martin, wife, and Joyce Martin Brown, daughter; Charles H. and Mary F. S. Worcester Collection; Lacy Armour Endowment; through prior gift of Frank H. and Louise B. Woods, 1997.336

In a career of less than ten years, Paulus Potter produced a range of exquisitely finished works in the narrow field in which he specialized — the painting of animals, especially cattle, in pastoral settings. In 1647, when he was barely out of his teens, Potter painted twelve outstanding paintings, including his masterpiece, the life-sized *Young Bull* (The Hague, Mauritshuis), and the Art Institute's *Two Cows and a Young Bull beside a Fence in a Meadow*.

This small, beautifully preserved panel reveals Potter's powers of observation and his masterful technique. The artist meticulously rendered the texture of the animals' hides and such details as their bulging eyes. To emphasize the splendid livestock, he reduced the landscape to a tiny vignette in the left corner, while the dramatic windswept sky conveys the moist atmosphere of the Dutch countryside. Potter's highly finished pictures were much sought after by the Dutch elite, who valued the life of the country gentleman. A bucolic scene such as this, in which the alert, young bull seems to assert his claim to the light-colored cow lying languidly in the foreground, would appeal to the collectors' pride in the land, while also making playful reference to the more formal conventions of the history and genre painting they acquired. The dynamic grouping of the animals, conveying an almost human interconnection, was no doubt intended to delight and amuse Potter's patrons.

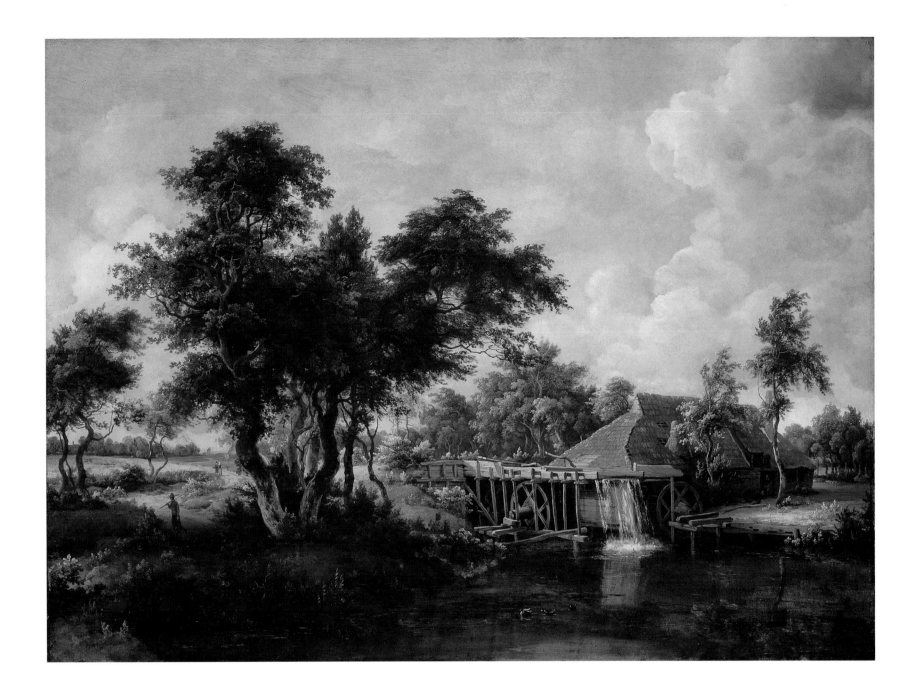

Meindert Hobbema
Dutch; 1638–1709

The Watermill with the Great Red Roof,
1662/65
Oil on canvas
81.3 x 110 cm (32 x 43 ¼ in.)
Gift of Mr. and Mrs. Frank G. Logan, 1894.1031

The seventeenth century was a period of extraordinary artistic production in the Netherlands, both in terms of the number of painters working and the level of quality they achieved.

The dunes, waterways, forests, and fields of Holland, as well as more exotic Scandinavian mountains and Italian hills, furnished subjects for a wealth of often highly specialized landscape painters. Meindert Hobbema focused almost exclusively on woodland scenes, painting them with a breadth and grandeur that are characteristic of Dutch art in general at midcentury and with a serenity and openness that are his own, distinct contribution.

The Watermill with the Great Red Roof is among the artist's finest works. It treats one of his favorite subjects, a picturesque and somewhat dilapidated mill in a wooded setting. The composition is anchored by the still expanse of pond in the foreground and by the dappled sunlight that plays across the fine spray of water over the mill, silhouettes the trees, and draws the viewer's eye back along the twisting path into the distance at the left. The dominant silver tonality and the lively, almost decorative, treatment of leaves and tree trunks are characteristic of Hobbema's art.

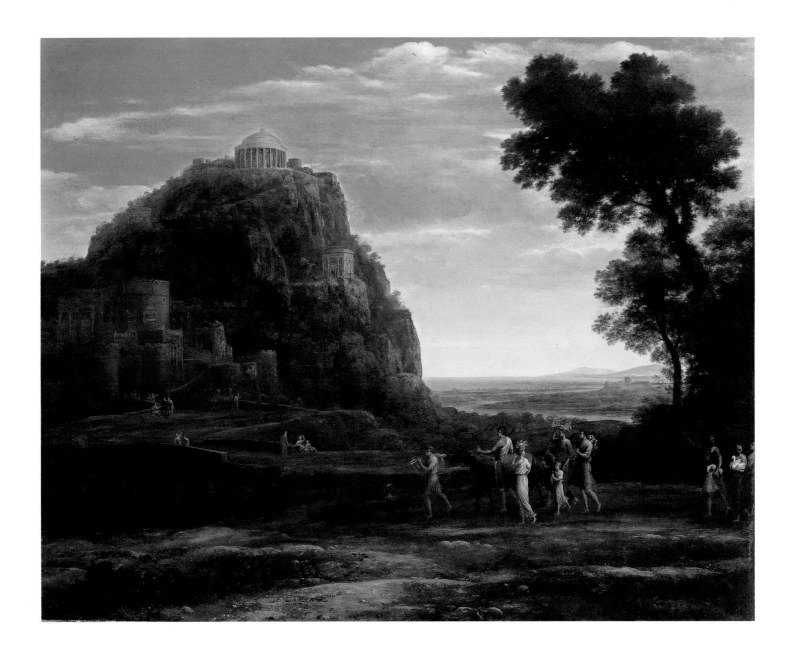

Claude Gellée (called Claude Lorrain)
French; 1600–1682

View of Delphi with a Procession, 1673
Oil on canvas
101.6 x 127 cm (40 x 50 in.)
Robert A. Waller Memorial Fund, 1941.1020

Although Claude Gellée was a native of the duchy of Lorraine in present-day France, it was in Rome that he earned his reputation as the greatest classical landscape painter of his time. A learned clientele of aristocrats and clerics, largely from France and his adopted city of Rome, was eager to acquire his poetic, idealized depictions of landscapes.

In keeping with Claude's frequent practice, *View of Delphi with a Procession* was intended as one of a pair of landscapes. The pair was commissioned by the erudite Cardinal Carlo Camillo Massimi, along with *Coast View with Perseus and the Origins of Coral* (England, private collection). Both works may have hung with another pair, which Massimi had ordered earlier from Claude. While the links between Claude's paired paintings often remain mysterious, they share a quiet balance of cool and warm light and the motif of grand trees serenely framing distant views.

Claude often introduced biblical, literary, or mythological subjects into his landscapes. In the Art Institute's painting, the fanciful depiction of the ancient Greek city of Delphi and the site of its famous oracle is based on the descriptions of the third-century Roman historian Marcus Justinus. In the foreground, a procession of priests leads a sacrificial bull to the oracle with somber dignity. Suffusing this idyllic vision is a remarkable, limpid illumination, an effect refined by the artist from his lifelong study of the *campagna*, the countryside around Rome. Clear and even, the light unifies the composition, producing a calm, ethereal continuity of space that harmonizes with the delicate, attenuated figures that are characteristic of Claude's late style.

Giovanni Battista Piazzetta
Italian; 1682–1754

Pastoral Scene, c. 1740
Oil on canvas
191.8 x 143 cm (75 ½ x 56 ¼ in.)
Charles H. and Mary F. S. Worcester Collection,
1937.68

The Venetian Giovanni Battista Piazzetta's
dark colors and brooding, shadowy figures do
not follow the early eighteenth-century Rococo
taste for chromatic brilliance and light, airy
compositions. As large and complex images of
everyday life, *Pastoral Scene* and its companion
piece, *Figures on the Shore* (Cologne, Wallraf-
Richartz Museum), are unusual even in
Piazzetta's work. Both were commissioned by
the avid collector Marshal von der Schulenburg.
The enigmatic interaction of the figures, their
melancholy demeanor, and the unusually large
size of both paintings suggest a more serious
intent than the representation of rustic life:
Why do the two male figures behind the rock
whisper together? Why does the young woman,
her arm outstretched and her dress slipping en-
ticingly from her shoulder, seem to engage the
viewer so wistfully? And what is the meaning of
the half-nude child and dogs chasing a duck?
The possibility of a deeper meaning has been
frequently and inconclusively debated. *Pastoral
Scene* could be a poetic allegory, a form of social
commentary, or an image of amorous dalliance.

Interestingly, when Piazzetta himself pre-
pared the inventory of von der Schulenburg's
collection in 1741, he discussed this painting by
describing the disposition of the figures, which
suggests that, if he intended any more elaborate
meanings, he wished them to be subjective and
allusive. Nevertheless, *Pastoral Scene* and its
pendant are among the most commanding and
evocative of Piazzetta's works.

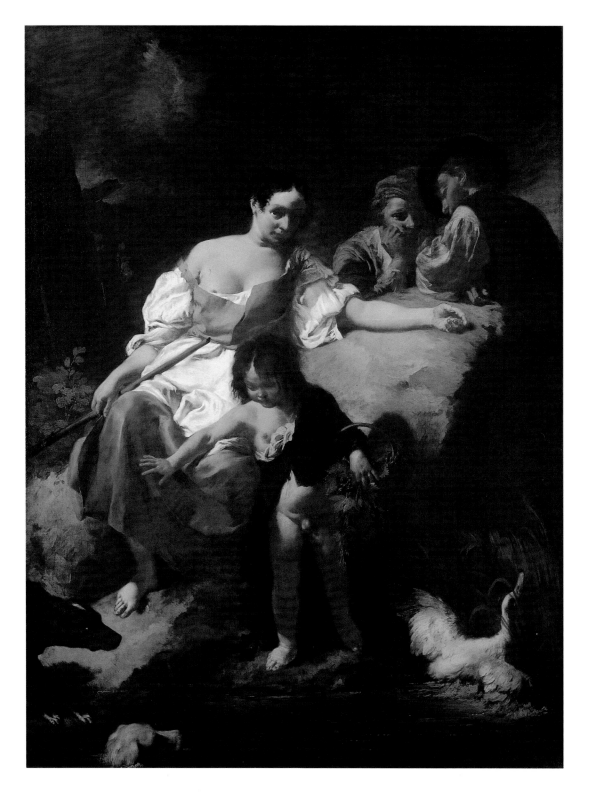

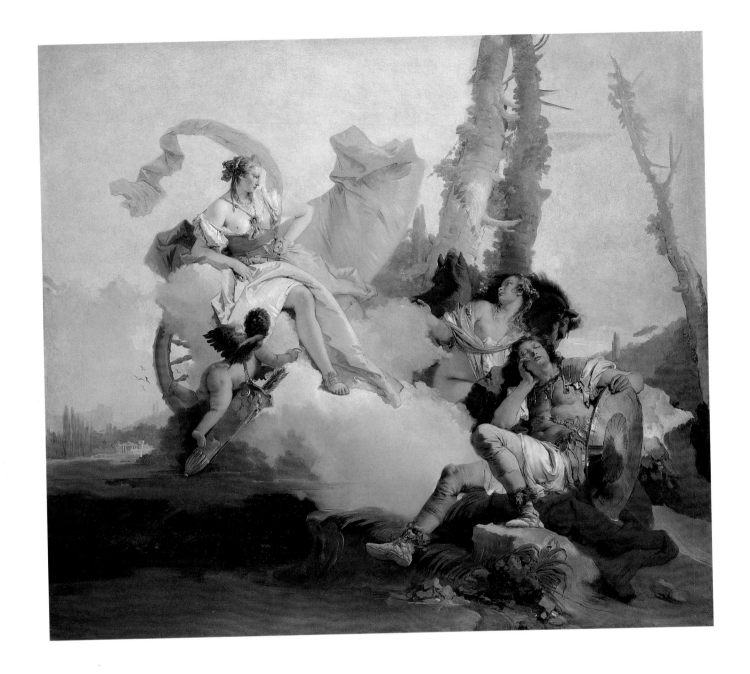

Giovanni Battista Tiepolo

Italian; 1696–1770

Rinaldo Enchanted by Armida, 1742
Oil on canvas
187.5 x 216.8 cm (73 ¹³/₁₆ x 85 ⅜ in.)
Bequest of James Deering, 1925.700

The Venetian Giovanni Battista Tiepolo was one of the eighteenth century's greatest artists. His light and high-keyed palette, virtuoso drawing, speed and spontaneity of execution, along with his mastery of perspective and illusionism, were perfectly suited to the large-scale architectural spaces he decorated in rapid succession in Italy, Germany, and Spain.

The Art Institute's suite of four canvases relating the story of Rinaldo and Armida exemplifies the exuberant, Rococo style Tiepolo had evolved by the 1740s. It is believed that these four canvases were the main narrative components of a pictorial ensemble that once decorated a room in a Venetian palace. In the first canvas of the narrative, illustrated here, Rinaldo, the hero of Tasso's epic poem *Gerusalemme liberata (Jerusalem Liberated)* (1581), is diverted by the beautiful sorceress Armida from his crusade to save the Holy Land from the infidels. In this imaginative version of the seduction, Armida, suspended on a billowing cloud, happens upon the sleeping crusader,

her shawl and drapery wafting behind her, as if a gentle wind had blown this mirage to Rinaldo. The painting's luminous, airy atmosphere is created by a vast, open expanse of sky and landscape behind the figures. The complex and elaborate arrangement of figures, draperies, and clouds, and the gentle diagonals of the trees, landscape, and other details further animate the composition. Thick, creamy paint surfaces enhance the extraordinary pictorial beauty of this magical, pastoral world. With seemingly effortless facility, Tiepolo achieved here one of his most poetic works.

François Boucher

French; 1703–1770

Are They Thinking about the Grape?, 1747
Oil on canvas
80.8 x 68.5 cm (31¾ x 27 in.)
Martha E. Leverone Endowment, 1973.304

No art epitomizes the light-hearted sensuality, fancifulness, and grace of the Rococo style better than that of François Boucher. The nineteenth-century critics the de Goncourt brothers described him as "one of those men who typify the tastes of a century, who express it, personify it, and incarnate it." In a period that demanded decorative ensembles and encouraged artists to design for many media, Boucher mastered every branch of the decorative arts and of painting. Championed by Madame de Pompadour, mistress of Louis XV (r. 1715–74), he became First Painter to the King in 1765 and played an important part in the remodeling of Fontainebleau and Versailles. His sure sense of design and ability to use color, texture, and linear rhythms to create images of a pleasing world somewhere between fantasy and reality endeared him to his sophisticated patrons.

Are They Thinking about the Grape? was inspired by a contemporary pantomime; Boucher had an association with the theater, having worked frequently as a set and costume designer. In this story, a lovestruck shepherd and shepherdess feed each other grapes as the shepherd gazes ardently at his beloved. Boucher's tongue-in-cheek title underscores the gentle voluptuousness of the scene. The arrangement of the landscape elements is contrived, the animals more toylike than realistic, the figures too opulently dressed and aristocratic in their gestures for their rustic origins. Yet Boucher's authoritative draftsmanship and understanding of nature provide a solid base for such artifice. Included along with a probable pendant (*The Flageolet Player*; Belgium, private collection) in the 1747 Salon, the official exhibition of the French Académie, this popular bucolic fantasy was reproduced in an engraving and a tapestry.

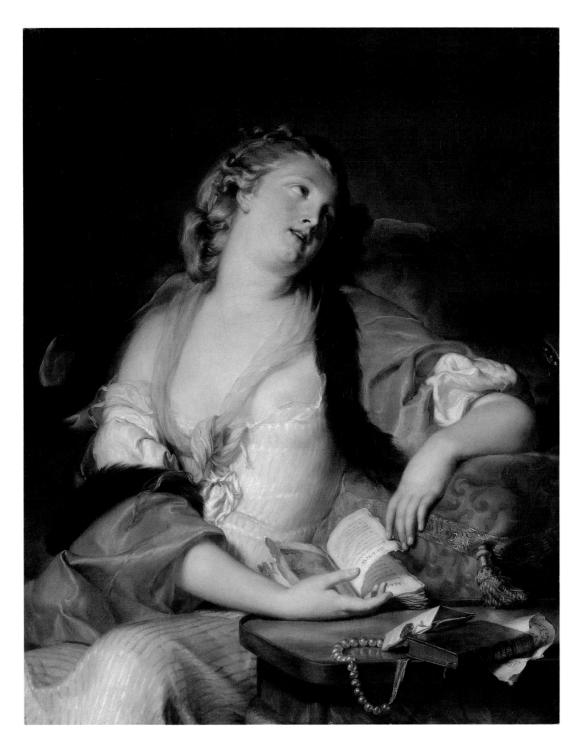

Jean Baptise Greuze
French; 1725–1805

Lady Reading the Letters of Héloise and Abelard, 1758/59
Oil on canvas
81.3 x 64.8 cm (32 x 25 ½ in.)
Mrs. Harold T. Martin Fund; Lacy Armour Endowment; Charles H. and Mary F. S. Worcester Collection, 1994.430

In eighteenth-century France, official patronage favored history painting — the representation of inspiring events from the Bible and mythology, as well as from history — while the public was charmed by glimpses of everyday life. Jean Baptiste Greuze sought to reconcile these two tastes by emphasizing the moral and rhetorical ingredients in his scenes of bourgeois life. Vividly combining sensuality and high-mindedness, *Lady Reading the Letters of Héloise and Abelard* may be one of Greuze's earliest as well as one of his most provocative ventures into this hybrid form.

In the Art Institute's painting, Greuze depicted a young lady reading a volume of the letters of Héloise and Abelard, medieval lovers whose ill-fated romance enjoyed tremendous popularity as retold by various eighteenth-century authors. After a passionate affair, the philosopher Abelard and his well-born, young pupil Héloise were forcibly separated and each compelled to join a cloistered religious order. In showing his reader swept away by an emotional response to their correspondence, Greuze placed her in a languorous pose that he knew would delight his viewers. At the same time, her pose references prestigious works by Baroque history painters Peter Paul Rubens (see p. 28) and Charles Le Brun, compositions that would have been familiar to Greuze's sophisticated Parisian audience and that helped elevate this view of a modern woman in her boudoir to the more generalized realm of human passion.

Sir Joshua Reynolds

English; 1723–1792

Lady Sarah Bunbury Sacrificing to the Graces,
1763–65
Oil on canvas
242.6 x 151.5 cm (95 ½ x 59 ¾ in.)
Mr. and Mrs. W. W. Kimball Collection,
1922.4468

With its subject dressed in a loose, vaguely
Greek or Roman costume and surrounded by
architecture, sculpture, and artifacts of antiq-
uity, *Lady Sarah Bunbury Sacrificing to the
Graces* was the grandest expression to date of
Joshua Reynolds's full-length, classically inspired
portraits. The artist cast Lady Sarah here as a
priestess of the Three Graces. These three figures
were mythical followers of the goddess Venus,
who symbolized the blessings of generosity—
both the giving and receiving of gifts. They are
normally represented with the central Grace
facing in the opposite direction from her com-
panions, but Reynolds showed them all facing
Lady Sarah and returning her sacrifice with
their own tribute to her: a wreath. It is as if the
statue has miraculously come to life and the
Graces themselves, recognizing the beauty and
good nature of Lady Sarah, are inviting her to
join them.

Although only eighteen when this portrait
was begun and twenty when it was finished,
Lady Sarah was already a famous, aristocratic
beauty. The young King George III (r. 1760–1820)
had fallen in love with her, but political consid-
erations had prevented him from taking her as
his queen. Her marriage, the year before this
portrait, to Sir Charles Bunbury, a baronet, was
to end in divorce after she had a love affair with
her cousin Lord William Gordon, bore his child,
and eloped with him. At the age of thirty-six,
she married Colonel the Hon. George Napier
and had another eight children. About her zest
for life, one contemporary remarked that she
"never *did* sacrifice to the Graces; her face was
gloriously handsome, but she used to play cricket
and eat beefsteaks on the Steyne at Brighton."

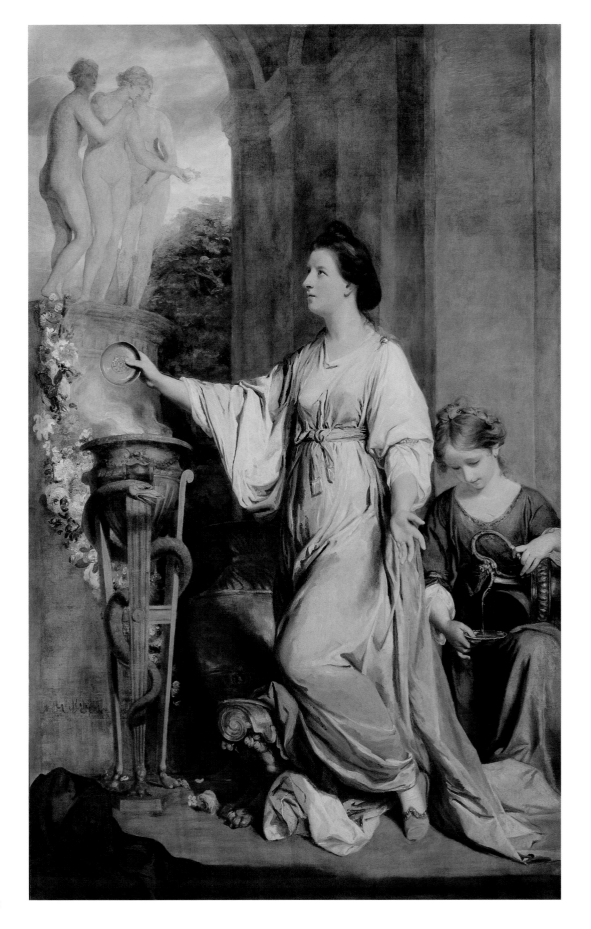

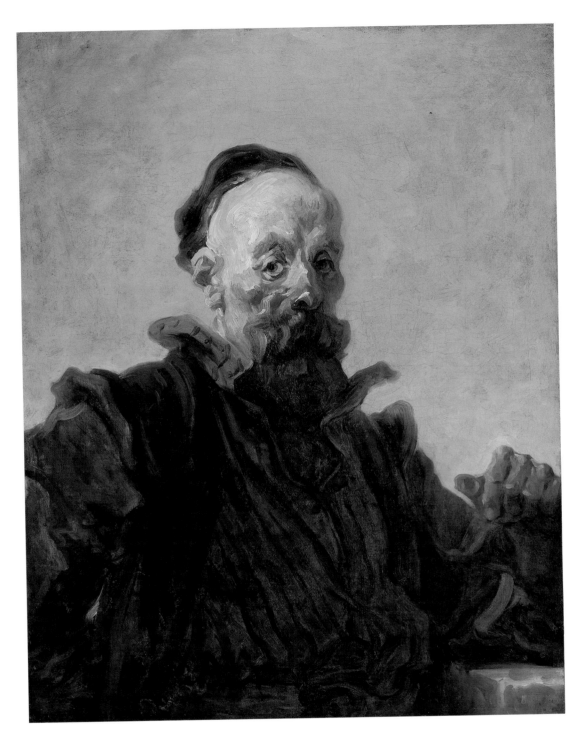

Jean Honoré Fragonard
French; 1732–1806

Portrait of a Man, 1768/70
Oil on canvas
80.3 x 64.7 cm (31 ⅝ x 25 ½ in.)
Gift of Mary and Leigh Block in honor of John
Maxon, 1977.123

One of the most brilliant eighteenth-century
French artists, Jean Honoré Fragonard painted
mythological subjects, sweeping landscapes,
and witty scenes of everyday life among the
privileged as well as the humble. His paintings
rarely attained the degree of finish then deemed
appropriate for a carefully prepared and exe-
cuted work. Instead, he applied his pigment
richly and impetuously, so that his compositions
often have the character of quick sketches.

Portrait of a Man belongs to a series of fan-
tasy portraits which, in many ways, summarizes
Fragonard's highly personal art. He executed
them in rapid, virtuoso strokes—some carried
a declaration that they were painted in an hour.
While a few of the sitters can be identified as
Fragonard's patrons and friends, their features
are never very specific. They are treated not
only as portraits, but also as vibrant types—
an old soldier, a coquette, a singer. The seven-
teenth-century costumes reflect Fragonard's
fascination with earlier painting and his appro-
priation of the style and subjects of his great
predecessors, notably Peter Paul Rubens (see p.
28). In fact, in *Portrait of a Man* (which used to
be called *Don Quixote*, without basis), the sitter's
beard and moustache and the striped garment
with extended shoulders relate to the fashions
of the early Baroque period. The restricted color
range gives added force to the man's head, sil-
houetted against a luminous background. His
large, world-weary eyes dominate the image
and, in their stillness, contrast poignantly with
the undulating contours of his costume.

Francisco José de Goya y Lucientes
Spanish; 1746–1828

Boy on a Ram, 1786/87
Oil on canvas
127.2 x 112.1 cm (50 1/16 x 44 1/8 in.)
Gift of Mr. and Mrs. Brooks McCormick,
1979.479

Francisco Goya had just been appointed
painter to Charles III of Spain (r. 1786–88) in
1786 when he was asked to produce a series of
designs for tapestries to decorate the dining
room of the Palacio del Pardo. Goya's full-scale
paintings, called cartoons, served as the models
from which the weavers made the final tapes-
tries. The tapestry based on *Boy on a Ram* hung
over a door, alongside other, larger decorations
that featured activities of each of the four sea-
sons.

This charming depiction of a boy implies
the potential of youth, while his whimsical
mount may refer to the zodiacal sign of Aries,
the ram, associated with spring. Exuding the
lighthearted gaiety of the Rococo era, this
painting also exhibits Goya's highly original
style and technique. With an unerring eye and
active, flickering brushwork, the artist imbued
his fanciful image of an elegantly dressed boy
with a sense of vitality and light.

The series of tapestries for the dining room
at the Palacio del Pardo was one of three major
royal tapestry commissions that Goya received
between the mid-1770s and the early 1790s.
Executed strictly for the weavers at the royal
tapestry factory at Santa Barbara, these painted
scenes of eighteenth-century popular life were
not intended for public viewing. They stayed in
the possession of the royal tapestry factory, until
most of them passed into the Museo del Prado,
Madrid, where they remain to this day. Goya's
tapestry designs show the evolution of his acute
powers of observation of daily life and his bold
technique, qualities that he would shortly de-
velop even further under the stress of war and
insurrection, when Napoleon sought to make
Spain part of his empire.

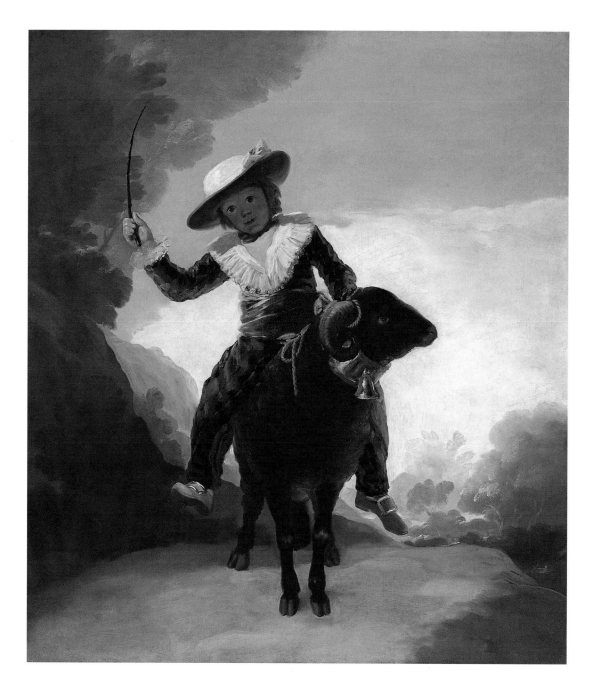

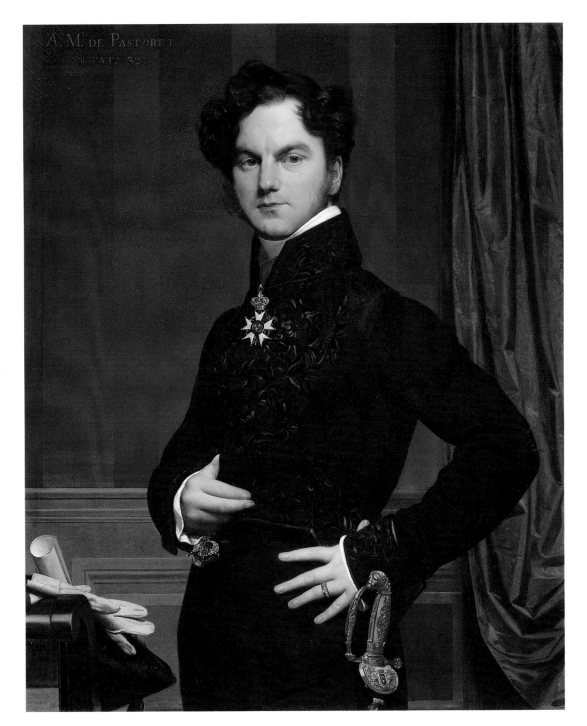

Jean Auguste Dominique Ingres
French; 1780–1867

Amédée-David, Marquis de Pastoret, 1823–26
Oil on canvas
103 x 83.5 cm (40½ x 32¾ in.)
Estate of Dorothy Eckhart Williams; Robert
Allerton, Bertha E. Brown, and Major
Acquisitions endowments, 1971.452

The aesthetic competition between the two painters who dominated French art in the first half of the nineteenth century is one of the legends of art history: Eugène Delacroix (see p. 44), the great Romantic, whose canvases are celebrations of color, movement, and passion, rivaled Jean Auguste Dominique Ingres, master of the eloquent line, whose exacting eye and love of precise, measured details indicated his devotion to classical ideals.

Ingres preferred to think of himself as a painter of epic moments in history and of the heroes and stories of the Bible and classical mythology. Yet, for many years, Ingres's livelihood came from his portraits, whether paintings or drawings, and it is these works that account for the great esteem in which he is held today. Amédée-David, the young count who, at the time of this portrait, was soon to assume his father's position as Marquis de Pastoret, is believed to have assisted Ingres in becoming a member of the French Académie. From the young nobleman's elegant silhouette to the precisely rendered details of his sword hilt and medal of the Légion d'honneur, everything about Ingres's portrait indicates the fastidiousness and sensitivity to detail that characterize his art. The man's slightly swaggering pose, elegant costume, long fingers, and even the tilt of his head proclaim his aristocratic status, along with something of the arrogance of his personality. All elements of the painting express both the confidence of the sitter and the assurance of a painter totally in command of his art.

Sir Thomas Lawrence
English; 1769–1830

Mrs. Jens Wolff, 1803–15
Oil on canvas
128.2 x 102.4 cm (50 ½ x 40 ⁵⁄₁₆ in.)
Mr. and Mrs. W. W. Kimball Collection,
1922.4461

Deep in thought, their costumes brilliant with
sheens and glints, the sitters in Thomas
Lawrence's paintings are the very image of
Romantic heroes and heroines. Lawrence was
well acquainted with Isabella Wolff, the subject
of this portrait, and was rumored to have had a
love affair with her. When he began this paint-
ing, she was living near London with her hus-
band, a wealthy Anglo-Dutch timber merchant
and ship broker. But the work was left
unfinished in the studio for over ten years, and,
by the time the artist took it up again, in 1814,
the couple had separated and Mrs. Wolff was
living with one of her sisters in a village in Kent.

In this portrait, Wolff contemplates the
figure of the Delphic Sibyl from the Sistine
Chapel ceiling in a book of engravings after
Michelangelo, and her pose ingeniously echoes
that of another Sibyl in the same work. The
Sibyls were priestesses of classical legend who
made enigmatic judgments and prophecies.
They are often depicted in exotic costumes and
settings, a tradition Lawrence followed in the
turban, shawl, and Oriental textile on the desk.
Over the sitter's shoulder, we glimpse another
noble figure of the ancient world: Niobe, who
turned to stone bewailing the loss of her chil-
dren (here Lawrence invoked the famous classi-
cal sculpture of this tragic figure in the Museo
degli Uffizi, Florence). Lawrence's intention was
clearly to represent Mrs. Wolff as a present-day
embodiment of the feminine ideal celebrated in
classical and Renaissance art.

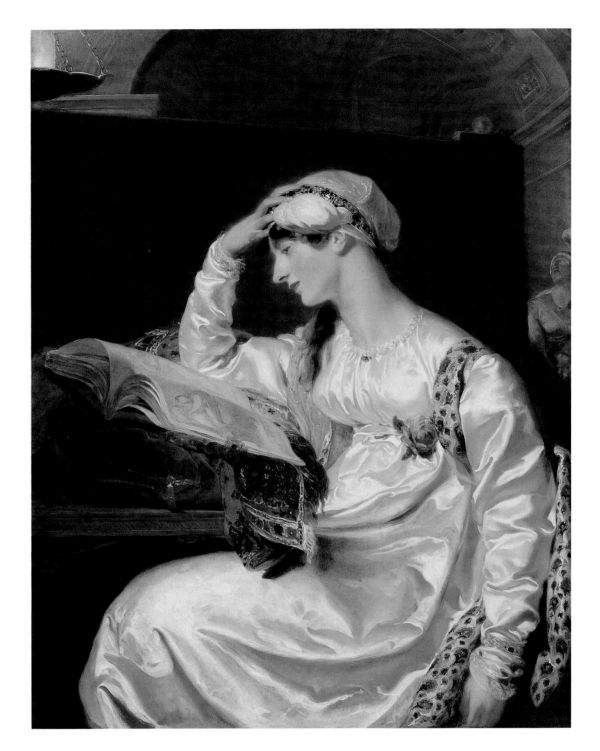

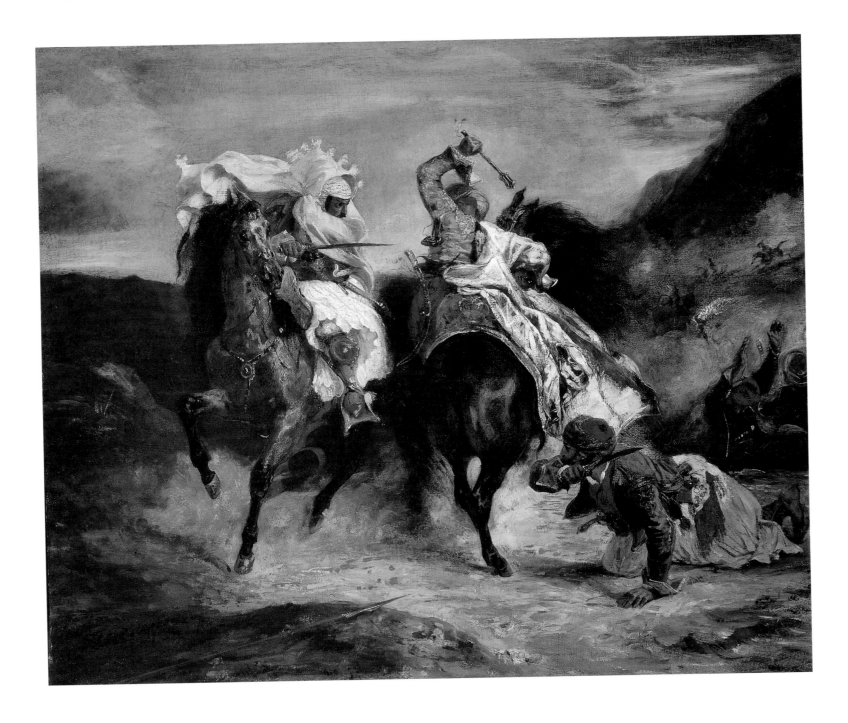

Eugène Delacroix

French; 1798–1863

The Combat of the Giaour and Hassan, 1826
Oil on canvas
59.6 x 73.4 cm (23 ½ x 28 ⅞ in.)
Gift of Bertha Palmer Thorne, Mrs. Rose Movius Palmer, Mr. and Mrs. Arthur M. Wood, Mr. and Mrs. Gordon Palmer, 1962.966

Admiration for Lord Byron's poem "The Giaour" (written in 1813 and translated into French in 1824) inspired the great Romantic painter Eugène Delacroix to interpret visually its themes of adventure and love. In *The Combat of the Giaour and Hassan,* Delacroix depicted the dramatic climax of the story related in Byron's poem: a Venetian known as the "Giaour" (a Turkish word for Christian infidel or non-Muslim) seeks to avenge his mistress's death at the hands of a Turk called Hassan, from whose harem she had fled. Set on a Greek battlefield, the painting focuses on the two men, mounted on spirited horses, facing each other in mirror-image poses, their weapons raised. Often considered the finest of the six known versions Delacroix based on Byron's poem, the Art Institute's painting was begun in 1826, two years after Byron died fighting for Greek independence from the Turks. It was first shown in Paris in 1827 at an exhibition to benefit the Greek cause.

The vigorous interaction of glowing colors, forms in motion, and dramatic subject are characteristic of Delacroix's art. The numerous Greek and Turkish battle scenes of his early years represent not only his identification with the Greek war of liberation, but also his lifelong preoccupation with exotic lands and themes of passion.

Carl Blechen

German; 1798–1840

The Interior of the Palm House on the
Pfaueninsel near Potsdam, 1834
Oil on canvas
135 x 126 cm (52 ½ x 50 in.)
Through prior acquisitions of the George F.
Harding Collection; L. L. and A. S. Coburn and
Alexander A. McKay endowments; through prior
gift of William Wood Prince; through prior
acquisitions of the Charles H. and Mary F. S.
Worcester Endowment, 1996.388

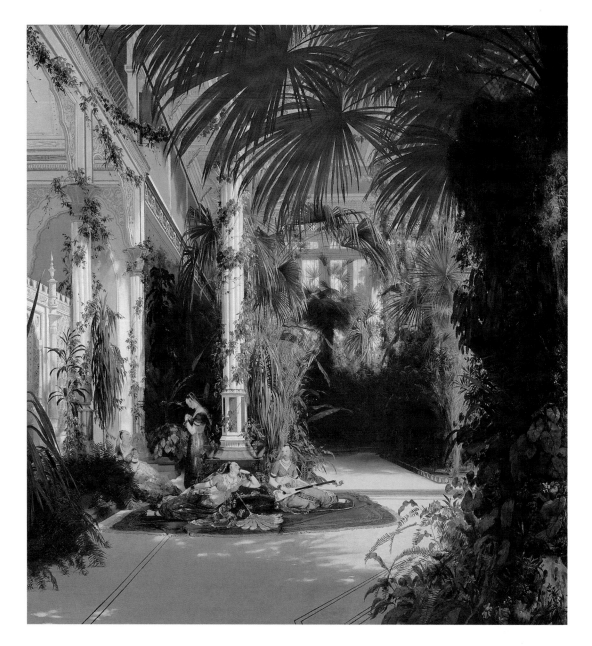

Carl Blechen is regarded as a pivotal figure in nineteenth-century German painting, his short career marking the transition from Romanticism to a more realistic view of nature. Inspired in part by the Italian landscape and light he encountered during a trip around 1828 or 1829, Blechen developed a fluid technique that enabled him to capture fleeting atmospheric effects. He often used his brilliantly observed landscapes as the setting for nostalgic or mysterious figures, reflecting his early contact with Romantic painters and the theater.

A commission from Friedrich Wilhelm III of Prussia (r. 1797–1840) to paint two views of an exotic pleasure building recently constructed near Potsdam constituted a major opportunity for the struggling young painter. After completing two exquisite, small paintings for the king, Blechen made this single, grand version for public viewing. *The Interior of the Palm House on the Pfaueninsel near Potsdam* was to be one of the artist's most ambitious statements, for he soon succumbed to melancholy and madness.

The architect Karl Friedrich Schinkel designed the Palm House to contain the King's collection of palms. It was situated on the Pfaueninsel, or Peacock Island, a favorite royal retreat dotted with whimsical buildings such as a tiny castle and a Gothic dairy. Blechen's painting is both a record of the appearance of the building, with its lush palms and fragments of an Indian temple, and an evocation of a fantasy world peopled by beautiful Asiatic women, purposefully playing to the imagination.

John Constable

English; 1776–1837

Stoke-by-Nayland, 1836
Oil on canvas
126 x 169 cm (49 ⅝ x 66 ½ in.)
Mr. and Mrs. W. W. Kimball Collection,
1922.4453

Even after living for many years in London, John Constable continued to portray the countryside dear to him from boyhood. Stoke-by-Nayland lies a few miles from his native village of East Bergholt in Suffolk. In this view, the brilliant, airy vista toward the village contrasts with the shady, tunnel-like country lane leading off to the right. Constable explained that the time is meant to be eight or nine o'clock on a summer's morning, with the earth still dewy and damp from a light rain shower during the night. To suggest the fertility of the land, Constable emphasized the abundance of water, flecking the surface with white highlights to create effects of sparkling wetness. Here, the whole scene appears doused, with a stream and puddles in the foreground and a central tree that droops as if heavy with moisture.

Painted as much with a palette knife as with brushes, *Stoke-by-Nayland* lacks the finish that Constable gave the pictures he brought before the public at exhibitions. It was either simply left unfinished or meant as a full-scale sketch for a work that he never realized. Yet his delight in freely scribbling and scraping the image into existence is obvious. What is lost in detail is gained in atmosphere and the sense of the changeability of weather. The roughness of the surface mimics the textures of nature, and the fusion of man-made and natural elements in the scene embodies an ideal of harmony indicative of Constable's vision of rural England.

Joseph Mallord William Turner

English; 1775–1851

Fishing Boats with Hucksters Bargaining for Fish, 1837/38
Oil on canvas
174.5 x 224.9 cm (68 ¾ x 88 ½ in.)
Mr. and Mrs. W. W. Kimball Collection,
1922.4472

In *Fishing Boats with Hucksters Bargaining for Fish,* Joseph Mallord William Turner pursued a theme of long-standing personal interest: the sea. Beginning in the 1790s with scenes of moonlight reflected in water, Turner moved on to depicting boats tossed by raging seas, as well as dramatic marine sunrises and sunsets.

On board the large vessel with billowing sails at the left are several roughly painted figures, who presumably will do business with a figure gesturing with an upraised arm, standing in a small boat to the right. With these few details, the "bargaining for fish" takes place, in the presence of an ominously threatening sea and sky. The low horizon line, as well as the subject itself, derives from Turner's exposure during his formative years to seventeenth-century Dutch sea paintings. *Fishing Boats with Hucksters Bargaining for Fish* dates from an im-

portant transitional phase of Turner's style in the mid-1830s, when he was increasingly absorbed in rendering the often sublime effects of atmosphere and light.

In a small, yet not insignificant, detail, Turner alluded to the arrival of a new era at sea. Plying the calmer waters of the distant horizon is a steam-driven vessel, emitting a trail of dark smoke. Thus, Turner appears to have achieved two notable results in *Fishing Boats*: he subtly opposed tradition and progress, while celebrating the moods and vicissitudes of nature.

Edouard Manet
French; 1832–1883

The Mocking of Christ, 1865
Oil on canvas
190.8 x 148.3 cm (74 ⅞ x 58 ⅜ in.)
Gift of James Deering, 1925.703

Throughout his career, Edouard Manet managed to shock and confound the public with his bold technique and unorthodox approach to his subjects. The most startling feature of his great religious composition *The Mocking of Christ* is that it was painted at all. After the advent of the Realist movement in earlier nineteenth-century French painting, avant-garde artists in France did not pursue religious themes. Yet, while Manet was most certainly a painter of secular subjects — indeed, he was particularly urbane in his themes and orientation — he was also interested in the biblical narratives that had compelled artists for many centuries. It is likely that there is a connection between this interest and the popular contemporary biography *Vie de Jésus (Life of Jesus)* (1863) by French philosopher and historian Joseph Ernest Renan, a controversial work that emphasizes the humanity of Jesus.

In *The Mocking of Christ*, Jesus is made very human and vulnerable by his frontal presentation; by his passive, almost limp pose; and by the earthy characters around him. The painting's visible brush strokes — as seen in Christ's worn feet — and its almost monochromatic tonality create an insistent sense of materiality that further evokes a palpable, unidealized Christ. The painting depicts the moment when Jesus' captors mock the "King of the Jews" by crowning him with thorns and covering him with a robe. Although, according to the Gospel story, this taunting is followed by beatings, Manet's would-be tormentors appear ambivalent as they surround the pale, stark figure of Christ. In these ways, Manet managed to present a traditional subject in a contemporary, challenging light.

Gustave Courbet

French; 1819–1877

Mère Grégoire, 1855 and 1857–59
Oil on canvas
129 x 97.5 cm (50 ¾ x 38 ⅜ in.)
Wilson L. Mead Fund, 1930.78

As the undisputed leader of the Realist move-
ment, Gustave Courbet played a crucial role in
the development of modern French painting.
However, critics and the public did not easily
accept his large, naturalistic, and unsentimen-
tal paintings of commonplace, often rural sub-
jects, calling him the "apostle of ugliness."

The ample, demurely dressed subject of
Mère Grégoire was inspired by the heroine of a
popular song written in the 1820s by French
lyricist Pierre Jean Béranger. Béranger often
wrote ribald lyrics; his "Madame Grégoire" was
the proprietor of a house of prostitution.
Courbet depicted the woman here in the midst
of a transaction, with coins scattered on a mar-
ble-topped counter and a ledger beneath her
right hand. Under her other hand is the small
bell she uses to summon one of her female em-
ployees. She presumably offers an unseen cus-
tomer a flower, a symbol of love.

The painting may also have a political
subtext. Béranger and Courbet were fierce
opponents of the monarchy and the Second
French Empire, respectively. In the mid-1880s,
the government harshly attacked the songs of
the popular writer and restricted freedom of
expression. Courbet's decision to portray
Béranger's "Madame Grégoire," whose flower
exhibits the red, white, and blue of the French
flag, may represent a protest not only against
government censorship, but also against the
Second Empire itself, making the heroine of
this painting embody the rights to freedom
in life and love that were forbidden under a
repressive regime.

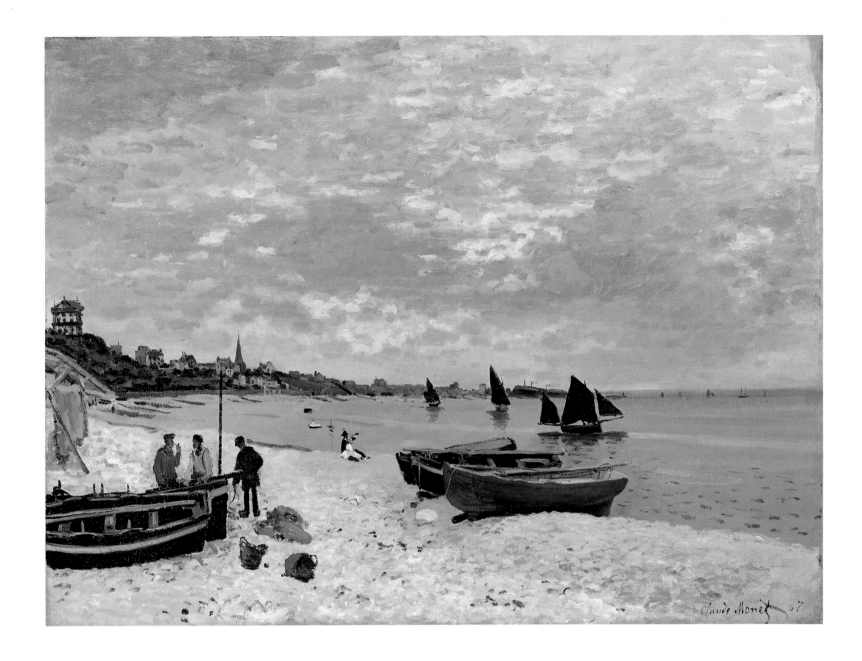

Claude Monet

French; 1840–1926

The Beach at Sainte-Adresse, 1867
Oil on canvas
75.8 x 102.5 cm (29 13/16 x 40 5/16 in.)
Mr. and Mrs. Lewis Larned Coburn Memorial
Collection, 1933.439

The summer of 1867 was a crucial period for Claude Monet. The poor, struggling artist stayed with his aunt at Ste.-Adresse, a well-to-do suburb of the port city of Le Havre near his father's home. The paintings Monet produced that summer, few of which survive, reveal the beginnings of the youthful artist's development of the revo-lutionary style that would come to be known as Impressionism.

In his quest to capture the effects of shifts in weather and light, Monet painted *The Beach at Sainte-Adresse* out-of-doors on an overcast day. He devoted the majority of the composition to sea, sky, and beach. These he depicted with broad sheets of color, animated by short brush strokes that articulate gentle, azure waves; soft, white clouds; and pebbled, ivory sand. While fishermen go about their chores, a tiny couple relaxes at the water's edge. Tourism, which had largely "created" Ste.-Adresse, would become a popular theme for Monet and many other Impressionists.

Monet did not exhibit this work publicly for almost ten years after he completed it. Because of its small, informal composition, seemingly unfinished character, and straight-forward depiction of everyday life, this painting and others like it were frequently rejected from the state-sponsored Salon exhibitions. To com-bat the official control of artistic standards and sales, Monet banded together with a diverse group of like-minded, avant-garde artists to mount the first of what would be eight inde-pendent exhibitions over the years 1874 to 1886. He included *The Beach at Sainte-Adresse* in the second of these unprecedented Impressionist group shows, in 1876.

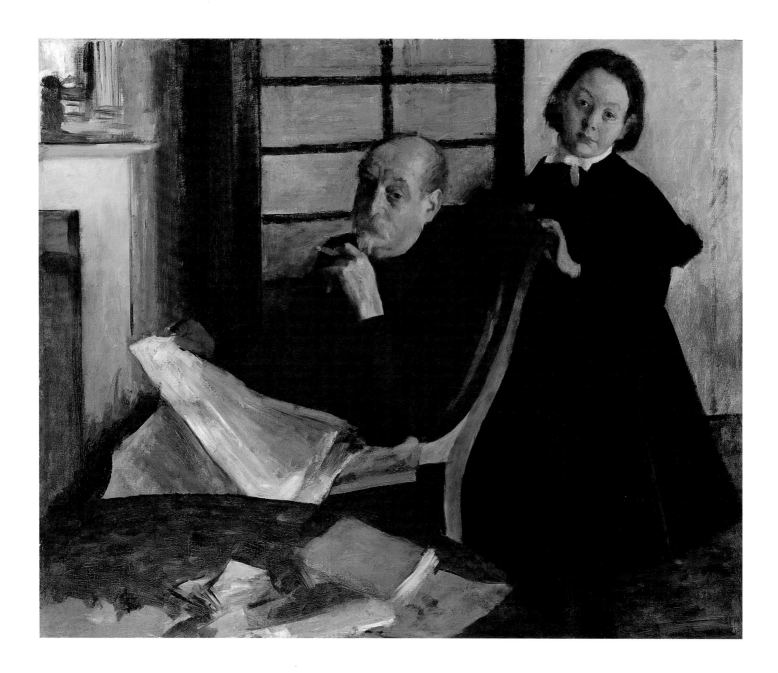

Hilaire Germain Edgar Degas
French; 1834–1917

Uncle and Niece (Henri Degas and His Niece Lucie Degas), 1875
Oil on canvas
99.8 x 119.9 cm (39 ¼ x 47 ³/₁₆ in.)
Mr. and Mrs. Lewis Larned Coburn Memorial
Collection, 1933.429

Edgar Degas was the most subtle portrait painter in the Impressionist group. His portraits, mostly of close friends and relatives, were painted primarily in the period from the late 1850s through the 1870s. During frequent visits to Florence and Naples, Degas recorded his Italian relatives with great candor. On one of his last trips to Naples, in the mid-1870s, Degas painted *Uncle and Niece,* a double portrait of his young, orphaned cousin Lucie and her uncle Henri, in whose care she had recently been placed. *Uncle and Niece* depicts two people separated by many years in age, who are tentatively accepting the circumstances of their new relationship. Degas, having recently lost his own father and witnessed other family misfortunes, addressed subjects such as this with awareness and sensitivity.

Areas of thin paint and unresolved details suggest that the painting was never completed. However, the spare treatment of the background effectively emphasizes the heads and upper portions of the two figures. Their connection is expressed in the similar tilt of their heads and in the black mourning clothes they both wear. But their psychological distance is suggested by the contrast of the plain wall behind Lucie and the darker glass-and-wood French door behind Henri, and by the curved chair back against which the old man sits and on which the girl leans. At once intimate and distant, casual and guarded, these two relatives, and the third relation who paints them on the other side of the paper-laden table, poignantly express the fragility and necessity of family ties.

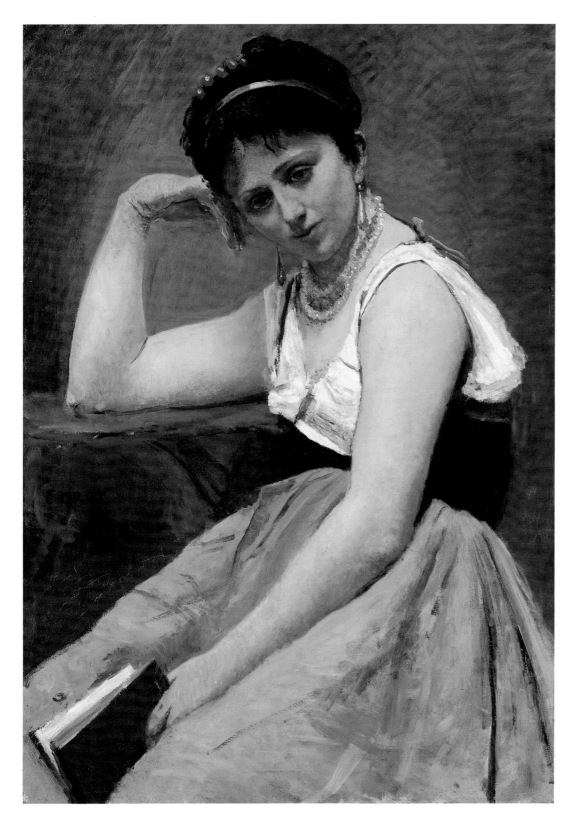

Jean Baptiste Camille Corot

French; 1796–1875

Interrupted Reading, c. 1870
Oil on canvas mounted on board
92.5 x 65.1 cm (36 ⁵/₁₆ x 25 ⅝ in.)
Potter Palmer Collection, 1922.410

Camille Corot devoted his long career to gaining acceptance for landscape painting in France. Only in later years, after this subject had achieved an elevated status, did Corot turn to other themes. *Interrupted Reading* recalls a well-established tradition that was especially popular in Romantic art: the reading figure. This motif occurs in other works by Corot, including his landscapes. The unidentified woman in the Art Institute's painting is pensive, solitary, and melancholic, the very essence of the Romantic sensibility. The inclusion of an open book—which the woman is, for the moment, not reading—creates about her an aura of muselike contemplation and meditation.

While the painting's content is traditional, the brushwork is as direct and bold as that of Edouard Manet (see pp. 48, 58). It is complemented by Corot's obvious love of detail, as seen in the ribbon in the sitter's hair, the earrings, and the necklace. In this work and in other figural studies, Corot explored the female form as a construction of masses that balance and support one another. Here, the curves of the woman's upper torso are repeated in the lines of the pleated skirt. A gentle light and subtle colors infuse this formal structure with the softness and intimacy that characterize the atmospheric landscapes with which the artist achieved his fame.

Gustave Moreau
French; 1826–1898

Hercules and the Lernaean Hydra, 1875/76
Oil on canvas
179.3 x 154 cm (70 9/16 x 60 5/8 in.)
Gift of Mrs. Eugene A. Davidson, 1964.231

Gustave Moreau developed a highly personal vision that combined history, myth, mysticism, and a fascination with the exotic and bizarre. Rooted in the Romantic tradition, Moreau focused on the expression of timeless mysteries of human existence rather than on recording or capturing the realities of the material world.

Long fascinated with the myth of Hercules, Moreau gave his fertile imagination full reign in *Hercules and the Lernaean Hydra*. Looming above an almost primordial ooze of brown paint is the seven-headed Hydra, a serpentine monster whose dead and dying victims lie strewn about a swampy ground. Calm and youthful, Hercules stands amid the carnage, weapon in hand, ready to sever the Hydra's seventh, "immortal" head, which he will later bury.

Despite the violence of the subject, the painting seems eerily still, almost frozen. Reinforcing this mysterious quality is Moreau's ability to combine suggestive, painterly passages with obsessive detail. The precision of his draftsmanship and the otherworldliness of his palette are the result of his painstaking methods; he executed numerous preliminary studies for every detail in the composition. In contrast to such exactitude, the artist made bold, colorful watercolors that eschew detail, as exercises to resolve issues of composition and lighting.

Moreau seems to have intended this mythological painting to express contemporary political concerns. He was profoundly affected by France's humiliating military defeat by the Prussians in 1870–71. Whether or not Hercules literally personifies France and the Hydra represents the Prussians, this monumental work portrays a moral battle between the forces of good and evil, light and darkness, with intensity and power.

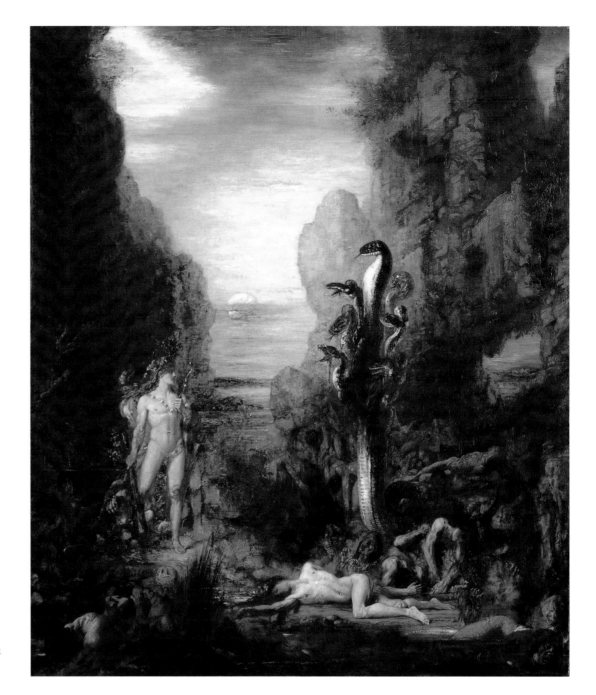

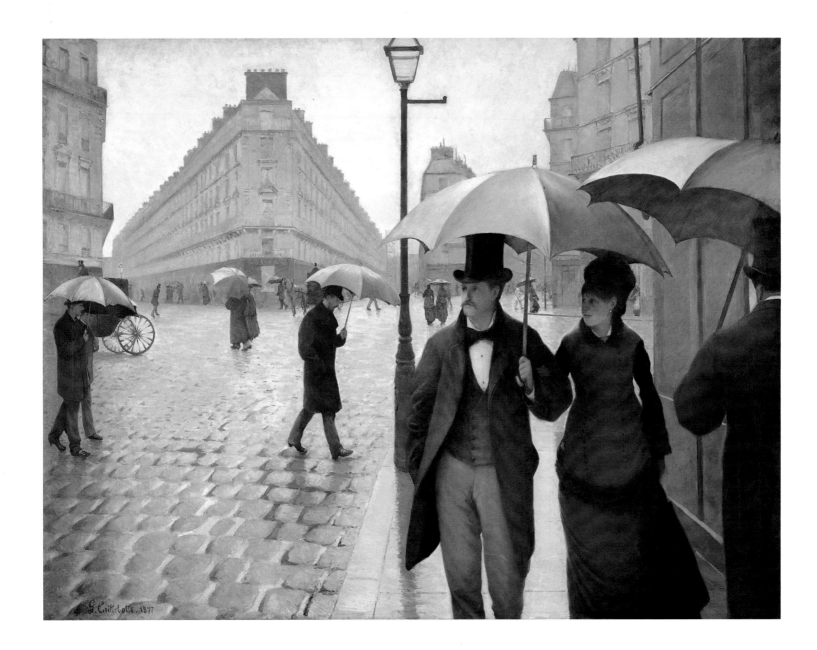

Gustave Caillebotte

French; 1848–1894

Paris Street; Rainy Day, 1877
Oil on canvas
212.2 x 276.2 cm (83 ½ x 108 ¾ in.)
Charles H. and Mary F. S. Worcester Fund,
1964.336

Gustave Caillebotte was the major organizing force behind the Impressionist exhibition of 1877. This show was the strongest of the eight the group organized, and it was dominated by Caillebotte's masterpiece, *Paris Street; Rainy Day*. The painting hung with Claude Monet's series of depictions of Gare St.-Lazare (see

p. 55) and Pierre Auguste Renoir's *Moulin de la Galette* (Paris, Musée d'Orsay).

In *Paris Street; Rainy Day*, the upraised umbrellas, reflections of water on the pavement, and pervasive gray tonalities all convey the artist's interest, shared with the Impressionists, in suggesting atmospheric conditions. Selecting a complex intersection near the Gare St.-Lazare, the artist changed the size of the buildings and the distance between them to create a wide-angle view. While the painting's panoramic sweep perhaps reflects new ways of seeing that resulted from advances in photography, it also captures the equally modern development of Paris's grand, new boulevards. Caillebotte's fascination with perspective can be seen in the

composition's careful structure, which makes calculated use of the lamppost to separate the foreground from the middle and distant views.

While *Paris Street; Rainy Day*'s highly crafted surface, monumental size, geometric order, and elaborate perspective are more academic than Impressionist in character, Caillebotte clearly employed all these elements, as did his Impressionist colleagues, to capture modern realities: notably, none of the figures interacts, suggesting a sense of urban alienation. Caillebotte also captured the momentary quality of everyday life: it is easy to imagine that, if we blink our eyes, everyone in the painting will have moved and nothing will be the same.

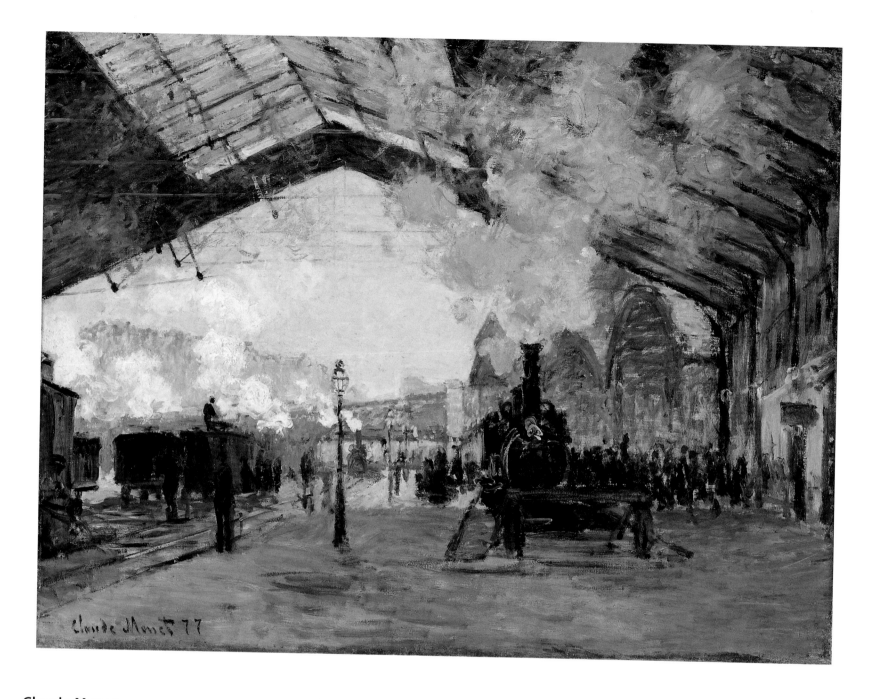

Claude Monet

French; 1840–1926

Arrival of the Normandy Train, Gare Saint-Lazare, 1877
Oil on canvas
59.6 x 80.2 cm (23 ½ x 31 ½ in.)
Mr. and Mrs. Martin A. Ryerson Collection, 1933.1158

The Impressionists frequently paid tribute to the modern aspects of Paris. Their paintings abound with scenes of grand boulevards and elegant, new blocks of buildings, as well as achievements of modern construction, such as iron bridges, exhibition halls, and train sheds. *Arrival of the Normandy Train, Gare Saint-Lazare* was an especially appropriate choice of subject for Claude Monet in the 1870s. The terminal, linking Paris and Normandy, where Monet's technique of painting out-of-doors had been nurtured in the 1860s (see p. 50), was also the point of departure for towns and villages to the west and north of Paris frequented by the Impressionists. Monet completed eight of his twelve known paintings of Gare St.-Lazare in time for the third Impressionist exhibition, in 1877, probably placing them in the same gallery.

Monet chose to focus his attention here on the glass-and-iron train shed, where he found an appealing combination of artificial and natural effects: the rising steam of locomotives trapped within the structure, and daylight penetrating the large, glazed sections of the roof. Monet's depictions of Gare St.-Lazare inaugurated what was to become for him an established pattern of painting a specific motif repeatedly, in order to capture subtle and temporal atmospheric changes (see p. 68). However, the series also represented his last attempt to deal with urban realities: from this point on in his career, Monet would be a painter of landscape.

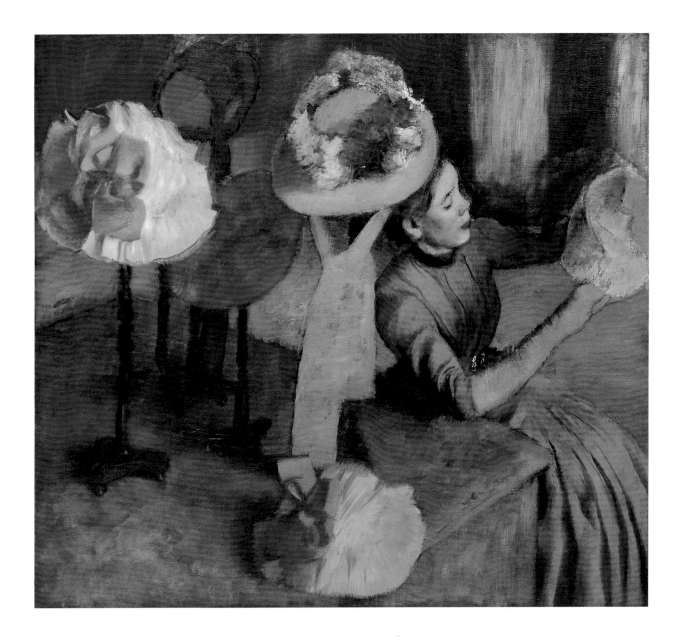

Hilaire Germain Edgar Degas
French; 1834–1917

The Millinery Shop, 1884/90
Oil on canvas
100 x 110.7 cm (39 ⅜ x 43 ⁹⁄₁₆ in.)
Mr. and Mrs. Lewis Larned Coburn Memorial
Collection, 1933.428

In contrast to the majority of other Impressionists' interest in the shifting light effects they studied out-of-doors, Edgar Degas focused particularly on composition, draftsmanship, and gesture. This often led him to portray carefully constructed interiors, such as that seen in *The Millinery Shop*. This work portrays a young female absorbed in the task of creating a hat.

These colorful objects of changing fashion were for Degas symbolic of the modern bourgeois woman, while also allowing him to indulge his fascination with contrasting colors. He explored the theme of hats, their making, and their purchase in at least fifteen pastels and oils, all created during the early 1880s.

Degas's fascination with Japanese woodblock prints and their unorthodox compositions, as well as with the newly developing art of photography and its unexpected croppings, inspired him to find new and highly effective ways of drawing the viewer into his pictorial spaces. In *The Millinery Shop*, the viewer assumes the role of potential buyer, perhaps looking down at the display of hats through a

window. The scene is dominated by hats, which, resembling peonies in full bloom, seem to relegate the figure to the side.

Despite her lateral position, the young milliner is pivotal to the painting. She is a picture of industry: her lips are firmly pursed around a pin, while her hands—scraped and repainted by Degas—convey vivid movement as she labors on a hat. Surrounded by her beautiful creations, which her economic circumstances most likely will prevent her from wearing in real life, the young woman, deeply absorbed in her creation, may have symbolized to Degas the role of artistic production in a modern, consumer society.

Pierre Auguste Renoir
French; 1841–1919

Acrobats at the Cirque Fernando (Francisca and Angelina Wartenberg), 1879
Oil on canvas
131.5 x 99.5 cm (51 ¾ x 39 ⅛ in.)
Potter Palmer Collection, 1922.440

Acrobats at the Cirque Fernando depicts a quintessentially modern subject: a circus that drew enthusiastic audiences—including men on the prowl in a world of available female entertainers—to its evening performances. But Pierre Auguste Renoir barely alluded to the unwholesome aspects of this environment, relegating an ogling group of dark-suited men to the very top of the composition. "For me a picture . . . should be something likeable, joyous, and pretty," Renoir insisted. "There are enough ugly things in life for us not to add to them."

Reflecting Renoir's worldview, this engaging work focuses on Francisca and Angelina Wartenberg, members of a family of German acrobats, taking their bows and receiving tributes of oranges from the appreciative crowd. The artist painted his models in his studio, since he feared that the circus's harsh gas lighting would turn "faces into grimaces." He also imparted a sense of innocence to the sisters by depicting them as younger than their actual ages—seventeen and fourteen, respectively. Renoir banished shadows and used delicate, multidirectional brushwork so that the figures seem to blend into the surrounding space. Finally, he enveloped the acrobats in a virtual halo of pinks, oranges, yellows, and whites, creating a kind of trouble-free zone where their youthful beauty can exist undisturbed. The painting's undeniable charm appealed to its owner, the famed Chicago collector Bertha Honoré Palmer, who became so enamored of it that she kept it with her at all times, even on her travels abroad.

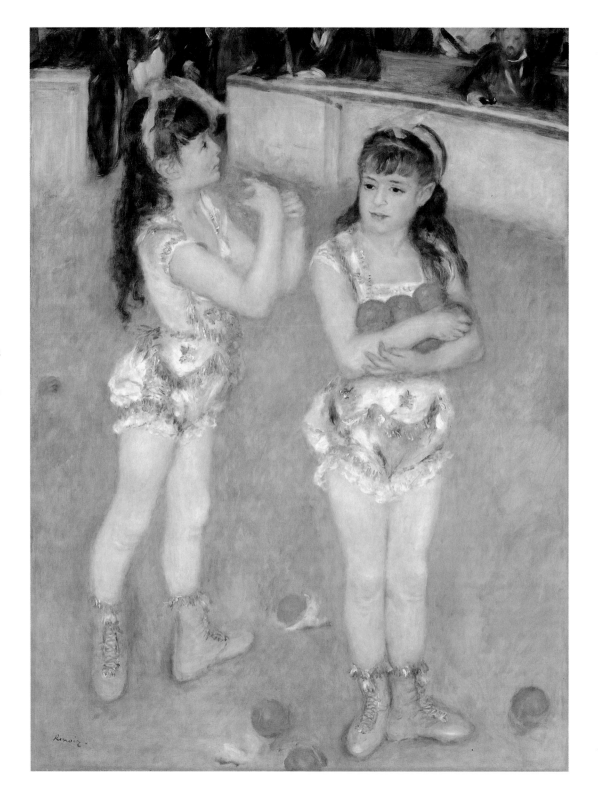

Edouard Manet

French; 1832–1883

The Reader, 1878/79
Oil on canvas
61.2 x 50.7 cm (24 ¹⁄₁₆ x 19 ⅞ in.)
Mr. and Mrs. Lewis Larned Coburn Memorial
Collection, 1933.435

During the late nineteenth century, Parisian cafés were the gathering places of artists and writers and were ideal locations for observing the urban scene. Many Impressionist paintings depict the Café Nouvelle-Athènes on the rue Pigalle, where two tables were reserved for Edouard Manet and his circle—a group that included the painters Degas, Monet, Pissarro, and Renoir, and the writers Baudelaire and Zola.

The Reader is thought to be set in the Café Nouvelle-Athènes; Manet could well have passed by this fashionably dressed young lady on his way into the establishment. The illustrated magazine attached to the wooden bar that the woman holds would have been taken from the café's reading rack. It is perhaps one of the popular French periodicals of the day in which Manet's drawings sometimes appeared. The woman's heavy clothing suggests that she is seated at an outdoor table and that the weather is cool. The colorful garden view behind her is thus probably a painted backdrop.

The Reader is one of the most Impressionistic of Manet's paintings; the quick, free brush strokes and light colors are characteristic of his technique late in his career. Painted only a few years before his death, this work admirably captures a fleeting moment, the sense of a fleeting glance that the Impressionists sought to represent.

Pierre Auguste Renoir

French; 1841–1919

Two Sisters (On the Terrace), 1881
Oil on canvas
100.5 x 81 cm (39 9/16 x 37 7/8 in.)
Mr. and Mrs. Lewis Larned Coburn Memorial
Collection, 1933.455

One of the Art Institute's most popular paintings, Pierre Auguste Renoir's *Two Sisters (On the Terrace)* is the final painting in a remarkable group of works by Renoir on a key Impressionist theme: modern Parisians relaxing in the country. Renoir completed the series in 1880 and 1881 in Chatou, a village in the heart of rowing country that the artist called "the prettiest of all the suburbs in Paris." In the museum's painting, two visually captivating figures (models, not sisters) sit within the shallow space of a terrace. Boats glide along the Seine behind them; the older figure wears the dark-blue flannel dress that female boaters favored.

A compositional and technical tour de force, *Two Sisters* displays Renoir's variegated brushwork and vibrant palette. The loosely rendered foliage and river contrast with the more carefully defined females, each endowed with a luminous, porcelain complexion. Juxtaposed with their delicate faces are their brightly colored hats — one brilliant red, and the other decorated with richly impastoed flowers. In the foreground, like a painter's palette, the bright balls of yarn in the basket exhibit the exact intense hues Renoir used to compose this image. Somewhat out of context, given the outdoor, nautical setting, the knitting basket may also represent the artist's ironic response to critics who denigrated his work as "a piece of knitting . . . a weak sketch . . . constructed of different balls of yarn." Despite such complaints, *Two Sisters*, one of twenty-five paintings that Renoir exhibited in the seventh Impressionist show, in 1882, was in fact a critical success.

Arnold Böcklin

Swiss; 1827–1901

In the Sea, 1883
Oil on panel
87 x 115.6 cm (34 ¼ x 45 ½ in.)
Joseph Winterbotham Collection, 1990.443

Far removed from contemporary trends such as Impressionism, Arnold Böcklin's art also had little in common with the idealized academic art of his time. Instead, Böcklin's depictions of demigods in naturalistic settings interpret themes from classical mythology in an idiosyncratic, often sensual manner.

In the Sea, part of a series of mythological subjects from the mid-1880s, displays an unsettling, earthy realism. Mermaids and tritons frolic in the water with a lusty energy and abandon verging on coarseness. Occupying the center of the composition is a long-haired, harp-playing triton. Three mermaids have attached themselves to his huge frame as if it were a raft; the one near his shoulder seems to thrust herself upon him. The physicality of the scene is intensified by the way the figures fill the space, and by the strong contrasts between the light sea and sky and the darker figures and shadows. The work's sense of boisterousness is tempered

by the ominously shaped reflection of the triton and mermaids in the reflective sea, and by the oddness of the large-eared heads that emerge from the water at the right.

In addition to imaginative, bizarre interpretations of the classical world such as *In the Sea*, Böcklin also painted mysterious landscapes punctuated by an occasional lone figure. These haunting, later works made Böcklin an important contributor to the international Symbolist movement. They also appealed to some Surrealist artists, particularly Giorgio di Chirico (see p. 118), who declared, "Each of [Böcklin's] works is a shock."

Henri Marie Raymond de Toulouse-Lautrec

French; 1864–1901

Equestrienne (At the Circus Fernando),
1887–88
Oil on canvas
100.3 x 161.3 cm (39 ½ x 63 ½ in.)
Joseph Winterbotham Collection, 1925.523

Born into a noble family and disabled since childhood, Henri de Toulouse-Lautrec turned away from his birthright and sought companionship and excitement in the bawdy nightlife of Paris, of which the Circus Fernando was a prime attraction. The Circus Fernando inspired a number of other French painters: Degas, Renoir, Seurat, and later Fernand Léger depicted the famous attraction.

With its thin, rapid lines, *Equestrienne (At the Circus Fernando)* has the spontaneous quality of a drawing, connecting it with Toulouse-Lautrec's involvement with graphic art. The artist was also inspired by compositional aspects of Japanese prints and photography, interests apparent in this work: for example the center of the image is empty, and the picture is instead structured around the sweeping arc of the ring. This curve is repeated continually throughout the scene: in the powerful haunches of the circus horse, the ring and gallery, the billowing trousers of a clown at the top of the picture, and most prominently in the extraordinary aquiline profile of the ringmaster himself. This menacing figure is linked by the whip in his hand and by his penetrating gaze to the rider, who, from her perch atop the horse, glances over her shoulder at him, creating a sense of tension. Isolated against the pale ground of the circus ring and striding forward, the ringmaster clearly dominates the scene both psychologically and visually.

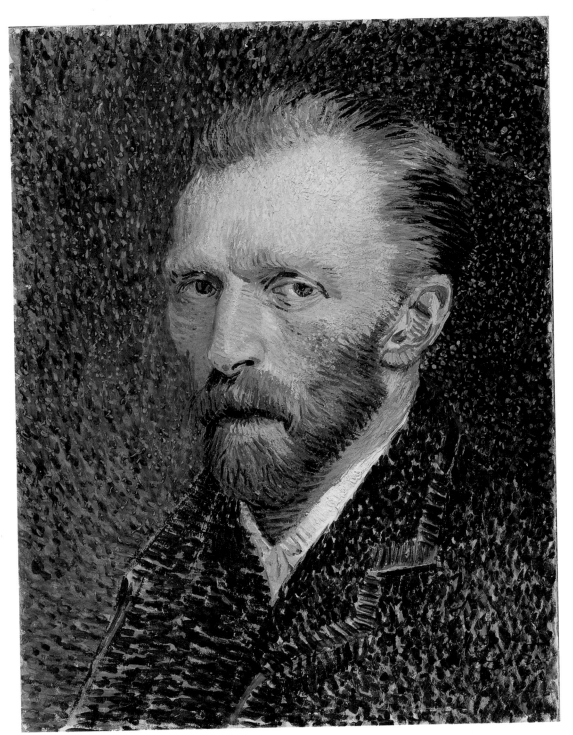

Vincent van Gogh
Dutch; 1853–1890

Self-Portrait, 1886/87
Oil on mill board mounted on cradled panel
41 x 32.5 cm (16 ⅛ x 13 ¼ in.)
Joseph Winterbotham Collection, 1954.326

Vincent van Gogh's tumultuous and intense career as a painter was actually very brief. After working for an art merchant, he became a missionary. In 1886 he left his native Holland and settled in Paris, where his beloved brother Theo was a dealer in paintings. He actively pursued his art for a period of only five years before his suicide in 1890.

In the two years that van Gogh spent in Paris, he painted no fewer than two dozen self-portraits. The Art Institute's early, modestly sized example displays the bright palette he adopted in reaction to the bustling energy of Paris and to his introduction to Impressionism. The dense brushwork, which was to become a hallmark of van Gogh's style, represents his response to *A Sunday on La Grande Jatte — 1884* (p. 63), in which Georges Seurat introduced his revolutionary "dot" technique. Van Gogh saw Seurat's painting when it was exhibited in the 1886 Impressionist exhibition.

In the Art Institute's *Self-Portrait*, the direct gaze of the artist, whose eyes practically frown in concentration, initially distracts the viewer from the dazzling array of dots and dashes that animate van Gogh's shoulders and the background. When one can finally tear one's gaze away from the painter's, attention shifts to his mouth. With its tightly closed, almost pursed, lips, it seems to reveal the man's intensity and his ultimately self-destructive sensitivity.

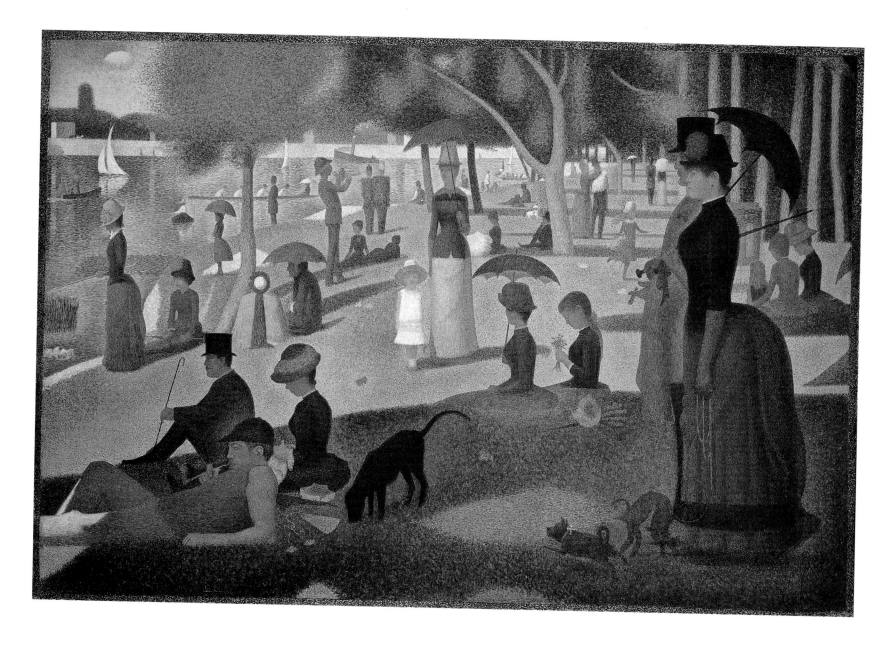

Georges Pierre Seurat
French; 1859–1891

A Sunday on La Grande Jatte — 1884, 1884–86
Oil on canvas
207.6 x 308 cm (81 ¾ x 121 ¼ in.)
Helen Birch Bartlett Memorial Collection,
1926.224

Georges Seurat developed his own, "scientific" approach to painting. He juxtaposed tiny dots of color to create hues that he believed, through optical blending, are more intense than pure colors mixed with black or white when used to define three-dimensional forms. Remarkable for its unusual technique, stylized figures, and enormous scale, *A Sunday on La Grande Jatte — 1884* is generally considered Seurat's masterpiece and one of the greatest paintings of the nineteenth century. Seurat labored over the *Grande Jatte,* executing numerous chalk drawings and oil sketches, which are brightly colored and much freer in handling than the final work. The artist Camille Pissarro, to whom Seurat showed the picture in 1885, seems to have criticized the canvas's extreme formality and lack of freshness, prompting Seurat to rework the painting. He increased the curving contours of the chief figures to make them appear more relaxed and added strokes of vivid color. In a final campaign on the picture, he added a border painted with colored dots to heighten the painting's palette even further.

The Grande Jatte is an island in the Seine just west of Paris. In Seurat's day, it was a park that attracted city residents seeking recreation and relaxation. Over the past several decades, many attempts have been made to explain the meaning of this great composition. For some it shows the middle class at leisure; for others it reveals, through its groupings and details, social tensions of modern city dwellers. Ironically, the Art Institute's most famous painting remains one of its most enigmatic.

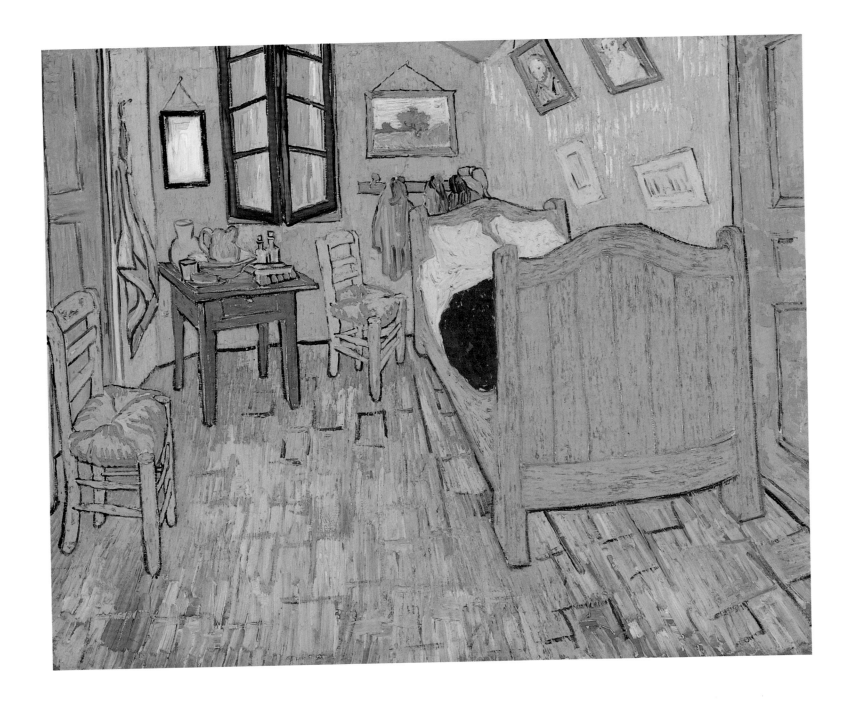

Vincent van Gogh

Dutch; 1853–1890

The Bedroom, 1889
Oil on canvas
73.6 x 92.3 cm (29 x 36 ⅝ in.)
Helen Birch Bartlett Memorial Collection,
1926.417

When Vincent van Gogh left Paris in 1888 for
the southern French city of Arles, his intention
was to create "The Studio of the South," a
colony for artists. He tried repeatedly to convince
his brother Theo and his artist friends Paul
Gauguin (see pp. 65, 67) and Emile Bernard to
join him in establishing a community there.

In anticipation of his friends' arrival, van
Gogh set out to create paintings to decorate his
home and studio; these included images of
flowers, views of Arles, and deeply revealing de-
pictions of his bedroom. Of the three versions
of this famous bedroom composition, the Art
Institute's—completed in 1889—is the second
in the series (the first, from 1888, is at the Van
Gogh Museum, Amsterdam; the third, from
1889, is at the Musée d'Orsay, Paris). To the
artist, the picture symbolized relaxation and

peace, despite the fact that, to our eyes, the can-
vas seems bursting with nervous energy, insta-
bility, and turmoil. Although the room looks
warm and bathed in sunshine, the very intensity
of the palette undermines the intended mood
of restfulness, especially when combined with the
sharply receding perspective and the inclusion
of pictures tilting off the wall. As in all of van
Gogh's paintings, each object seems almost pal-
pable, as solid as sculpture, although modeled
in pigment. The result is an overwhelming sense
of presence, an assertive vitality that seems to
escape the confines of the canvas.

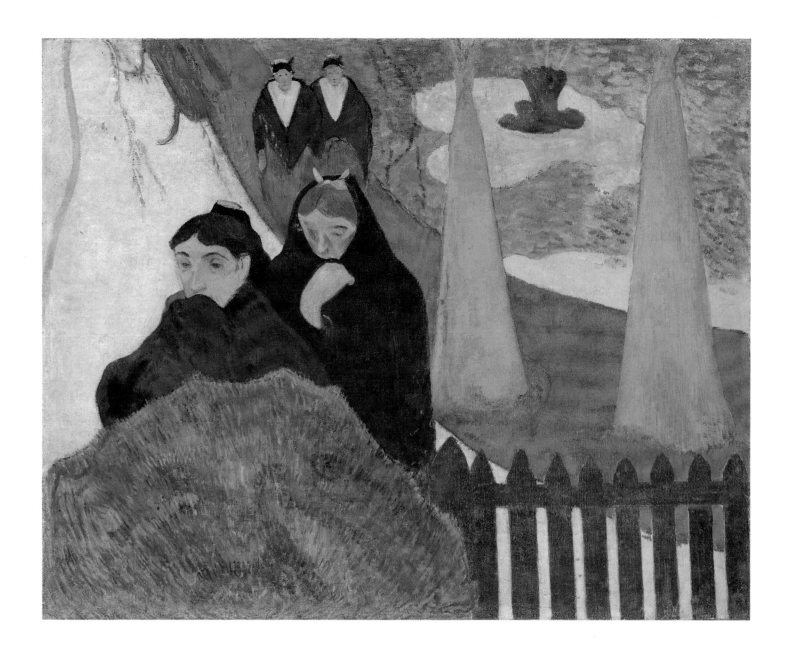

Paul Gauguin
French; 1848–1903

The Arlesiennes (Mistral), 1888
Oil on canvas
73 x 92 cm (28¾ x 36³⁄₁₆ in.)
Mr. and Mrs. Lewis Larned Coburn Memorial
Collection, 1934.391

Paul Gauguin arrived in the southern French city of Arles in October 1888, having accepted an invitation from Vincent van Gogh (see pp. 62, 64) to join him in establishing an artists' colony. The two months they spent together were difficult and, in the end, devastating for van Gogh. The deliberate and willful Gauguin was the antithesis of the fast-working, emotionally expressive Dutch painter. Gauguin's art was becoming increasingly abstract at this time; he used color in large, flat areas and forsook traditional handling of space in works such as this in order to inform his work with the visual unity and symbolism he desired.

Set in the garden opposite the house Gauguin shared with van Gogh, *The Arlesiennes (Mistral)* conveys an aura of repressed emotion and mystery. Walking slowly through the garden are four somber women. Their gestures are slight, but distancing; their expressions are withdrawn, introspective. Other elements in the painting are equally elusive in meaning: the bench on the path at the upper left rises steeply, defying logical perspective, and the conical objects at the right — probably protective straw coverings placed over plants during the winter — are specterlike presences. Another puzzling feature of the painting is the ghostly appearance of a face in the bush (this may have been unintentional, since such visual tricks are inconsistent with Gauguin's use of images in his oeuvre). In this powerful and enigmatic painting, Gauguin explored the capacity of art to express the mysteries, superstitions, and emotions that he believed underlie appearances.

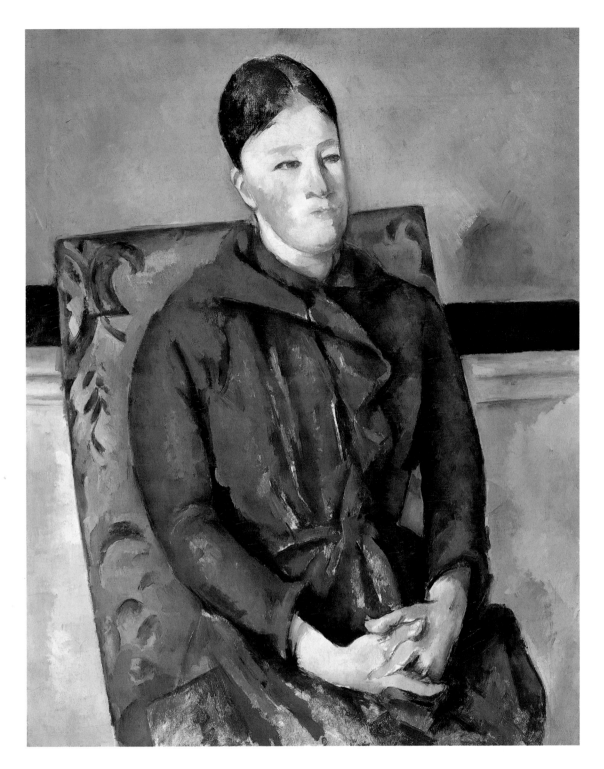

Paul Cézanne
French; 1839–1906

Madame Cézanne in a Yellow Chair, 1893/95
Oil on canvas
80.9 x 64.9 cm (31 13/16 x 25 9/16 in.)
Wilson L. Mead Fund, 1948.54

Paul Cézanne is generally hailed today as the father of modern painting, but recognition of the magnitude of his contribution to the history of art came only after his death. In part this was a result of how he chose to live and work. As a student in Paris, he joined the Impressionists and even exhibited with them in 1874 and 1877. Unable to cope, however, with the public ridicule of his art, Cézanne withdrew from the group and opted for a reclusive existence, painting in solitude, mostly in Provence, especially in and around his native Aix-en-Provence.

Although hermitlike by nature, Cézanne did marry. The union seems not to have been very satisfactory for either the artist or his wife. Our greatest insight into the character of Madame Cézanne comes from the artist's many depictions of her. The Art Institute's *Madame Cézanne in a Yellow Chair* is one of three portraits of her in the same chair and pose from the same period. The simplicity of the portrait is instantly apparent: a three-quarter-length figure sits in a three-quarter-turn view; the sitter's dress is red, the chair is yellow, the background is blue. The presentation is honest, straightforward, and unadorned, much like the woman herself. Her masklike face and tightly sealed lips reveal nothing. Her hands, although somewhat twisted, lie dormant, completing the serene oval of her arms. Madame Cézanne, who posed for hours, presents herself with a sense of deliberation not unlike that which was shown by the artist in composing the image itself.

Paul Gauguin
French; 1848–1903

Ancestors of Tehamana, 1893
Oil on canvas
76.3 x 54.3 cm (30 1/16 x 21 3/8 in.)
Gift of Mr. and Mrs. Charles Deering
McCormick, 1980.613

In April 1891, Paul Gauguin set sail for Tahiti, sponsored by the French government to paint the island's "landscape and costumes." The former stockbroker was convinced that he would find a culture that was more spiritually pure than what he believed existed in modern-day Europe. This quest for the "primitive" (as well as the need to live frugally) had already led the restless, mainly self-taught artist to Martinique, Brittany, and Provence. He was to spend all but two of the remaining years of his life in the South Seas.

This stately portrait represents Gauguin's teenaged Tahitian companion Tehamana, whose expressionless face and immobile posture seem to embody the mystery of the exotic "other" that the artist sought in life and art. He placed the young woman in front of a painted frieze on which appear ancient Polynesian symbols. Wearing a crown of flowers, Tehamana holds a fan of plaited leaves, much as a queen bears a scepter. The fan points to a similarly frontal figure, Hina, the ancient deity from whom all Tahitians believed they were descended; she also wears a red flower in her hair. Two ripe mangoes, perhaps an offering or tokens of fertility, rest beside Tehamana's hip.

This portrayal of a young woman and her ancestry reflects Gauguin's desire to preserve a culture that, to his despair, was quickly disappearing. "Our missionaries have already imported much hypocrisy," Gauguin lamented, "and they are sweeping away part of the poetry." Indicating this Europeanization, Tehamana—unlike her ancestor—wears the high-necked Mother Hubbard dress that French missionaries imposed upon the Tahitian population for propriety's sake.

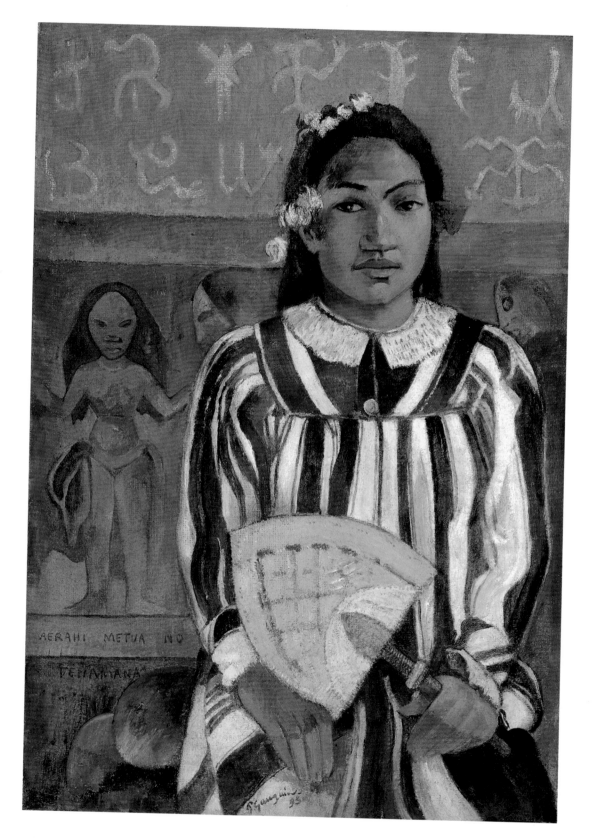

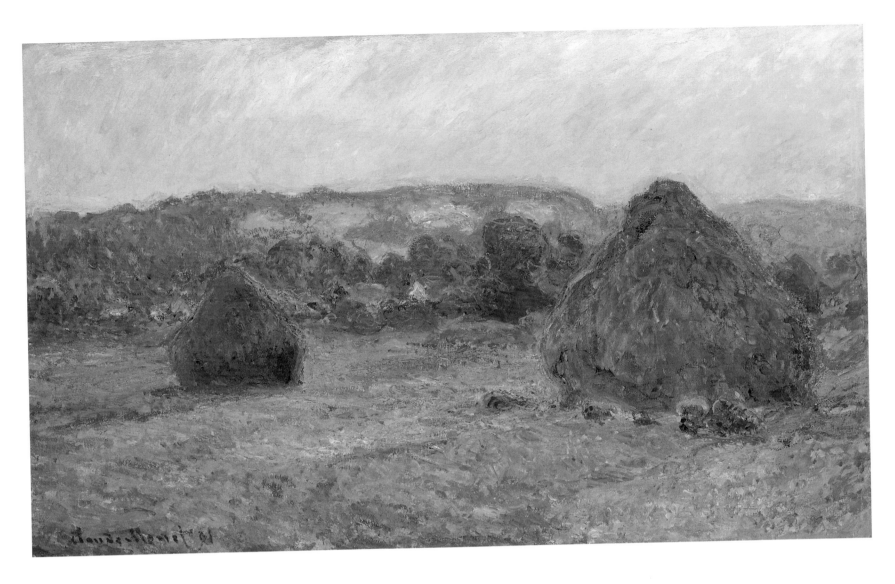

Claude Monet

French; 1840–1926

Stacks of Wheat (End of Summer), 1890–91
Oil on canvas
60 x 100 cm (23 ⅝ x 39 ⅜ in.)
Gift of Arthur M. Wood in memory of Pauline
Palmer Wood, 1985.1103

Enormous stacks of harvested wheat, rising
fifteen to twenty feet in height, stood just out-
side Claude Monet's farmhouse door at Giverny,
his home from 1883 until his death. Monet
painted the stacks in 1890 and 1891, both in the
field, where he worked at several easels simulta-
neously, and in the studio, where he refined his
paintings. Only by executing multiple views of
the same subject, Monet found, could he truly
render, as he put it, "what I experience" — how
he perceived and responded to these stacks of
grain, defined by light and air as time passed
and weather changed.

Constructed by man but created by nature,
the stacks were for Monet a resonant symbol of
sustenance and survival. While the composi-
tions seem simple, Monet modulated his
palette and brushwork to each temporal situa-

tion he confronted. In late summer views, such
as this, as well as in most of the autumn views,
the pointed tops of the stacks often seem to
burst through the horizon into the sky. On the
other hand, in the majority of winter views, the
long-lasting stacks seem nestled into hill and
field, as if hibernating from the cold of the sea-
son.

In May 1891, the artist hung fifteen of the
wheat-stack compositions next to one another
in a small room in his dealer's Paris gallery,
thus firmly establishing his famous method of
working in series. The Art Institute boasts the
largest group of Monet's *Stacks of Wheat* in the
world; five of the six in the collection numbered
among the original canvases Monet placed on
view in 1891.

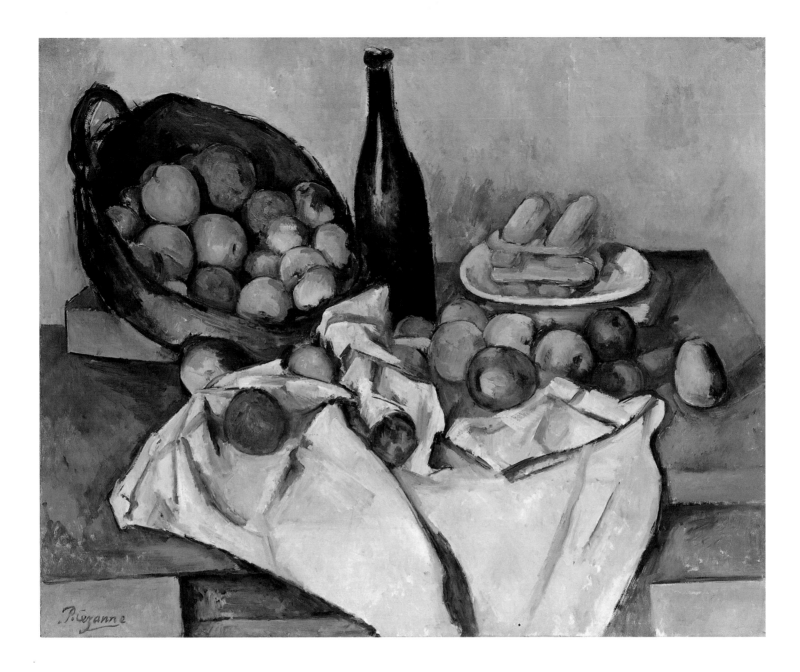

Paul Cézanne
French; 1839–1906

The Basket of Apples, c. 1895
Oil on canvas
65 x 80 cm (25 7/16 x 31 1/2 in.)
Helen Birch Bartlett Memorial Collection,
1926.252

Although Paul Cézanne withdrew from avant-garde art circles in Paris to paint in virtual isolation in Provence, his work was known by a few and known of by many more. Thus, when art dealer Ambroise Vollard finally convinced Cézanne to show his work in Paris in 1895, the exhibition was a very important event.

The Basket of Apples, one of Cézanne's so-called "Baroque" still lifes (because it was inspired by seventeenth-century Dutch proto-types), was included in the exhibition. Like other paintings on display, it was signed by the artist, a rare concession probably made to satisfy Vollard. By its very name, the term "still life" suggests an array of inert, or dead, objects; this association is even clearer in the French term *nature morte* (dead nature). Yet Cézanne interpreted still life in a way that actually animates the objects. On one of his characteristic tilted tables — an impossible rectangle in which none of the corners lines up with the others — are placed a cloth, apples, a plate of neatly stacked

cookies, a bottle, and a basket of apples. The basket careens forward from a slablike base that appears to upset rather than support it. The apparent precariousness of the objects on the table is tempered by their heavy modeling, which gives them great density and weight. Even the white tablecloth possesses sculptural folds that seem to arrest movement and contribute to the sense of permanence and inevitability with which Cézanne imbued his compositions.

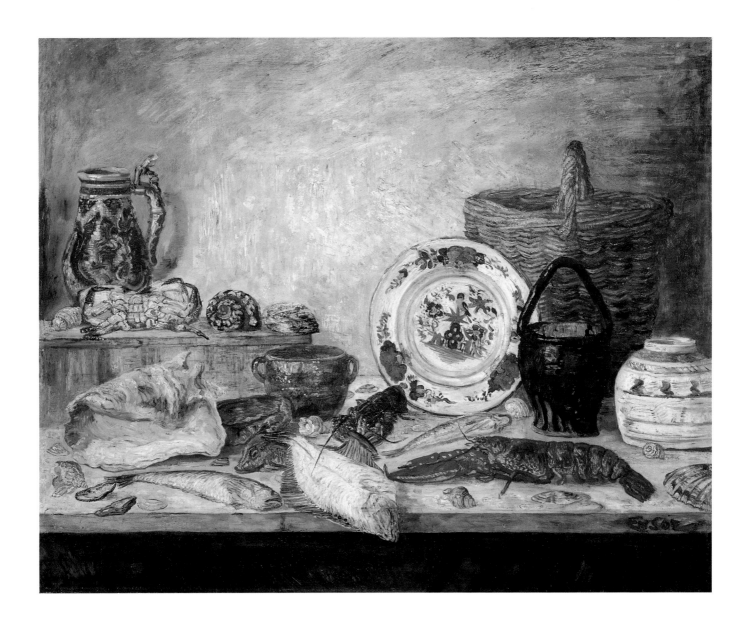

James Ensor
Belgian; 1860–1949

Still Life with Fish and Shells, 1898
Oil on canvas
81 x 100.5 cm (31 ⅞ x 39 ½ in.)
Gift of Mary and Leigh Block, 1978.96

The enigmatic, highly original Belgian artist James Ensor was born in the sea-resort community of Ostend, where his parents ran a souvenir shop. Apart from training in Brussels, Ensor rarely left his hometown, executing his major works, mostly before 1900, in the family attic. In relative isolation, Ensor developed an utterly personal form of Symbolism—a movement that questioned the positivist assumptions of Realism and Impressionism, suggesting instead that greater truths can be revealed in the spiritual and irrational. Fantastic, even macabre, his images of skeletal or masked figures are also fiercely satirical.

Ensor was one of the founding members of Les Vingt (The Twenty), the avant-garde Belgian group whose exhibitions during the late 1880s were the most daring in Europe. Yet, for many years, only a few critics, artists, and patrons appreciated his work, which was even rejected for some Les Vingt exhibitions.

Although *Still Life with Fish and Shells* reveals the influence of seventeenth-century Northern European marine still lifes, Ensor's interest in the subject may have had a more immediate source. "In my parents' shop," he recalled, "I had seen the wavy lines, the serpentine forms of beautiful seashells, the iridescent lights of mother-of-pearl, the rich tones of delicate chinoiserie." Indeed, in this composition, Ensor seems to have been particularly fascinated by the pearly hues of shiny, hard objects—both animate and inanimate. He gave equal weight to each form, exploring it with scumbled, bravura brushwork that, while influenced by Impressionism, anticipates the emotionally expressive, gestural techniques of twentieth-century artists. The overall effect of this bizarre arrangement is unsettling, almost menacing, like most of Ensor's Symbolist masterpieces.

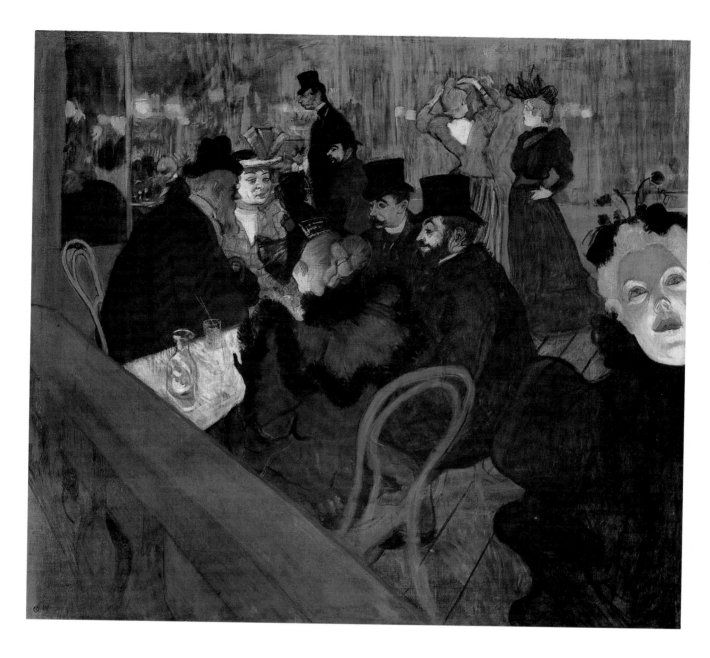

Henri Marie Raymond de Toulouse-Lautrec

French; 1864–1901

At the Moulin Rouge, 1892/95
Oil on canvas
123 x 141 cm (48 7/16 x 55 ½ in.)
Helen Birch Bartlett Memorial Collection,
1928.610

The "café-concert," a place for drinking that provided theatrical (often bawdy) entertainments, was a popular institution in late nineteenth-century Paris; the performers and audience alike attracted the attention of artists such as Edgar Degas (see pp. 51, 56) and Henri de Toulouse-Lautrec. The Moulin Rouge was the most famous such establishment in Paris during the 1890s. Toulouse-Lautrec's *Equestrienne (At the Circus Fernando)* (p. 61) was displayed in its lobby.

In *At the Moulin Rouge,* Toulouse-Lautrec turned his acute powers of observation onto the café's clientele. Rather than depicting anonymous figures, the artist portrayed actual habitués of late-night Paris—customers and entertainers—whom Toulouse-Lautrec counted among his friends and companions. The central group, seated around the table, includes a photographer, a poet, a vintner, and two female entertainers. A third entertainer, whose greenish face looms eerily at the right edge of the canvas, seems to have just left the group. In the upper right, adjusting her coiffure, is a dancer, accompanied by a friend. The latter seems to stare toward the far left, at two men in the process of departing: the dwarfish figure of Toulouse-Lautrec himself and his very tall cousin.

At the Moulin Rouge has suffered considerable alteration. Apparently cut down along the right and bottom after the artist's death, possibly to make it less radical in composition and more attractive to buyers, the painting was restored sometime before 1924, when it was shown in its present state in a special Toulouse-Lautrec exhibition at the Art Institute.

Edouard Vuillard
French; 1868–1940

Landscape: Window Overlooking the Woods,
1899
Oil on canvas
249.2 x 378.5 cm (96 ⅛ x 149 in.)
L. L. and A. S. Coburn, Martha E. Leverone, and
Charles Norton Owen funds; anonymous
restricted gift, 1981.77

While French artist Edouard Vuillard is known
mostly as an Intimist, or painter of small-scale
images of domestic interiors, early in his career,
his most important works were large-scale
paintings commissioned to embellish the apart-
ments of a devoted circle of Parisian patrons.

Landscape: Window Overlooking the Woods
figured in a decorative ensemble for the library
of the wealthy investment banker Adam
Natanson; its pendant, *The First Fruits* (1899), is
now at the Norton Simon Museum, Pasadena.
These decorations were Vuillard's largest and
final commission for the Natansons, the artist's
greatest supporters for almost a decade. This
project also marked the end of Vuillard's most
prolific period as a painter-decorator.

The Art Institute's painting shows L'Etang-
la-Ville, a suburb west of Paris where Vuillard
often visited his sister and brother-in-law, the
painter Ker Xavier Roussel. Vuillard conceived
the scene as if viewed through an open window,
with the bottom of the canvas indicating the

ledge. Instead of creating an image one can
imagine walking into, Vuillard flattened the
rolling hills and rustic village into patterned,
tawny-colored tiers. He framed the sides and
top edge of the work with garland borders,
recalling sixteenth- and seventeenth-century
tapestries intended to decorate and insulate
large interiors. With its muted colors, flattened
forms, and harmonious design, Vuillard's mon-
umental painting also reflects the decorative
aims of the Nabis (or "prophets"), a group of
French painters in which Vuillard played a
prominent part.

John Smibert

American, born Scotland; 1688–1751

Richard Bill, 1733
Oil on canvas
127.6 x 102.2 cm (50 ¼ x 40 ¼ in.)
Friends of American Art Collection, 1944.28

Born in Edinburgh, Scotland, where he was apprenticed as a house plasterer, John Smibert moved to London in 1709. Smibert developed his formal portrait style in Sir Godfrey Kneller's academy in London and through study in Italy from 1717 to 1720. After briefly maintaining a studio in Covent Garden, he left for America in 1728 and eventually settled in Boston, where his marriage to a woman from a distinguished family assured him of lucrative patronage for his works. He ran an artist's supply shop and organized North America's first art exhibition, in which he displayed, among other things, his Old Master copies and fashionable portraits. Accustomed to the products of self-taught painters, viewers were fascinated by Smibert's polished style, skillfully rendered textures, and light effects.

Dating from early in Smibert's career in Boston, *Richard Bill* exemplifies the painter's style in its merging of the iconographic symbols of English portraiture with direct likenesses of wealthy patrons. The Art Institute's portrait shows a fashionably attired man in a wig and ruffled shirt, underscoring his proud bearing. A letter lying next to the subject's right hand identifies him as "Richard Bill, Esq." of Boston. Other objects further identify Bill as an important and powerful shipping merchant: to the right is an anchored ship, referring to the family's wealth and probably copied by Smibert from European maritime prints available in his art shop. Despite his success, Richard Bill died insolvent in 1757.

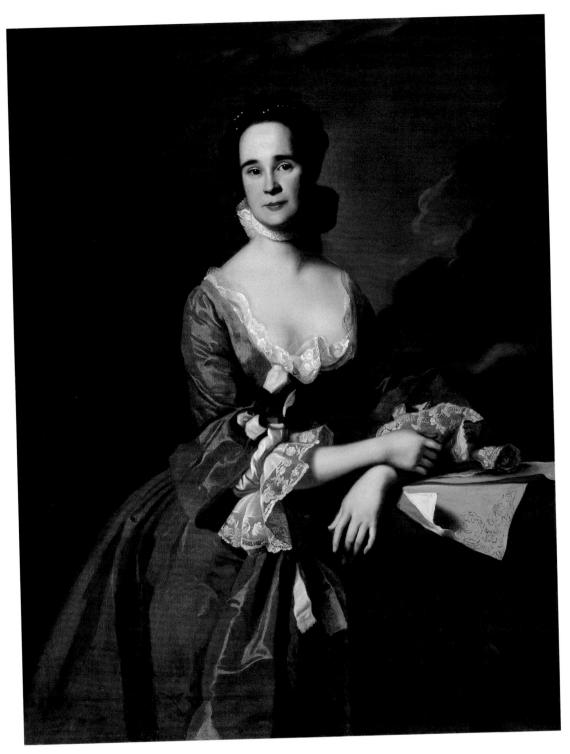

John Singleton Copley
American; 1738–1815

Mrs. Daniel Hubbard (Mary Greene), c. 1764
Oil on canvas
127.6 x 100.9 cm (50 ¼ x 39 ¾ in.)
The Art Institute of Chicago Purchase Fund,
1947.28

The most famous portrait painter in the American colonies before the Revolutionary War, John Singleton Copley was essentially self-taught. From the print collection of his stepfather (Peter Pelham, a mezzotint engraver), he learned the conventions of aristocratic portraiture — the poses, accessories, and backgrounds that constituted a likeness. These sources, however, did not instruct him about color, texture, and the application of oil paint, all of which he mastered on his own by studying the work of other American painters of the time. Copley developed a sophisticated portrait style that was eagerly sought by New England's well-to-do merchant and professional classes. Copley's growing powers of observation resulted in a large number of penetrating, precisely detailed portraits executed from the 1750s to 1774, when the artist left Boston to settle in London because of his Loyalist sympathies.

Mrs. Daniel Hubbard (Mary Greene) was inspired by an oil portrait of an English noblewoman that Copley had seen copied in mezzotint. Standing on a balcony or terrace, Mrs. Hubbard leans informally on a pedestal on which have been placed several sheets of paper decorated with a floral needlework pattern that echoes her lace sleeves. The needlework on the paper suggests Mrs. Hubbard's embroidery skills, an appropriate talent for an upper-class woman. A string of pearls woven into her coiffure adds pinpoints of light to her dark hair. Behind her, restless clouds seem to part, dramatically highlighting her head and shoulders against the blue of the clearing sky and emphasizing her direct, candid gaze. This image was painted along with a portrait of Mrs. Hubbard's husband, also in the Art Institute's collection.

John Ritto Penniman

American; c. 1782–1841

Meetinghouse Hill, Roxbury, Massachusetts,
1799
Oil on canvas
73.6 x 94 cm (29 x 37 in.)
Centennial Year Acquisition and the Centennial
Fund for Major Acquisitions, 1979.1461

John Ritto Penniman was only about seventeen years old when he painted this tranquil vista of Roxbury, Massachusetts, seen from a nearby hill as the sun sets over the town. Lacking the sophisticated training and clients of famous colo-nial portrait painters such as Gilbert Stuart (see p. 80), Penniman had instead collaborated with local craftsmen in the decoration of glass objects, frames, and clocks. *Meetinghouse Hill, Roxbury, Massachusetts,* Penniman's earliest-known landscape, exhibits the attention to detail characteristic of many ornamental painters: here Penniman used carefully controlled brush strokes; a bright, limited color range; simple, unmodeled forms; and sharp contrasts between light and dark tones to convey a topographi-cally accurate view of Roxbury.

The site of the summer and country houses of many Bostonians, Roxbury was famous for the role its citizens had played in the Revolu-tionary War and for its influential families, who had served as governors of Boston since the town's settlement in 1630. The neatly cultivated, expansive landscape in *Meetinghouse Hill* blends harmoniously with the Federal-style architec-ture to present a vision of an orderly society. Moreover, with its emphasis on Roxbury's clapboard town meetinghouse, its steeple rising over the pristine terrain, the image suggests a Puritan society constructed around the central authority of the church.

Joshua Johnson

American; c. 1763–after 1825

Mrs. Andrew Bedford Bankson and Son,
Gunning Bedford Bankson, 1803/05
Oil on canvas
81.3 x 71.1 cm (38 x 32 in.)
Restricted gifts of Robin and Timm Reynolds
and Mrs. Jill Zeno; Bulley & Andrews, Mrs. Edna
Graham, Love Galleries, Mrs. Eric Oldberg,
Ratcliffe Foundation and Mr. and Mrs. Robert O.
Delaney funds; Walter Aitken, Dr. Julian Archie,
Mr. and Mrs. Perry Herst, Jay W. McGreevy, John
W. Puth, Stone Foundation and Mr. and Mrs.
Frederick G. Wacker endowments; through prior
acquisitions of the George F. Harding Collection
and Ruth Helgeson, 1998.315

Joshua Johnson holds a unique place in American history as the first African American to achieve professional standing as an artist. We know little about him, and his extant oeuvre consists of fewer than one hundred paintings. The son of a white man and a black slave woman, Johnson was released from slavery in 1782. By 1798 Johnson was advertising his skills as a "self-taught genius" in the *Baltimore Intelligencer*. He probably studied paintings by various Peales at the Peale Museum, and may have even received instruction from a member of the Peale family of artists (see p. 81).

Johnson lived in a neighborhood of prominent Abolitionists with whom he formed close ties, such as the Bedford Banksons. This portrait of Mrs. Andrew Bedford Bankson and her small son, Gunning, is characteristic of Johnson's straightforward, elegant manner. The figures sit on a Federal-style sofa, ornamented with brass upholstery tacks, a favorite motif which earned Johnson the nickname of the "brass-tack artist." The artist here balanced color, form, and line with grace and refinement: He set the echoing curved outlines of the couch and curtains against a pale, gold background. The simple jewelry that adorns Mrs. Bankson's brown hair is echoed in the upholstery tacks, while the white-clad figure of Gunning is enlivened by touches of red. The drapery tassel dangles over the child's head, almost like a halo.

Ammi Phillips

American; 1788–1865

Cornelius Allerton, 1821/22
Oil on canvas
84.1 x 69.5 cm (33 x 27 ½ in.)
Gift of Robert Allerton, 1946.394

As the wealth and population of western New England increased, individuals often wished to record their success by preserving their own or their family members' likenesses for posterity. With this increased demand, talented decorative sign painters such as Ammi Phillips saw an opportunity: with no formal training, Phillips taught himself in his teens to be a limner — a painter of portraits. By 1811 he had begun to use conventional poses adopted from popular European prints and had learned painting techniques from examples by Connecticut limners of the 1790s, who painted full-length, three-quarter, or bust portraits on canvas, wood, or glass. Until his death in 1865, Phillips succeeded as an inventive, prolific, and well-paid portraitist of rural bankers, judges, doctors, farmers, and their families.

Phillips depicted Dr. Cornelius Allerton seated in a painted chair and framed against a somber, gray background. The man's small head, with its flattened ear, is placed high on the canvas in a manner typical of Phillips's portraits. The artist captured the sense of an individual in the detailed, but unmodeled, face. The inclusion of a volume of *Parr's Medical Dictionary* conveys Allerton's profession, while a tiny horse in the distance may suggest his financial status. Itinerant painters such as Phillips were often commissioned to portray several members of a family; in addition to this portrait, Phillips completed one of Allerton's mother (also in the Art Institute) and mother-in-law (Hartford, Connecticut Historical Society).

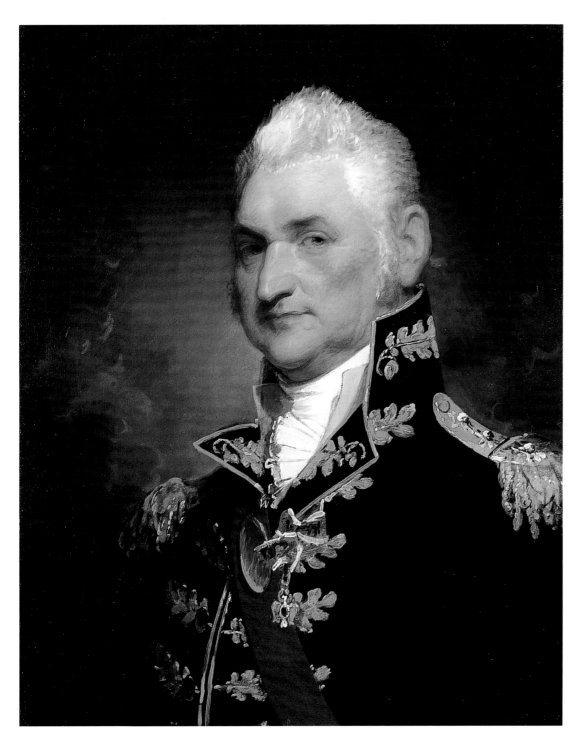

Gilbert Stuart
American; 1755–1828

Major-General Henry Dearborn, 1812
Oil on mahogany panel
71.5 x 57.1 cm (28 3/16 x 22 1/2 in.)
Friends of American Art Collection, 1913.793

The American portrait painter Gilbert Stuart studied for many years in England with the American expatriate artist Benjamin West. Stuart painted his subjects' faces directly onto the canvas with assured brush strokes and spirited color, maintaining conversation with his sitters in order to encourage in them a lively demeanor. Later, in his studio, he filled in the sitters' bodies and the backgrounds. Upon his return to the United States in 1793, Stuart began to paint, among other subjects, a series of portraits of the young republic's military and political heroes, from which his many images of George Washington are the most famous.

Henry Dearborn had been a distinguished soldier in the Revolutionary War; from 1801 to 1809, he served as President Thomas Jefferson's Secretary of War. As the United States expanded westward, several frontier posts were named after Dearborn, including Fort Dearborn, built in 1803 near the conjunction of the Chicago River and Lake Michigan. Contemporary written accounts of Dearborn's appearance suggest that Stuart idealized his subject: the major-general was sixty-one years old and weighed two hundred fifty pounds at the time of this painting. Many copies were made of Stuart's portrait; the Art Institute's is the version that the artist painted from life.

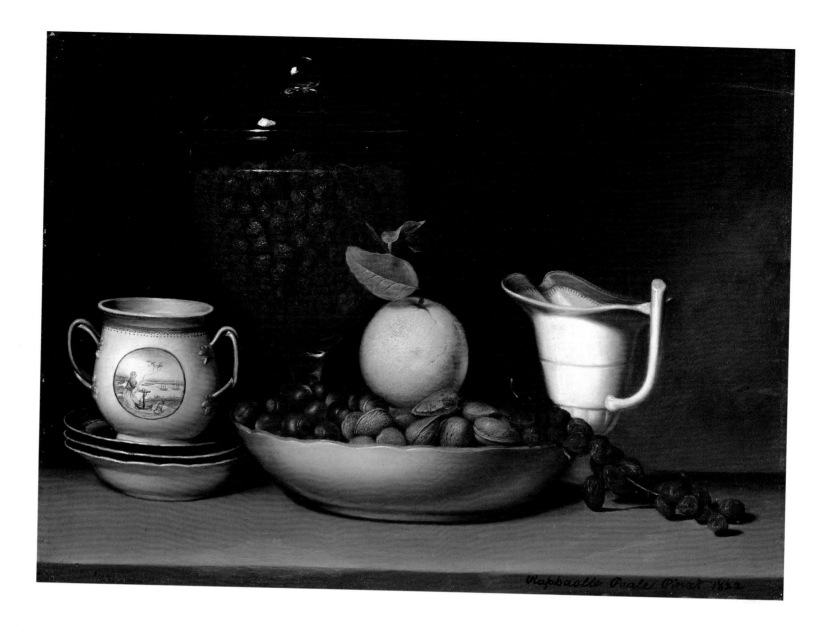

Raphaelle Peale

American; 1774–1825

Still Life — Strawberries, Nuts, &c., 1822
Oil on wood panel
41.1 x 57.8 cm (16 ⅜ x 22 ¾ in.)
Gift of Jamee J. and Marshall Field, 1991.100

Now acknowledged as America's first professional still-life painter, Raphaelle Peale experienced little success during his lifetime. He was the eldest son of Charles Willson Peale of Philadelphia, the head of what has often been called North America's founding family of art. Raphaelle and his siblings bore the names of famous Old Master painters (including Rembrandt, Titian, and Rubens), and were expected to achieve artistic greatness. Although Raphaelle Peale was trained in portraiture, the prestigious genre in which his father excelled, his true talent lay in the less admired and less lucrative genre of still life. In the face of illness, chronic debt, and an unhappy marriage, Peale managed to produce approximately one hundred fifty still lifes, of which only around fifty survive.

This particularly fine, late example typifies Peale's oeuvre and displays his prodigious talent at trompe-l'oeil (fool the eye) effects. The artist created a restrained and harmonious display of food, crockery, and glassware against a bare, dark background. He painstakingly balanced horizontal and vertical elements; the crockery is offset by the upright compote. Peale enlivened the composition with his convincing depictions of a variety of textures, notes of bright colors, and elegant touches, such as the raisins that seem to stray from the bowl.

Still Life — Strawberries, Nuts, &c. also offers a glimpse into Peale's life. The combination of winter and summer fruits reflects the Peales' botanical experiments: among the plants raised in the family's greenhouse were such precious products as these out-of-season strawberries. Another luxury item, of a different sort, is the piece of Chinese export porcelain. Peale's emphasis on consumable goods, whether food or decorative objects, made his paintings particularly marketable within a growing, urban art world.

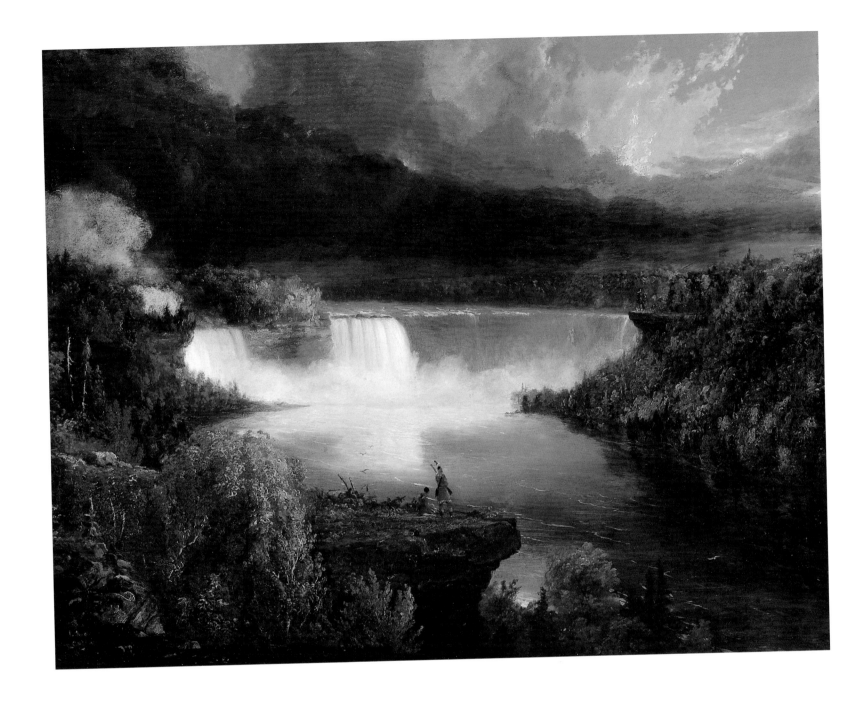

Thomas Cole

American, born England; 1801–1848

Distant View of Niagara Falls, 1830
Oil on panel
47.9 x 60.6 cm (18 ⅞ x 23 ⅞ in.)
Friends of American Art Collection, 1946.396

In mid-nineteenth-century America, a love of the "sublime" landscape, inspiring in the viewer an almost religious sense of destiny, was nowhere felt more powerfully than at Niagara Falls, New York, by far the most frequently depicted and visited spectacle in the New World.

Before he left the United States to study the countryside of England, France, and Italy, Thomas Cole visited Niagara Falls in May 1829 to gaze with wonder at his nation's scenery. Cole, an originator of the Hudson River School of landscape painting, stood in rapture before "the voice of the landscape," sketching and writing of the magnificent cataract in his diary. Cole even penned a long poem describing the site's fearful, primordial power.

The Art Institute's canvas expresses the untamed spirit of the waterfall described in Cole's verse. As was typical of his early methods,

Cole did not execute this painting directly from nature; his letters indicate that he finished it in London in 1830. The completed image bears little resemblance to the actual site in the 1830s: factories, scenic overlooks, and tourist hotels were then becoming the reality of Niagara Falls. In his depiction of the pristine landscape, dramatic stormy clouds, and two Native American figures, Cole portrayed a romantic, untouched American wilderness.

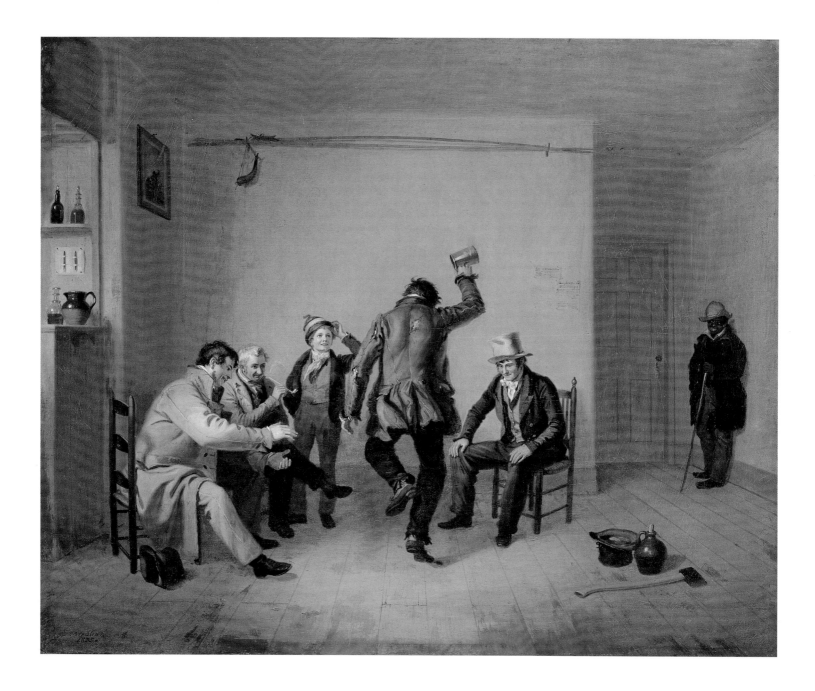

William Sidney Mount

American; 1807–1868

Bar-room Scene, 1835
Oil on canvas
57.4 x 69.7 cm (22 ⅝ x 27 ⁷/₁₆ in.)
The William Owen and Erna Sawyer Goodman
Collection, 1939.392

In contrast to the panoramic, heroic landscapes of Thomas Cole and Frederic Edwin Church (see pp. 82, 84), the paintings of William Sidney Mount express the activities of everyday life in the age of Jacksonian democracy. Mount

learned to paint signs and portraits from his brother in New York City and then attended more formal art classes, copying prints and casts at the National Academy of Design. In the 1830s, prints of several of Mount's rural images were distributed throughout Europe and America, making him one of the few American artists known in Europe at that time.

Mount painted this 1835 tavern interior, *Bar-room Scene,* in Setauket, New York, in the house of a local military general. The sensitive tonal effects, crisp colors, and balanced composition of this work are typical of Mount's rural

subjects at their best. A boisterous figure, raising a drinking vessel over his head, stamps his feet along the floor line as others clap a beat or watch his feet. Mount skillfully rendered the varied details of clothing and furniture, captured animated facial expressions and gestures, and conveyed the effects of light. Separating the smiling black man at the right from the more active, white participants, the artist arranged the composition along the invisible lines that defined social relations in the United States in the 1830s.

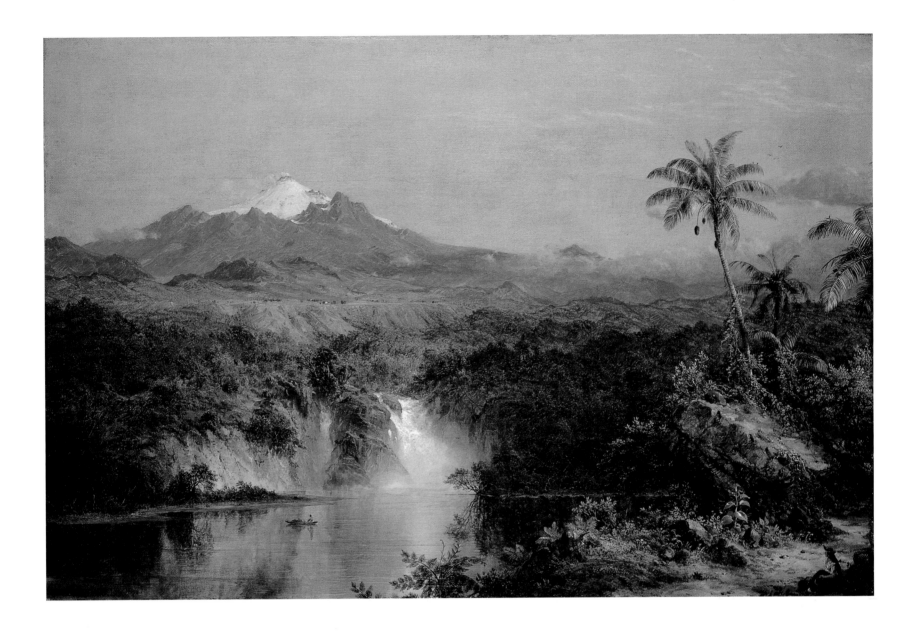

Frederic Edwin Church
American; 1826–1900

View of Cotopaxi, 1857
Oil on canvas
62.2 x 92.7 cm (24½ x 36½ in.)
Gift of Jennette Hamlin in memory of Mr. and
Mrs. Louis Dana Webster, 1919.753

A leading American landscape painter of the mid-nineteenth century, Frederic Edwin Church studied for four years with Thomas Cole (see p. 82), absorbing his descriptive, Romantic landscape style. While Church, like Cole, found inspiration in the wilderness of his homeland, he also became fascinated by the natural beauty of the dense rainforests and mountainous terrain of Latin America. He made his first voyage there in 1853, inspired by the writings of the German natural historian Alexander von Humboldt. Humboldt had visited South America and had described his scientific explorations in his book *Cosmos* (published in English in 1849). He encouraged painters and explorers to turn their gaze to this untamed New World, and presented the area as a symbol of primordial nature and a source for spiritual renewal.

Executed in 1857, almost four years after Church viewed the famed Ecuadorian volcano, the Art Institute's landscape was painted from sketches and memory. *View of Cotopaxi* depicts lush flora, a waterfall, and the hills leading to the distant peak in a brightly lit, realistic style. An elevated vantage point permits the viewer to witness an awesome vista filled with contrasts— of abundant, green foliage and rugged, barren slopes; of water that is calm (the lake), explosive (the cascades), and frozen (the peak); of great warmth and extreme cold. In this panoramic composition, Church combined an eye for scientific detail with a symbolic and evocative vision of the vast New World.

Albert Bierstadt

American, born Germany; 1830–1902

Mountain Brook, 1863
Oil on canvas
111.8 x 91.4 cm (44 x 36 in.)
Restricted gift of Mrs. Herbert A. Vance; fund of
an anonymous donor; Wesley M. Dixon, Jr., Fund
and Endowment; Henry Horner Straus and
Frederick G. Wacker endowments; through prior
acquisitions of various donors, including Samuel
P. Avery Endowment, Mrs. George A. Carpenter,
Frederick S. Colburn, Mr. and Mrs. Stanley
Feinberg, Field Museum of Natural History, Mr.
and Mrs. Frank Harding, International Minerals
and Chemicals Corp., Mr. and Mrs. Ralph Loeff,
Mrs. Frank C. Miller, Mahlan D. Moulds, Mrs.
Clive Runnells, Mr. and Mrs. Stanley Stone, and
the Charles H. and Mary F. S. Worcester
Collection, 1997.365

By 1861 German-born Albert Bierstadt's majestic paintings of the American West had earned him the respect of his peers and the status of full academician at New York's prestigious National Academy of Design. In order to enlarge his reputation, Bierstadt also painted New England subjects. His choice of the White Mountains as a setting made sense; this once-remote spot of wilderness rivaled other tourist spots such as Niagara Falls and the Catskills in popularity at mid-century. Bierstadt probably developed the composition for *Mountain Brook* during an 1860 trip to New Hampshire with his younger brothers, Charles and Edward, both of whom were photographers.

In this composition, Bierstadt traced the path of a mountain through the heart of a forest. He conveyed the depth of the forest with a subdued palette of dark russet, browns, and greens. Shafts of sunlight pierce the canopy of the trees, highlighting the boulder and white ribbon of a stream, which draws attention to the foreground of rocks, water, and ferns, rendered with jewellike clarity. A small, blue-and-white bird perched above the waterfall provides a means to gauge scale, and adds a further note of delicacy to the wilderness scene.

James McNeill Whistler
American; 1834–1903

The Artist in His Studio, 1865/66
Oil on paper mounted on panel
62.9 x 46.4 cm (23 ¾ x 18 ¼ in.)
Friends of American Art Collection, 1912.141

Born in Massachusetts, James McNeill Whistler spent most of his adult life in Europe, studying in Paris before establishing himself in London in 1862. In *The Artist in His Studio*, Whistler, wearing his long-sleeved waistcoat, stands before what is presumably his easel and appears to study the viewer, his brush poised in his left, non-painting hand. His pose echoes that of Spanish master Diego Velázquez in his famous exploration of artistic creation and identity, *Las Meninas* (1656; Madrid, Museo del Prado).

Like a high priest in a cult of art, Whistler surrounded himself here with beautiful people and objects, which seem to define him as much as does his actual appearance. His precious collection of rare Chinese porcelain glints dimly in the left corner, reflecting the artist's enthusiasm for Asian culture. The standing model, whom Whistler referred to as "la Japonaise," wears a kimono and holds a fan. Whistler's mistress Joanna Hiffernan sprawls on the chaise, wearing a classically diaphanous white gown.

The limited palette and broad brushwork of this composition reveal Whistler's shift in style at this point in his career from a realistic approach to the more abstract, aesthetic manner that would earn the witty and outspoken artist the controversy he seemed to relish (see p. 90). By the mid-1860s, Whistler had begun to emphasize the formal qualities of color, shape, and design, rather than a picture's story or moral, in a celebration of "art for art's sake." As the artist would soon proclaim, "Art should be independent of all clap-trap—should stand alone and appeal to the artistic sense of eye or ear."

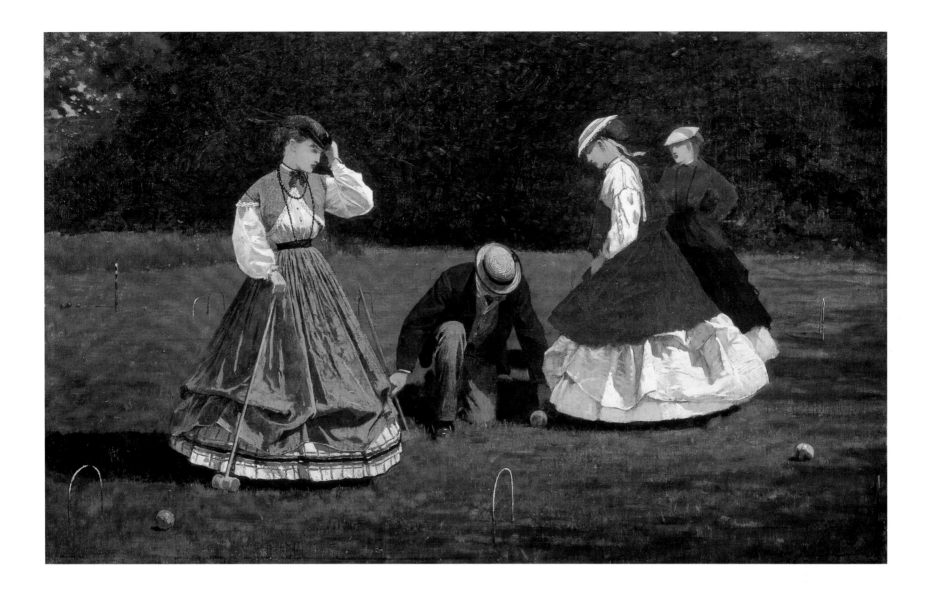

Winslow Homer
American; 1836–1910

Croquet Scene, 1866
Oil on canvas
40.3 x 66.2 cm (15 ⅞ x 26 1/16 in.)
Friends of American Art Collection; the
Goodman Fund, 1942.35

Employed as an illustrator during the Civil War,
Winslow Homer began to work in oil paint in
1862, remaining, for the most part, self-taught.
His early paintings demonstrate how his skills
as a draftsman and printmaker informed his art:
graphic qualities such as broad, simple planes
and carefully constructed spatial organization
appear in many of his works, including *Croquet*
Scene. After the war, Homer became interested
in country life, depicting farmers and their fam-
ilies, and the upper-middle class vacationing at
summer resorts. In oil paintings, watercolors,
and wood engravings, he portrayed these aspects
of contemporary American existence with
acute observational and technical skills, rarely
exaggerating or sentimentalizing his subjects.

Croquet was introduced to America at
mid-century from Ireland and England. Homer
recorded people enjoying the game as a leisure
pastime in a series of paintings, of which the Art
Institute's is an outstanding example. Despite
the attention given to the players' clothing, in
the bright sunlight the forms of the four figures
seem to flatten out against the lawn and trees
behind them. Indeed, the contrast of the dense,
dark foliage and the bright hues of the women's
fashionable dresses throw the figures into high
relief. As the woman in red prepares to place
her foot upon the croquet ball (and then pre-
sumably knock away her opponent's ball), the
male figure in the center leans down to adjust
the placement of the ball. This gesture could be
a chivalrous effort to help the woman maintain
her modest pose, or an attempt to view the
woman's ankle. In this way, *Croquet Scene* em-
bodies Homer's consummate ability to capture
both visual and societal details.

William Bradford

American; 1823–1892

The Coast of Labrador, 1866
Oil on canvas
72 x 113.3 cm (28 ⅜ x 44 ⅝ in.)
Ada Turnbull Hertle Fund, 1983.529

While William Bradford's early works are documentary "portraits" of ships in harbors, he went on to study the coast of New England, eventually following the shoreline as far north as Labrador, Canada. The artist made his first journeys to Labrador between 1854 and 1857, but it was not until 1861 that he began to thoroughly explore the region, with its icebergs and ice fields. Celebrated not only in North America but also in England, the artist included Queen Victoria among his collectors.

Bradford is linked with several American painters of the 1850s and 1860s who shared a fascination with light: along with artists such as John Frederick Kensett and Martin Johnson Heade (see p. 91), Bradford was interested not only in transcribing the radiance of light, but

also in conveying its power to create mood, express emotion, and unify a diverse natural world. In *The Coast of Labrador,* the artist recorded, in meticulous detail, a stretch of shore where large boulders and jutting cliffs dominate the coast. In the foreground, a fisherman tends to his nets, while, in the far distance, two tiny figures walk along the beach. Yet, despite these closely observed elements, it is the pale sun centered in a hazy sky and its suffused, glowing light that establish the meditative mood of the scene. Through delicate atmospheric effects achieved by subtle tonal gradations, Bradford unified sky, sea, and land into a harmonious whole.

Winslow Homer

American; 1836–1910

Mount Washington, 1869
Oil on canvas
41.3 x 61.8 cm (16 ¼ x 23 ⁵⁄₁₆ in.)
Gift of Mrs. Richard E. Danielson and Mrs.
Chauncey McCormick, 1951.313

Like *Croquet Scene* (p. 87), Winslow Homer's *Mount Washington* explores themes of leisure in the post-Civil War United States. Mount Washington, the highest peak of the White Mountains of New Hampshire, was a favorite destination for tourists, artists, and naturalists. Homer traveled to the White Mountains in the summers of 1868 and 1869 specifically to document tourist activity. The sketches and paintings that resulted from these journeys depict the interaction between people and the landscape.

While the solidity of form in *Mount Washington* recalls the style of earlier Hudson River School painters, such as Thomas Cole (see p. 82) and Frederic Edwin Church (see p. 84), Homer inverted these artists' compositional emphases on vast landscapes that dwarf all human activity. In *Mount Washington*, the landscape serves as a backdrop for the figures, who are engaged in what was called "scenic touring." The women ride on horseback and are accompanied by fashionably dressed men who point to designated spots with grand overlooks. The objective was to undergo a memorable experience tinged with danger; the rocks surrounding the tourists and their horses produce a shadowy suggestion of peril. The women in this scene dominate the composition: despite their implied dependence upon their male escorts, they appear capable and free in their practical clothing, perhaps suggesting the emergence of women in the public sphere during this period.

James McNeill Whistler

American; 1834–1903

Nocturne: Blue and Gold—Southampton Water, 1872
Oil on canvas
50.5 x 76 cm (19 ⅞ x 29 ¹⁵/₁₆ in.)
The Stickney Fund, 1900.52

A celebrated spokesman for the "aesthetic" movement in art, James McNeill Whistler insisted that the primary task of the painter is to present a harmonious arrangement of color and form on a flat surface rather than to depict a familiar or narrative subject. To underscore this approach, as well as the close relationship the artist believed exists between art and music, he shocked the public by titling his paintings "Arrangements," "Symphonies," and "Nocturnes."

Nocturne: Blue and Gold—Southampton Water is one of the first compositions to which Whistler gave such an appellation. Writing to thank his patron Frederick Leyland for suggesting this term to him, Whistler enthused: "I say I can't thank you too much for the name 'Nocturne' as a title for my moonlights! You have no idea what an irritation it proves to the critics and consequent pleasure to me—besides, it is really so charming and does so poetically say all I want to say and no *more* than I wish." Thus, rather than emphasizing here the ships one can discern in an inlet, Whistler was more interested in the mood created by a specific time of day (a moonlit night) and the dominant color harmony (blue and gold). In fact he relegated the ships to either side of the composition, creating a kind of visual frame for the tranquil expanse of water and sky at the painting's center.

Martin Johnson Heade

American; 1819–1904

Magnolias on Light Blue Velvet Cloth, 1885/95
Oil on canvas
38.6 x 61.8 cm (15 ¼ x 24 ⅜ in.)
Restricted gift of Gloria and Richard Manney;
Harold L. Stuart Endowment, 1983.791

Never settling in one place long enough to pursue formal artistic training, Martin Johnson Heade lived in New York City, Philadelphia, St. Louis, Chicago, Trenton, Providence, Boston, and finally in St. Augustine, Florida. In addition to trips to England and the Continent, Heade traveled three times to Brazil to study exotic flora and fauna. Over his very long career, he painted a wide range of subjects, including pristine, sensitive views of East Coast salt marshes, romantic images of South American forests, and still lifes of native or foreign flowers and of Brazilian orchids and hummingbirds.

Late in his life, at a time when highly realistic rendering was unpopular, Heade completed several groups of flower paintings. Living in St. Augustine, he painted arrangements of local flowers, including roses, orange blossoms, water lilies, and lotus blossoms, mostly in a vertical format. Heade selected a horizontal format, however, for his sensuous and decorative images of magnolia blossoms. The Art Institute's *Magnolias on Light Blue Velvet Cloth* is one of at least five compositions by Heade featuring this lemon-scented flower. Here the shiny leaves, rough bark, and smooth petals lying on blue velvet present a variety of rich textures. Like his spectacular paintings of Latin American orchids, Heade's depiction of magnolias captures the curvaceous flower's delicate texture and subtle, pale hues in painstaking detail. Many of these still lifes eventually decorated the homes of wealthy southerners.

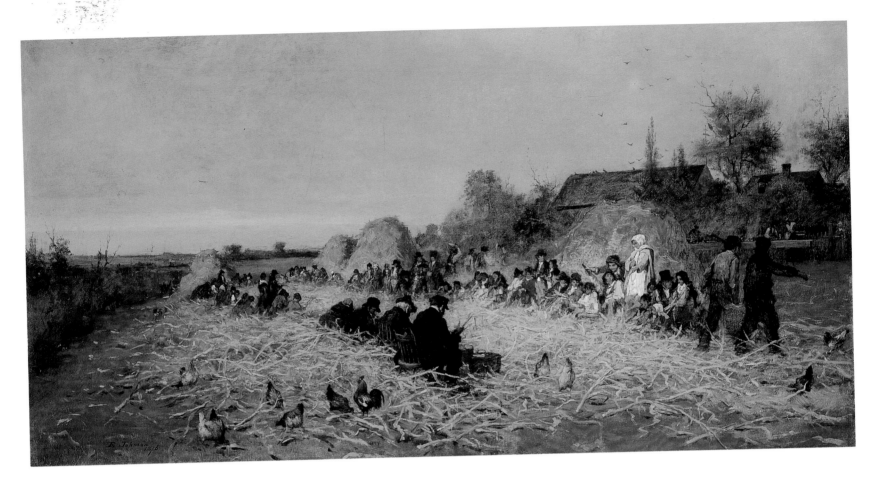

Eastman Johnson

American; 1824–1906

Husking Bee, Island of Nantucket, 1876
Oil on canvas
69.3 x 137 cm (27 ¼ x 54 ³/₁₆ in.)
Potter Palmer Collection, 1922.444

Late on a fall day, the American portrait and genre painter Eastman Johnson was driving with his wife on the island of Nantucket, where they had a vacation home. As Elizabeth Johnson later recalled, they came upon a scene that would inspire the Art Institute's painting, complete with "the yellow corn and husks, the bright chickens running about, [and] the old sea captains with their silk hats of better days."

Reflecting his training abroad in the 1850s, Johnson imbued this indigenous American event with the directness and naturalism of French landscape painters, as well as with an admiring, romantic view of rural life. Broadly applied patches of red, blue, and green and the shimmering gold of the husks of corn establish a sense of the season. Images of harvest and Thanksgiving abound: two rows of figures — youth versus age — face each other as they compete to husk corn for winter storage. A woman

on the right finds a red ear of corn, which, according to folk tradition, lets her kiss the person of her choice; on the far right, in the middle distance, people spread a feast on the table for later consumption.

When Johnson painted *Husking Bee, Island of Nantucket,* industrialization was revolutionizing farming, forcing small farmers to abandon their land and seek work in the cities; yet Johnson's painting reveals none of these sweeping economic and social changes. The year in which Johnson executed this work, 1876, marked the nation's centennial; *Husking Bee* portrays deeply treasured American values — hard work, democracy, economic independence — that were honored during the United States' hundredth year. The painting depicts a nostalgic vision of American life, with a preindustrial, classless society enacting a communal task.

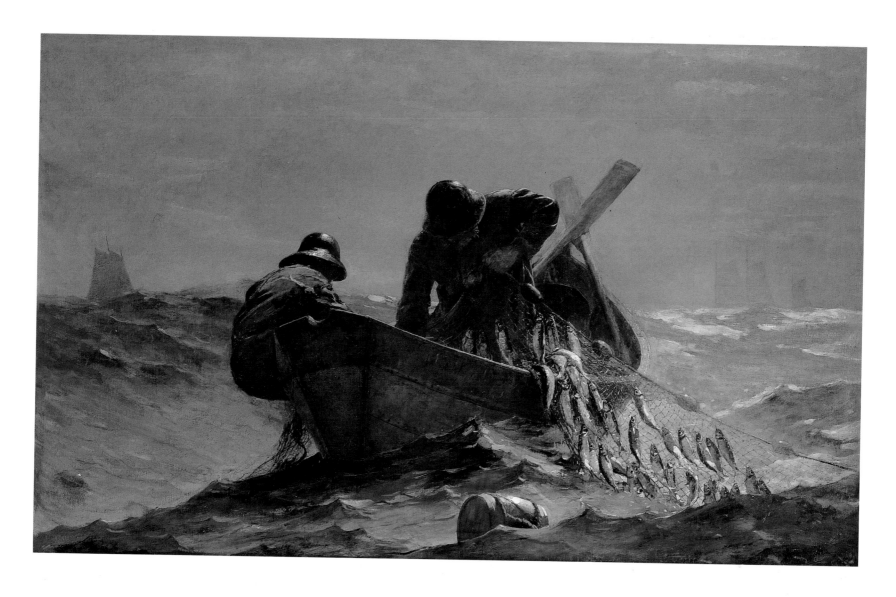

Winslow Homer

American; 1836–1910

The Herring Net, 1885
Oil on canvas
76.5 x 122.9 cm (30 ⅛ x 48 ⅜ in.)
Mr. and Mrs. Martin A. Ryerson Collection,
1937.1039

During the 1870s, Winslow Homer often represented the life of fishermen and their families, which he witnessed during visits to Gloucester, Massachusetts, and other small fishing villages along the New England coast. While these summer excursions encouraged his interest in the sea and related subjects on the theme of survival, a trip in 1881–82 to Tynemouth, England, fundamentally changed his work and way of life. In most of Homer's paintings from this date forward, he attempted to capture the unceasing hardship of men and women struggling with the enormous forces of nature.

The year after Homer returned from the rugged shores of England, he moved to an isolated cottage overlooking the Atlantic at Prout's Neck, Maine. From there he could observe the ocean's forces and the heroic efforts of those who depended on it for their livelihood. In 1885, after spending hours at sea sketching fishermen, Homer painted *The Herring Net.* Riding in a small boat that hovers precariously between high waves, two anonymous, statuesque figures loom large against the horizon, dotted with the forms of distant ships. Their haul, the netted herring—a staple of the New England fishing industry—glistens in the misty atmosphere. Like so many of Homer's paintings on this theme, this image lasts in the viewer's mind, a powerful poem about humanity's complex relationship with nature, conveyed in a manner that is appropriately broad and masterful.

William Michael Harnett
American, born Ireland; 1848–1892

For Sunday's Dinner, 1888
Oil on canvas
94.3 x 53.6 cm (37 ⅛ x 21 ⅛ in.)
Wilson L. Mead Fund, 1958.296

In nineteenth-century America, where imitative still-life painting was not as highly regarded as anecdotal scenes or landscapes, William Harnett became a very adept painter of deceptively real paintings, called trompe l'oeil (fool the eye). In 1880, after attending art classes in Philadelphia and New York, Harnett settled in Munich, Germany, where he remained for six years. There he sold small, increasingly lavish trompe-l'oeil paintings to tourists. By the time Harnett returned to the United States, collectors had learned to appreciate—and to pay higher prices for—fastidious still lifes, as they associated them with Old Master paintings they could not afford.

In 1888, when his reputation was at its peak, Harnett painted *For Sunday's Dinner*. In contrast to his many compositions filled with carefully arranged objects, this work represents a single, plucked chicken, waiting to be cooked. The bird, shown life-sized, hangs against a plank door, its remaining feathers catching the light and appearing to float off into the air. The weathered door, with its chipped and cracked boards and brass hinges, is depicted parallel to the picture plane with emphatic presence and clarity. This rough door, along with the painting's title, suggests an unpolished country dinner, hinting at nostalgia for a more simple past.

Frederic Remington

American; 1861–1909

The Advance Guard, or The Military Sacrifice,
1890
Oil on canvas
87.3 x 123.1 cm (34 ⅜ x 48 ½ in.)
George E. Harding Collection, 1982.802

Although he was born in Canton, New York, and later attended classes at the Yale School of Art, New Haven, Connecticut, and the Art Students League in New York City, Frederic Remington gained widespread distinction for his heroic, even mythic, vision of life on the western plains. Remington moved to Montana and later to Kansas, worked as a ranch hand in the early 1880s, and traveled across the West and Southwest, observing Native American customs, ranch life, and soldiers on horseback patrolling the United States' expanding frontier. Capturing the individuality and self-determination of these populations with a superb sense of drama, Remington romanticized the vanishing life of the Old West in magazine illustrations, etchings, oil paintings, and bronze sculptures.

During the late 1880s, Remington worked as an illustrator for *Harper's Weekly* and accompanied the U.S. Sixth Cavalry as it pursued Northern Plains Sioux Indians across the canyons of the Badlands. To protect the regiment from ambush, commanders sent single cavalrymen far ahead to draw their adversaries' fire. *The Advance Guard* depicts the moment when the regiment's vedette, the forward-most sentinel, is shot by a Sioux warrior hidden in the surrounding rocky ravine. Remington meticulously represented the cavalryman's self-sacrifice in the brightly lit foreground. The stricken soldier's distant companions retreat hastily to warn the regiment of the imminent danger.

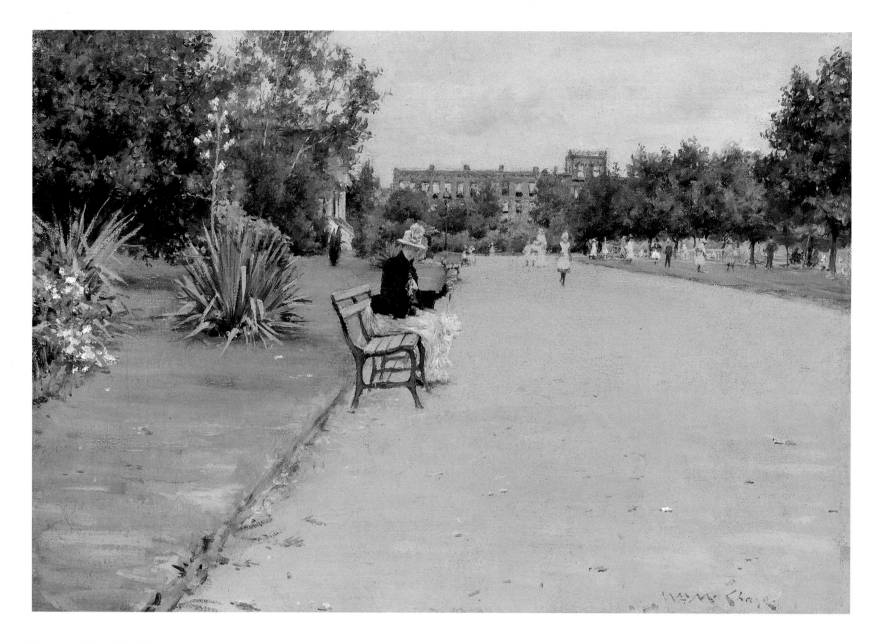

William Merritt Chase
American; 1849–1916

A City Park, c. 1887
Oil on canvas
34.6 x 49.9 cm (13 ⅝ x 19 ⅝ in.)
Bequest of Dr. John J. Ireland, 1968.88

Indiana-born William Merritt Chase was one of the most influential painters in North America at the turn of the twentieth century. After an extended stay in Europe, which ended upon the establishment of his studio in New York City in 1878, Chase demonstrated his extraordinary versatility, painting portraits, landscapes, still lifes, and scenes of daily life. His vigor as a painter was equaled by his long and successful career as a teacher: his classes in New York, Philadelphia, and Europe attracted many students.

In the mid-1880s, Chase embarked on a group of paintings inspired by the parks of New York City. Influenced by the unorthodox compositional formats of the Impressionists, he often countered a broad, empty foreground with a detailed background. In the Art Institute's painting, which probably depicts a park in Brooklyn, almost half of the canvas is filled by the wide, empty walkway which, with its strong diagonal borders, carries the eye into the background. The swift movement into space is slowed by the woman on the bench, who appears to gaze expectantly toward someone approaching along the path. To the left, colorful flowers provide a contrast to the bare, dun-colored walk at the right. This informal, seemingly spontaneous work, capturing the sparkle, light, and activity of a summer's day, testifies to the freshness and vitality Chase brought to the painting of such scenes.

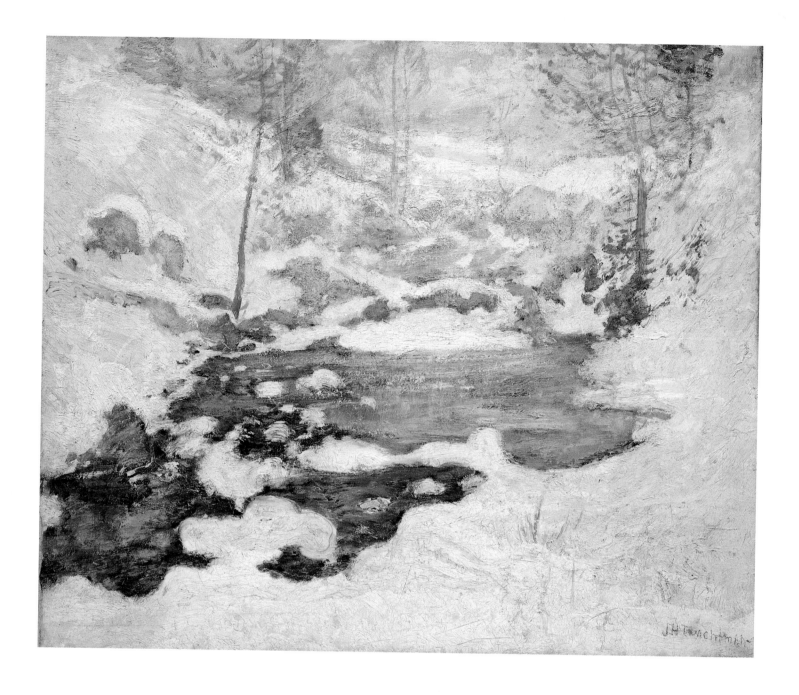

John Henry Twachtman

American; 1853–1902

Icebound, c. 1889
Oil on canvas
64.2 x 76.6 cm (25 ¼ x 30 ⅛ in.)
Friends of American Art Collection, 1917.200

The gentle and introspective vision of John Twachtman is revealed in the subtle nuances of his muted tonal harmonies. Like the French Impressionists, whose style deeply influenced Twachtman, he returned again and again to the same site in order to explore its changing phases and his own emotional responses. During his lifetime, writers often compared his art to that of James McNeill Whistler (see pp. 86, 90, 101) and the effect of his paintings to the music of French composer Claude Debussy.

In 1889 Twachtman purchased a farm near Cos Cob, Connecticut, where he could concentrate on his study of nature. For the next decade, his home and the land surrounding it provided him with an inexhaustible supply of subjects. *Icebound* depicts a peaceful winter scene in a limited range of whites and blues. Even though its title suggests a landscape that is frozen and still, a subtle sense of activity is nonetheless implied: a stream descends from the rocks in the background, a descent accentuated by the sinuous arabesques of white snow against blue water; thick brush strokes of white and streaks of violet amid the blue of the water enliven the picture's surface; and finally the vivid red-orange of the leaves stands out against the dominant white and serves as a reminder of the autumnal life that will not let go. These several details, however, scarcely intrude upon the hushed tranquility of the scene.

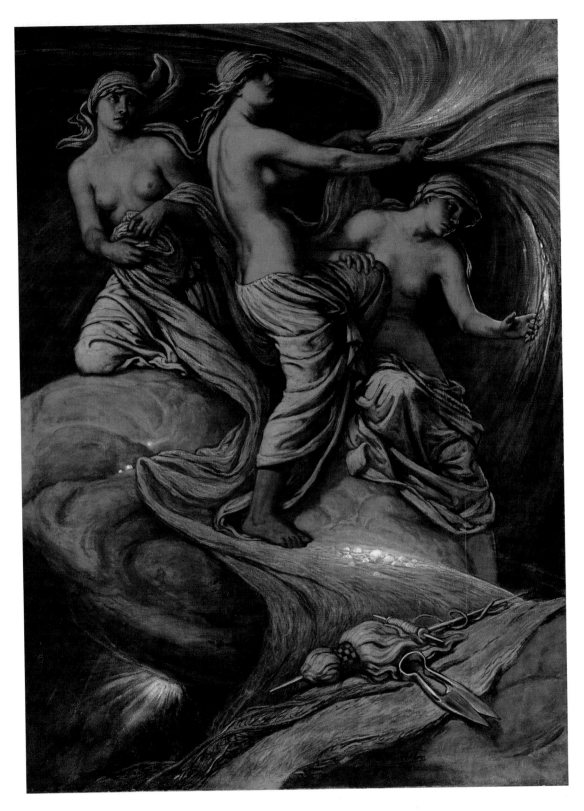

Elihu Vedder
American; 1836–1923

The Fates Gathering in the Stars, 1887
Oil on canvas
113 x 82.6 cm (44 ½ x 32 ½ in.)
Friends of American Art Collection, 1919.1

Although he lived and worked in Rome for most of his long career, American-born Elihu Vedder was more appreciated in his homeland than in Italy for his visionary paintings, book illustrations, and stained-glass designs. He developed an elongated, classical, figural manner that was inspired by the art of antiquity and the Renaissance, and by the dreamy images of the English Pre-Raphaelite painters. He mixed these art-historical sources with aspects of Eastern mysticism and decoration to fashion a distinctly personal style. Vedder's sensitivity to symbol and design made his work particularly appealing to contemporary American sculptors, decorators, and architects, such as Augustus Saint-Gardens, Louis Comfort Tiffany, and Stanford White.

After producing elegant covers for *The Studio* and *Century* magazines, Vedder executed illustrations for an edition of *The Rubáiyát of Omar Khayyám* (Boston, 1884), a popular book of translated Persian poetry. The commission brought him wide fame and financial security. *The Fates Gathering in the Stars*, painted after an image done for this publication, represents the partially draped Fates, standing upon swirling clouds, as they sweep in nets full of stars (a scene corresponding to quatrains 72–74). The three sinuous figures, their twisting drapery, and the whirling nets are conceived in a linear way that conveys a sense of motion across the entire surface. Vedder's refined, ethereal style was well suited to the popular *Rubáiyát*, which focuses on the beauty of momentary pleasures.

George Inness

American; 1825–1894

Early Morning, Tarpon Springs, 1892
Oil on canvas
107.2 x 82.1 cm (42 ¼ x 32 ⅜ in.)
Edward B. Butler Collection, 1911.32

In 1878 the painter George Inness wrote in
Harper's Magazine:

Details in the pictures must be elaborated only
enough fully to reproduce the impression that the
artist wishes to reproduce. When [there are more
details], the impression is weakened or lost, and
we see simply an array of external things which
may be cleverly painted and may look very real,
but which do not make an artistic painting. . . .
The one is poetic truth, the other is scientific
truth; the former is aesthetic, the latter is analytic.

In the last ten years of his life, the prolific
painter eschewed precision of detail, conveying
mood and emotion through richness of tone
and broad handling. Inness first visited Florida
about 1890, and subsequently established a
house and studio in Tarpon Springs, where he
executed the Art Institute's painting. In a pink
and blue morning light, a lone man studies a
cluster of buildings in the middle distance.
Although a wooden bridge leads from fore-
ground to figure, in fact the pool of light that
illuminates the central clearing quickly draws
the viewer's eye into the middle of the picture
and from there to the cloudlike expanses of
green foliage atop the thin-trunked trees encir-
cling the clearing. Through blurred outlines
and delicate, subtle tonalities, as well as the
solitary presence of the figure, Inness master-
fully evoked the brightening light and peaceful
mood of early morning.

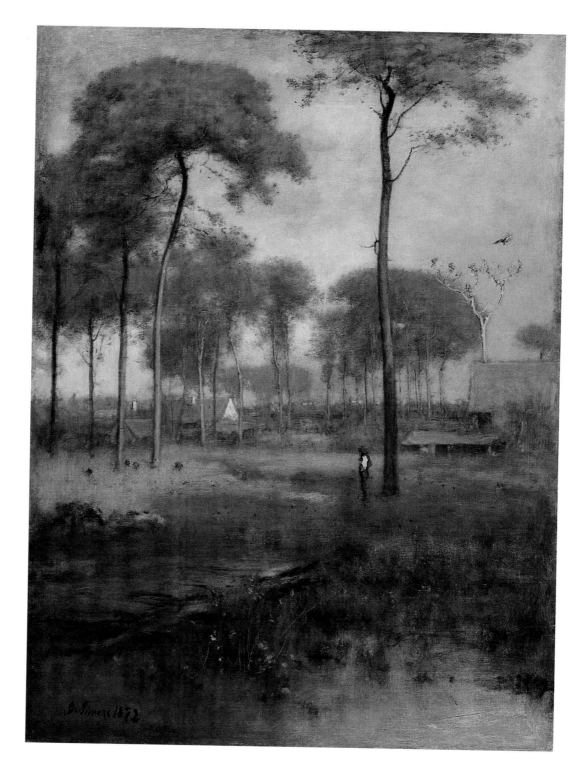

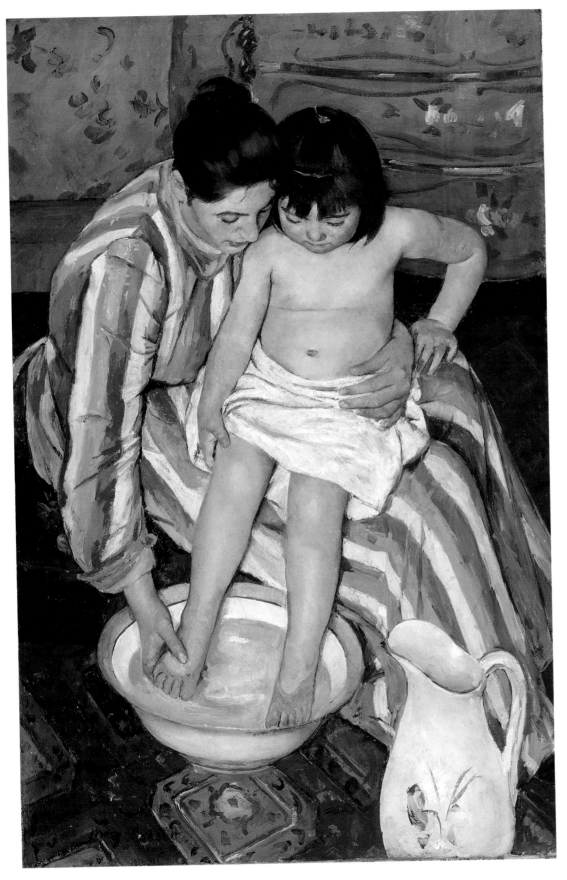

Mary Cassatt
American; 1844–1926

The Child's Bath, 1893
Oil on canvas
100.3 x 66.1 cm (39 ½ x 26 in.)
Robert A. Waller Fund, 1910.2

Mary Cassatt grew up in a wealthy family and studied at the Pennsylvania Academy of the Fine Arts from 1861 to 1865. In 1866 she traveled to Paris to study with the fashionable and influential painter Jean Léon Gérôme, and to copy works in the Musée du Louvre. She sent her first painting to the official French Salon in 1868 and, two years later, traveled to Italy and Spain to complete her education. Eventually, she settled in Paris and became one of America's foremost expatriate painters. By 1877 Cassatt had met Edgar Degas (see pp. 51, 56) and later accepted his invitation to join the Impressionists, thus becoming the first American to exhibit with them. Significantly for her work, Cassatt chose Degas, the consummate draftsman, as her artistic mentor. Like him, she concentrated almost exclusively on the figure.

The Child's Bath reflects Cassatt's interest in exploring unorthodox compositions, which she learned in part from her study of Japanese prints. The wallpaper, painted chest, striped dress, and patterned carpet are daringly played off one another. Even more boldly, the torso and bare, pale legs of the child dramatically cut across the diagonal stripes of the woman's dress. Despite these striking effects, it is the tender rapport between mother and child—the woman assured, supportive, the child tentative, wary—that commands the viewer's attention. As a critic wrote of the 1893 one-person exhibition in Paris at which *The Child's Bath* was first exhibited: "Here we find work of rare quality, which reveals an artist of lively sentiment, exquisite taste, and great talent."

James McNeill Whistler

American; 1834–1903

Arrangement in Flesh Color and Brown: Portrait of Arthur Jerome Eddy, 1894
Oil on canvas
209.9 x 92.4 cm (82 ⅝ x 36 ⅜ in.)
Arthur Jerome Eddy Memorial Collection, 1931.501

By the early 1890s, James McNeill Whistler had begun to earn recognition for his art on both sides of the Atlantic, and received many commissions to portray prominent Americans and Europeans. Sensitive and understated in their characterization of sitters, his portraits were also conceived as compositions of subtle color and form, as the first part of the title of the Art Institute's work, *Arrangement in Flesh Color and Brown*, demonstrates.

This portrait depicts the lawyer Arthur Jerome Eddy. Eddy asked Whistler to paint his likeness after seeing the artist's work in the World's Columbian Exposition, held in Chicago in 1893. Eddy traveled to Whistler's Paris studio, where the two apparently formed a lasting friendship (the year after Whistler's death, Eddy wrote *Recollections and Impressions of James A. McNeill Whistler* [Philadelphia/London, 1903] as a memorial to the painter).

In the portrait, Whistler used a muted palette and placed his subject against a subdued, gray background. Eddy commented on the artist's technique: "It was as if the portrait were hidden within the canvas and the master by passing his wand day after day over the surface evoked the image." In 1913 Eddy purchased many works from the famous Armory Show, which introduced Americans to revolutionary European art (and enraged many in the process). This exhibition, which Eddy encouraged to have shown in Chicago, prompted him to write the first book by an American on modern European art, *Cubists and Post-Impressionism* (Chicago, 1914). The Arthur Jerome Eddy Memorial Collection, including this portrait, was presented to the Art Institute in 1931.

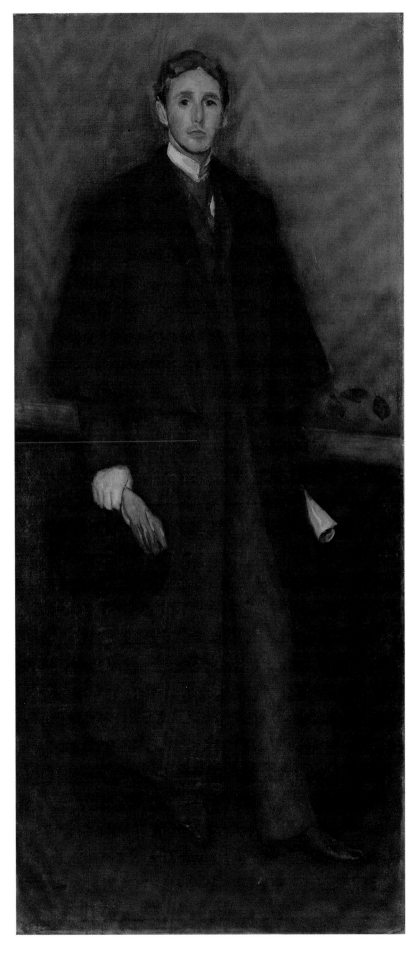

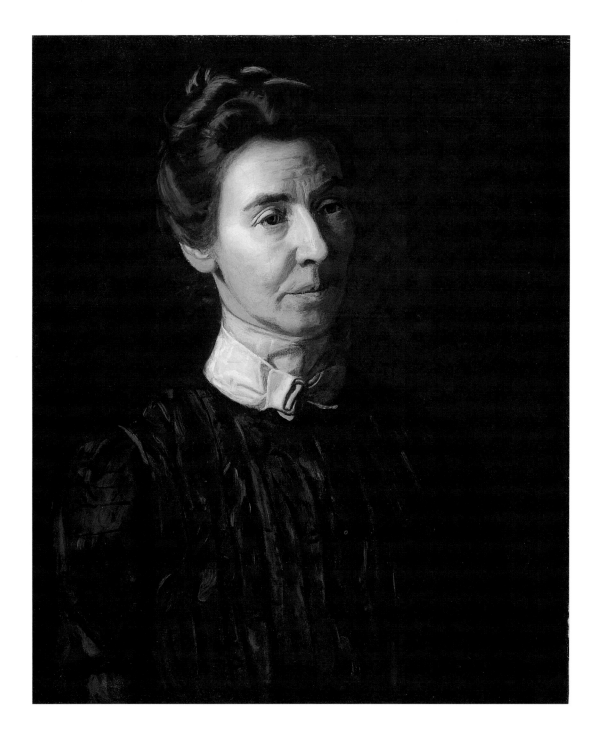

Thomas Eakins
American; 1844–1916

Mary Adeline Williams, 1899
Oil on canvas
61 x 51 cm (24 x 20 1/16 in.)
Friends of American Art Collection, 1939.548

One of the greatest American artists of his time, Thomas Eakins studied art in his native Philadelphia before spending three years at the Ecole des beaux-arts in Paris. After his return to the United States in 1870, he lived, taught, and painted in Philadelphia until his death in 1916. Convinced that science—anatomy and perspective—is an essential area of knowledge for an artist, Eakins insisted that all his students, female as well as male, practice drawing from the nude. This stand, revolutionary at the time, contributed to his dismissal from the teaching staff of the Pennsylvania Academy of the Fine Arts in 1886.

Eakins's uncompromising realism is apparent in his portraiture. His portraits were not popular in his own day, which explains why many of them were private in nature, depicting friends, relatives, or professional acquaintances. In this portrait of Mary Adeline Williams (Williams, a longtime family friend, eventually moved into the Eakins's household), the dark background and severity of dress and coiffure throw into relief the sitter's plain features. Her erect posture, pursed lips, and furrowed brow are softened by the three-quarter pose that casts her left side in shadow, while the light that illuminates her right side reveals a thoughtful, inward gaze and a reserved, but warm, demeanor. In such breathtakingly honest portraits as this one, Eakins showed his sensitivity to subtleties of character and his constant need to contemplate, through his sitters, the complexities of the human condition.

Childe Hassam
American; 1859–1935

New England Headlands, 1899
Oil on canvas
68.9 x 68.9 cm (27 ⅛ x 27 ⅛ in.)
Walter H. Schulze Memorial Collection, 1930.349

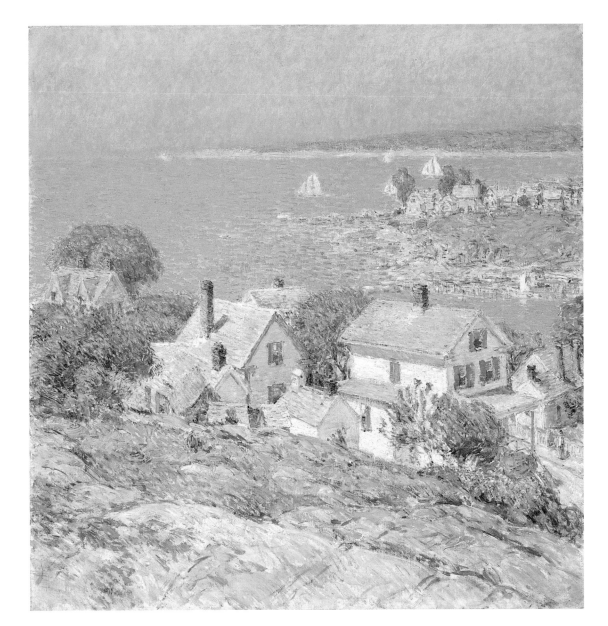

In the 1880s, American artist Childe Hassam studied in Paris at the height of the Impressionist movement. He then settled in New York City, where he painted spacious views of sunny, tree-lined boulevards and parks. To vary his subjects and refine his eye, Hassam frequently traveled, outside New York, making painting excursions along the New England coast.

Among Hassam's favorite sites was Gloucester, Massachusetts, North America's oldest commercial seaport. In the Art Institute's panoramic landscape, the artist captured the bright light and rural charm that made the bustling village a magnet for turn-of-the-century painters of modern life. Hassam chose to emphasize the picturesque aspects of the old fishing town — its quaint buildings and sailing boats — rather than its many industrial plants for drying and packing fish. On a note attached to the frame, Hassam explained the view: "This part of the town (really East Gloucester) then had many examples of the small New England frame houses painted white with green blinds which are seen in the foreground — The little promontory on the right is Rocky Neck and at the point of the land in the distance is Norman's Woe celebrated in the poem by Longfellow."

New England Headlands reveals Hassam's mastery of Impressionist techniques: He executed the work boldly, employing a bright palette and broken brushwork, and leaving areas of the canvas bare as a compositional device. Saturated blues and crisp whites convey the sparkling, fresh sense of sunlight and sea, while the square canvas helps structure the painting, underscoring the compelling harmony between nature and humankind. In such works, Hassam celebrated the benefits — physical, mental, and perhaps even aesthetic — of life on the New England seacoast.

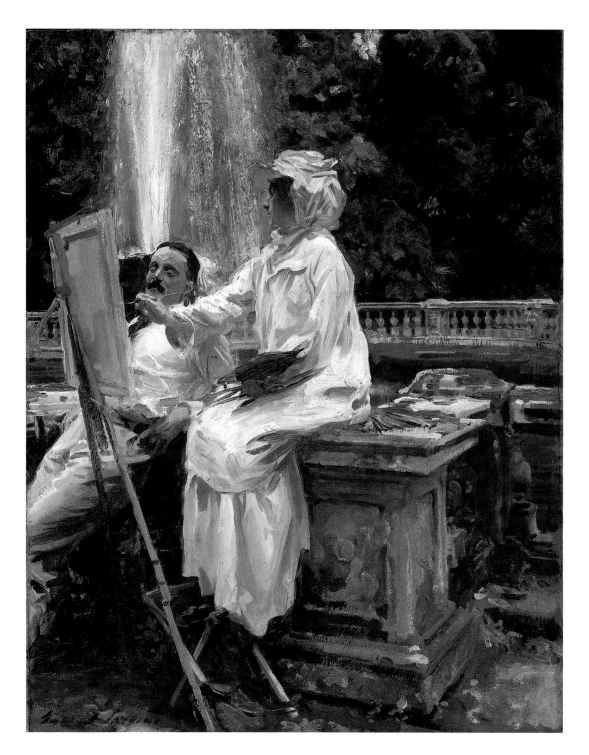

John Singer Sargent

American; 1856–1925

The Fountain, Villa Torlonia, Frascati, Italy,
1907
Oil on canvas
71.4 x 56.5 cm (28 ⅛ x 22 ¼ in.)
Friends of American Art Collection, 1914.57

A celebrated portraitist of high society, John Singer Sargent depicted the cosmopolitan world to which he belonged with elegance and verve. Born in Italy to a wealthy American expatriate couple, Sargent spent most of his career abroad. He developed his acclaimed, fluid technique in the Parisian studio of portrait painter Charles Emile Auguste Carolus-Duran and was deeply influenced by the breathtaking brushwork of both the Spanish Baroque master Diego Velázquez and the nineteenth-century French painter Edouard Manet (see pp. 48, 58). By the age of twenty-three, Sargent was already exhibiting his work at the official Paris Salon.

Considering London his home after the mid-1880s, the peripatetic artist made frequent sojourns to sunny locales to master the effects of outdoor painting. Joining Sargent on an autumn holiday to Italy in 1907 were fellow artists from the United States, Wilfrid and Jane Emmet von Glehn. One of their stops was Villa Torlonia in Frascati, a popular hillside resort near Rome. Sargent painted this charming portrait of the von Glehns in the villa's elaborately landscaped gardens. One of the artist's most accomplished informal, outdoor portraits, *The Fountain, Villa Torlonia, Frascati, Italy* celebrates the act of painting. Not only did Sargent show Jane von Glehn creating her own picture, but the sun-drenched setting enabled him to employ thick impasto and virtuoso brushwork to indicate the play of bright light on a variety of textures: he even captured the way spray issues from a fountain by dragging a dry brush across the canvas. The work's fresh and spontaneous quality belies the artist's careful orchestrating of the von Glehns' poses, so that figures, architecture, and landscape—as well as light and shade—are perfectly balanced.

TWENTIETH-CENTURY PAINTINGS

Henry Ossawa Tanner

American; 1859–1937

Two Disciples at the Tomb, c. 1905
Oil on canvas
129.5 x 105.7 cm (51 x 41⅝ in.)
Robert A. Waller Fund, 1906.300

Two Disciples at the Tomb was acquired by the
Art Institute after being cited as "the most im-
pressive and distinguished work of the season"
at the museum's "Annual Exhibition of
American Art." At that time, Henry Ossawa
Tanner was at the height of his reputation, en-
joying international fame and winning prizes
on both sides of the Atlantic. The son of a
bishop of the African Methodist Episcopal
Church, Tanner was raised in Philadelphia,
where he studied with Thomas Eakins (see p.
102) before working as an artist and photogra-
pher in Atlanta. Repelled by the racial prejudice
he encountered in the United States, he chose
to spend nearly all of his adult life in France.

Tanner's early subjects included many
scenes of African American life, but later he
specialized in religious paintings, of which *Two
Disciples at the Tomb* is one of the most austere
and affecting. The somber spirituality of the
moment when two of Jesus' followers realize
that he has risen from the dead is conveyed by
the composition's dark tones, compressed space,
and lack of superfluous incident. Although
Tanner painted in a relatively conservative
representational manner throughout his life,
the sinuous lines and simplified, harsh model-
ing here suggest his awareness of Art Nouveau
and Expressionist currents in contemporary
European painting. Likewise, his emphasis
on psychological experience also parallels de-
velopments during the same period, including
Symbolism and Pablo Picasso's early work, such
as *The Old Guitarist* (p. 108).

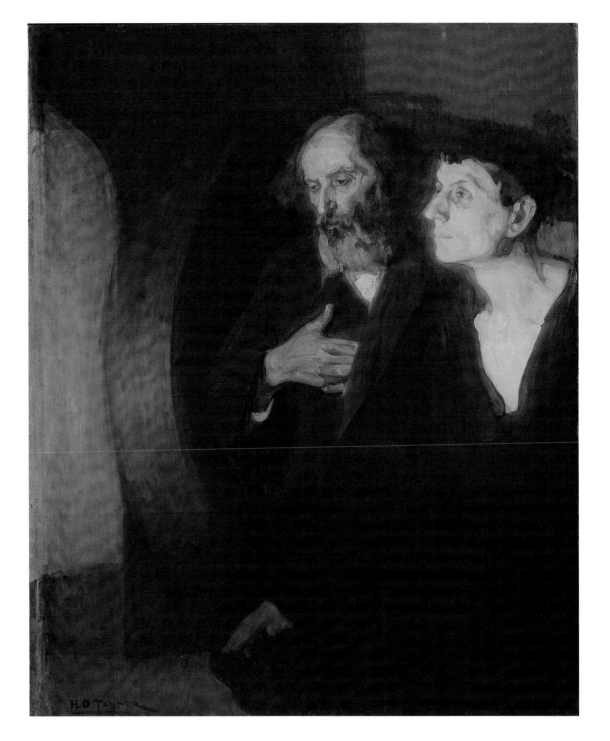

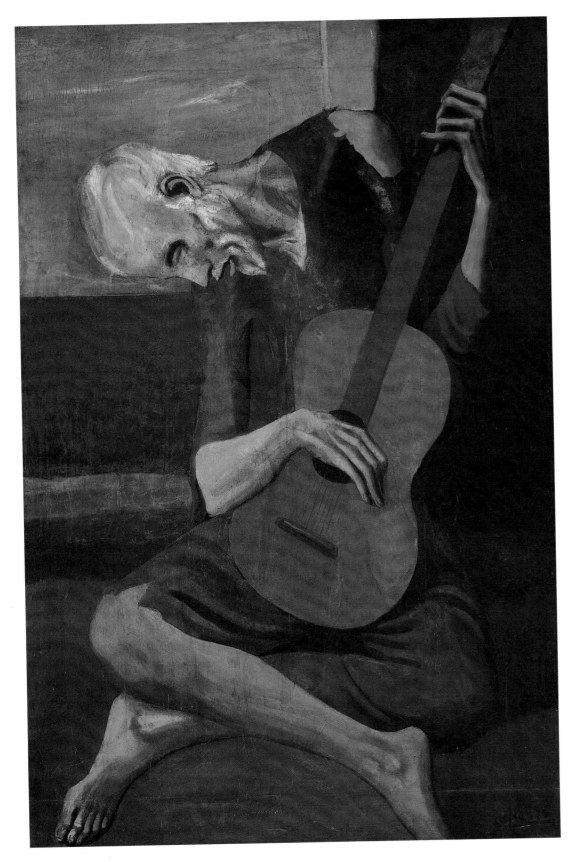

Pablo Picasso

Spanish; 1881–1973

The Old Guitarist, 1903
Oil on panel
122.9 x 82.6 cm (48 ⅜ x 32 ½ in.)
Helen Birch Bartlett Memorial Collection,
1926.253

Pablo Picasso painted *The Old Guitarist*, one of his most haunting images, when he was twenty-two years old. In the paintings of his Blue Period (1901–1904), of which this is a prime example, Picasso worked with a monochromatic color palette, flattened forms, and pensive themes. There have been many attempts to explain Picasso's nearly exclusive use of blue during this time: he may have been too poor to buy other colors; or perhaps he meant to utilize the psychological impact of blue, which can convey a sense of mystery and sadness.

The emaciated figure of the blind musician in this work reflects Picasso's artistic roots in Spain. The old man's elongated limbs and angular posture recall the figures of the great sixteenth-century artist El Greco (see p. 22). (see p. 22) The image also reflects Picasso's sympathy for the plight of the downtrodden; he painted many canvases at this time depicting the miseries of the destitute, the ill, and the outcasts of society. Picasso knew what it was like to be poor, having been nearly penniless during all of 1902.

With the simplest means, Picasso presented in *The Old Guitarist* a timeless expression of human suffering. The bent and sightless man holds close to him his large, round guitar — its brown body the painting's only shift in color. This emphasis on the instrument, as well as the man's total absorption in his playing, suggests that one can be passionate about one's art in the face of poverty and infirmity.

Georges Braque
French; 1882–1963

Landscape at La Ciotat, 1906–1907
Oil on canvas
60.3 x 72.7 cm (23 ¾ x 28 ⅝ in.)
Walter Aitken, Major Acquisition Centennial,
Martha E. Leverone funds; restricted gift of
Friends of The Art Institute of Chicago in honor
of Mrs. Leigh B. Block, 1981.65

Although Georges Braque is mainly associated
with Cubism, *Landscape at La Ciotat* is an ex-
ample of the period during which he was
counted among the Fauve painters. Fauvism, a
short-lived but potent artistic movement,

gained recognition in 1905, when a group of
artists, led by Henri Matisse and André Derain,
began painting with brilliant colors and freedom
of line and caused a sensation in Paris. The group
was labeled by a critic *les fauves* (wild beasts).

In the summer of 1906, the young Braque
began to work in the bright hues and curvilin-
ear forms of the Fauves. The following spring,
the artist went to the small port and summer
resort town of La Ciotat, east of Marseilles,
where he painted the Art Institute's landscape.
Because of its clarity of light and expanse of sky
and water, the Mediterranean coast in the
south of France was a favorite site for artists in-
terested in outdoor scenes. In this painting, a

steep, tree-lined road winds by a wall enclosing
a group of houses, rendered in improbable tones
of yellow, pink, green, lavender, and orange.

Among the last and the youngest to join
the Fauves, Braque painted about forty pictures
in that style in 1906 and 1907. These works ex-
hibit an individual approach: Braque used more
subdued color, applied paint less densely, and
created more lyrical compositions than did the
other Fauves. By the end of 1907, Braque's inter-
est in Fauve methods had diminished, and the
movement itself had come to an end.

Georges Braque

French; 1882–1963

Little Harbor in Normandy, 1909
Oil on canvas
81.1 x 80.5 cm (31 $^{15}/_{16}$ x 31 $^{11}/_{16}$ in.)
Samuel A. Marx Purchase Fund, 1970.98

Paul Cézanne's 1907 memorial exhibition and Pablo Picasso's revolutionary painting *Les Demoiselles d'Avignon* (1907; New York, The Museum of Modern Art), both seen by Georges Braque in the same year, inspired him to turn away from his Fauve style (see p. 109) in favor of more subdued studies of shape and volume. Over the next several years, Braque worked closely with Picasso to develop the groundbreaking style that came to be known as Cubism.

While Braque executed many of his Fauve works out-of-doors, he painted *Little Harbor in Normandy* from memory in his Paris studio. Between a pair of lighthouse structures, two sailboats, with their strongly defined hulls and swelling sails punctuated by spars and masts, enter a harbor and approach a wharf. Braque's compressed treatment of space seems to propel the boats forward to the front edge of the picture. A turbulent, steel-blue sea with a fringe of whitecaps and a stormy blue sky with dashes of white clouds further energize the powerful composition. *Little Harbor in Normandy* may have been exhibited in Paris in March 1909 at the Salon des Indépendants. If so, this painting was the first major Cubist work to have appeared in such a prominent venue.

Pablo Picasso

Spanish; 1881–1973

Daniel-Henry Kahnweiler, 1910
Oil on canvas
101.1 x 73.3 cm (39 ¹³⁄₁₆ x 27 ⅞ in.)
Gift of Mrs. Gilbert W. Chapman, in memory of
Charles B. Goodspeed, 1948.561

It may be difficult at first to see the subject of this painting. Yet, despite its highly abstract character, Pablo Picasso provided clues to direct the eye and focus the mind: a wave of hair, the knot of a tie, a watch chain. From flickering, partially transparent planes of brown, gray, black, and white emerges the upper torso of a seated man, hands clasped in his lap. To the left is an elongated sculpture similar to a figure from New Caledonia that hung in Picasso's studio, and below this is a small still life.

The process by which we discover and read these details is an important part of the experience of Cubist paintings. No longer seeking to create the illusion of appearances, Picasso invited the viewer to probe the forms that he broke down and recombined in totally new ways. In this work, we are presented with objects whose volumes the artist fractured into various planes, shapes, and contours and presented from several points of view. The term Analytical Cubism has been given to this phase of the movement. The portrait's subject, Daniel-Henry Kahnweiler, was a dealer who championed this radical, new style. Two years before this portrait was done, he had introduced Picasso to Georges Braque (see pp. 109, 110), and the two artists worked closely together to create Cubism. Kahnweiler purchased the majority of the paintings they produced between 1908 and 1915, and wrote an influential book, *Der Weg zum Kubismus* (*The Rise of Cubism*) (Munich, 1920), which offered a theoretical framework for the movement.

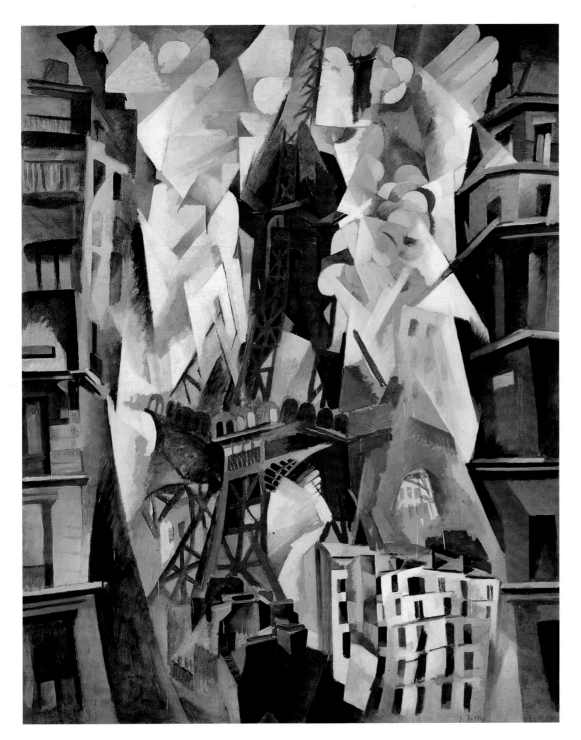

Robert Delaunay
French; 1885–1941

Champs de Mars: The Red Tower, 1911/23
Oil on canvas
160.7 x 128.6 cm (63 ¼ x 50 ⅝ in.)
Joseph Winterbotham Collection, 1959.1

Robert Delaunay was four years old when the Eiffel Tower was erected in Paris on the Champ de Mars. This engineering triumph became a symbol for that city, as well as for the modern age. One of many artists to focus on the landmark, Delaunay did a series of Eiffel Tower paintings, of which the Art Institute's example is among the most important. Using a visual language adapted largely from Cubism and influenced by nineteenth-century color theory, the artist attempted to infuse the dynamism of modern life into this image by employing multiple viewpoints, extreme fragmentation of form, and strong color contrasts.

Tall, dark buildings on the sides of the composition frame and accentuate the red tower. An illusion of the structure's height is created by the smaller, lower buildings at its foot, which are seen from a high vantage point. The tower's girders are broken and interrupted by planes depicting clouds, walls of buildings, and patches of sky. Its top and struts seem to lean, tumble down, and soar at the same time. The vigor and strength of the iron structure, which totally commands the city over which it stands, seems to have affected the surrounding buildings and park, whose fragmented forms appear to dance and merge before the viewer's eyes.

Lyonel Feininger

American; 1871–1956

Carnival in Arcueil, 1911
Oil on canvas
104.8 x 95.9 cm (41 ¼ x 37 ¾ in.)
Joseph Winterbotham Collection, 1990.119

The son of German immigrants, Lyonel Feininger was born in New York and moved to Germany in 1887. By the 1890s, he had become an accomplished cartoonist (his series "Wee Willie Winkie's World" and "Kin-der-Kids" ran for many years in the *Chicago Tribune*). Feininger began to paint in 1907 and quickly became associated with the German avant-garde. An important teacher at the famed art school the Bauhaus, Feininger left Germany for the United States in 1937.

Feininger's 1911 *Carnival in Arcueil* is important not only for the considerable skill it exhibits but also for the way it combines past and future interests of the artist. Feininger spent several months each year in the French city of Arcueil. Depicting its famed Roman viaduct soaring over a swaying row of houses, the composition reveals a fascination with architectural forms that would continue throughout Feininger's life. Against an expressive, colorful backdrop of buildings, the artist set a scene of revelry. With their elongated and angular bodies, fanciful costumes, and antic behavior, the fantastic characters in the foreground—like the toy figures and houses Feininger fashioned at the same time—are rooted in the artist's cartooning, in which he was still involved. While his subsequent work retains the elegance of draftsmanship and keen sense of observation he developed as a cartoonist, Feininger became increasingly committed to expressing universal and spiritual ideas in the color-saturated meditations on architecture, landscapes, and sea scenes for which he is now best known.

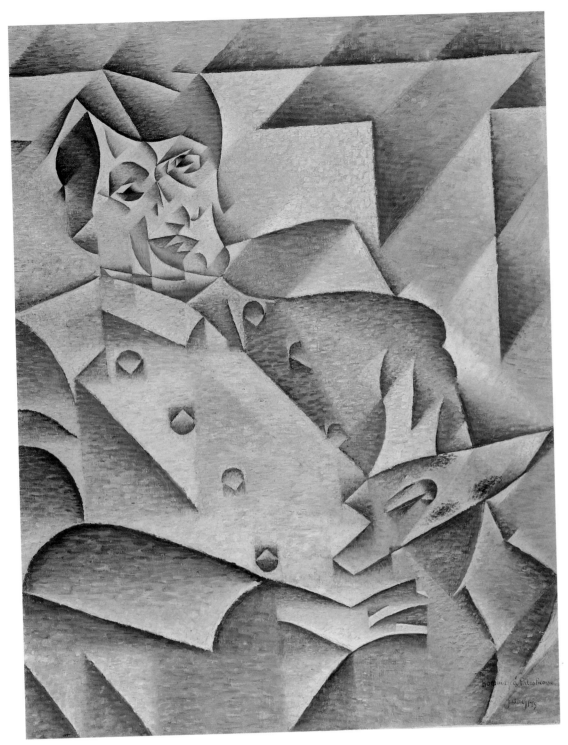

Juan Gris

Spanish; 1887–1927

Portrait of Pablo Picasso, 1912
Oil on canvas
93 x 74.1 cm (36 ⅞ x 29 ¼ in.)
Gift of Leigh B. Block, 1958.525

Juan Gris's *Portrait of Pablo Picasso* is among the most important portraits of the Cubist movement. In an inscription, "*Hommage à Pablo Picasso,*" added at the bottom of the painting, Gris indicated his admiration for the cofounder of Cubism, a fellow Spaniard six years his senior. Born in Madrid, Gris went to Paris in 1906 and moved into the Bateau-Lavoir, the famous gathering place for the avant-garde where Picasso lived. By 1912 Gris had evolved a significant Cubist style of his own. The portrait of Picasso was exhibited at the Salon des Indépendants in Paris that year.

Gris's early Cubist method depends greatly on systematic patterns of planes carefully delineated through light and shadow. Picasso is portrayed here half-length, seated, holding his palette. Although Gris reorganized Picasso's facial features into many parts, a resemblance remains. The artist limited his palette to cool tones: blues, browns, and grays. The almost monochromatic colors of Gris's early pictures perhaps relate to the name the artist chose as a pseudonym. In 1905 José Victoriano González Pérez renamed himself Juan Gris; *gris* translates to "gray" in both Spanish and French. In many of his later paintings, however, Gris restored light and hue to Cubism, creating faceted surfaces that are at times almost jewellike in their intense coloration.

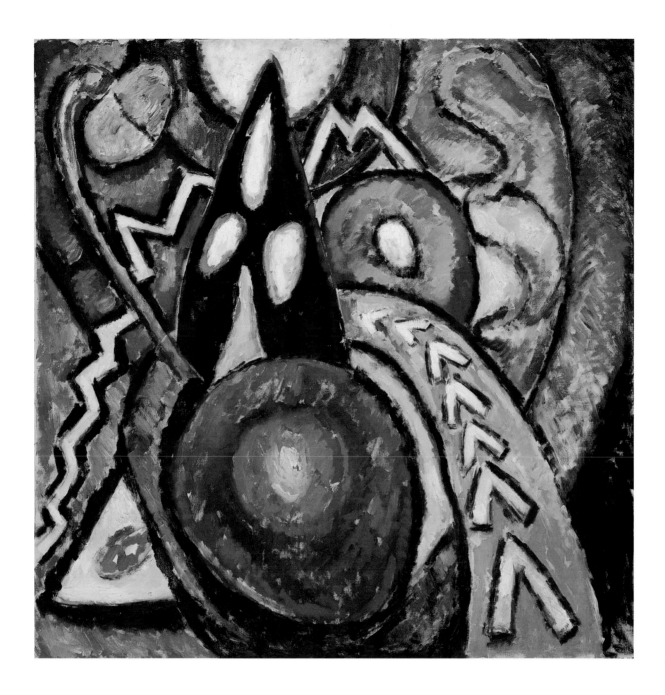

Marsden Hartley

American; 1877–1943

Movements, c. 1915
Oil on canvas
119.7 x 120 cm (47 ⅛ x 47 ¼ in.)
Alfred Stieglitz Collection, 1949.544

Marsden Hartley was among the most talented, and restless, of the avant-garde American artists exhibited by the photographer and dealer Alfred Stieglitz in his 291 Gallery in New York. Hartley's work underwent frequent changes in style and subject, reflecting a life of continual physical displacement. After mixing in New York's

avant-garde circles, in 1912 Hartley moved to Paris and befriended the American expatriate poet Gertrude Stein, whose collection of works by Paul Cézanne, Henri Matisse, and Pablo Picasso had a great impact on him, particularly Matisse's use of strong colors and emphatic decorative patterns. Hartley probably executed *Movements* in 1915 in Germany, where he was influenced by the abstract art of Vasily Kandinsky (see p. 117) and other German Expressionists.

Movements suggests a musical analogy for its nearly abstract forms, which are rhythmically orchestrated around a central red circle and black triangle. The triangle implies a

mountain, and the composition's other shapes may be read as symbols of a natural scene: sun, sky, lightning, water, and vegetation. Hartley's brilliant, intense color is not naturalistic, nor is the heavy outline that weaves the whole together. The effect would be like stained glass, were it not for the active brush strokes that call attention to the rich, painterly surface. The charged energy of this painting remained constant in Hartley's subsequent work, even when he turned to a less abstract approach.

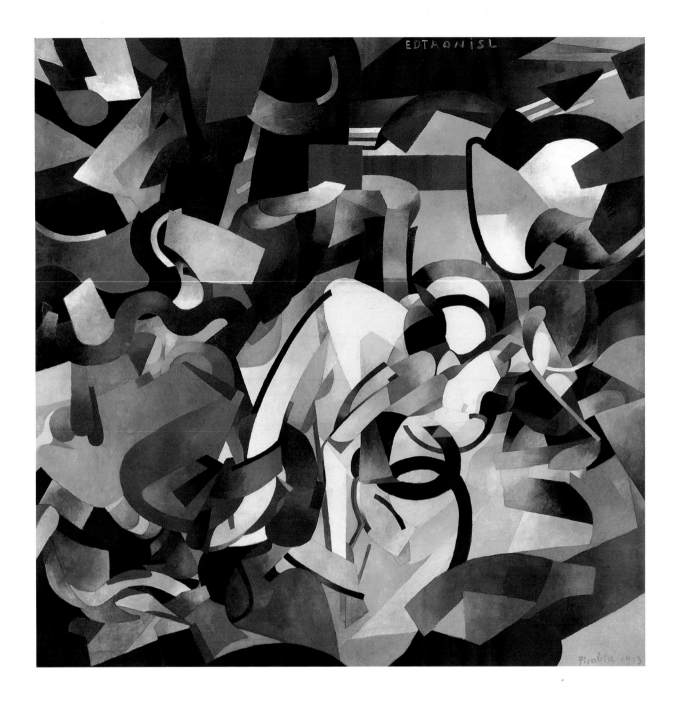

Francis Picabia
French; 1879–1953

Edtaonisl (Clergyman), 1913
Oil on canvas
300.4 x 300.7 cm (118 ¼ x 118 ¾ in.)
Gift of Mr. and Mrs. Armand Bartos, 1953.622

Francis Picabia, the son of a Cuban father and a French mother, was one of the most versatile artists of this century, working in a variety of styles. The riddle posed by the title of the Art Institute's painting *Edtaonisl* relates to an experience Picabia had aboard a transatlantic ship in 1913, on his way to the opening in New York City of the Armory Show, North America's first major exhibition of modern art. Two of his fellow passengers fascinated the artist. One, Stasia Napierskowska, was an exotic dancer well known in Paris. *Edtaonisl* is an acronym made by alternating the letters of the two French words *étoile* (star) and *dans[e]* (dance). To Picabia's amusement, another passenger captivated by the dancer's shipboard rehearsals was a Dominican priest. This probably led to his giving the painting the subtitle *Clergyman,* thereby juxtaposing the sensual with the spiritual.

Only the cryptic title hints at the inspiration of this painting. Purely abstract shapes in a profusion of colors float rhythmically across the canvas. The sense of perpetual motion created by the shapes' fragmentation and overlapping reflects Picabia's indebtedness to Italian Futurism and the related French movement, Orphism. While interpretations of the meaning of a work such as *Edtaonisl* should not be too literal, the intended theme of the painting perhaps relates to the excitement of the clergyman as he watched the dancer and her troupe.

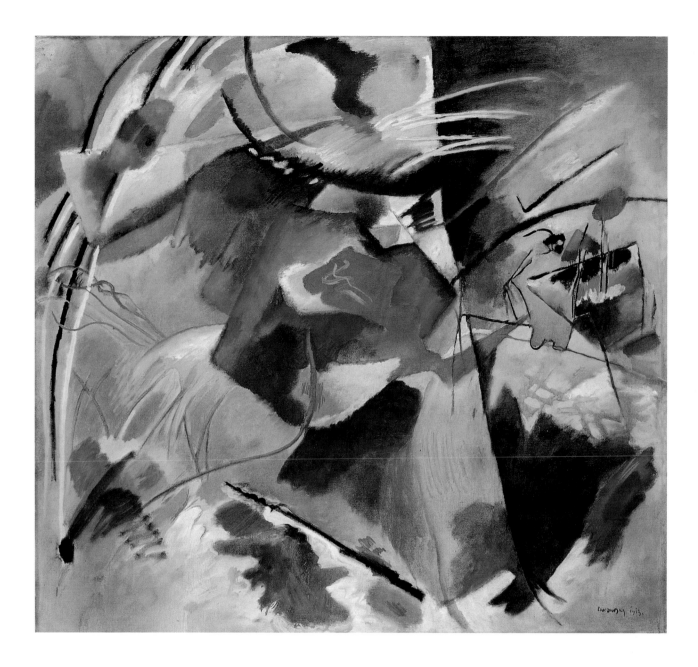

Vasily Kandinsky
French, born Russia; 1866–1944

Painting with Green Center, 1913
Oil on canvas
108.9 x 118.4 cm (42 ⅞ x 46 ⅝ in.)
Arthur Jerome Eddy Memorial Collection,
1931.510

In his seminal *Ueber das Geistige in der Kunst*
(*Concerning the Spiritual in Art*), first published
in Munich in 1912, Vasily Kandinsky advocated
an abstract art that moves beyond imitation
of the physical world, inspiring, as he put it,
"vibrations in the soul," and heightening the
viewer's consciousness. Between 1910 and 1914,

the artist produced a revolutionary group of in-
creasingly abstract works, with titles such as
Last Judgment and *Resurrection*, in which he
envisioned the end of materialism and the
beginning of a new spiritual age that would
embrace abstraction.

Believing that lines, shapes, and colors pos-
sess the power to provoke various emotions and
even to suggest sounds and smells, Kandinsky
imbued the forms and palettes of such works
as *Painting with Green Center* with symbolic
meanings to help orient the viewer to his new
visual language. Central to the artist's vision
was the concept of the forces of good, symbol-
ized by a knight on horseback, prevailing in the

struggle with the forces of evil, embodied in a
dragon. In this composition, only vestiges of
these combatants remain: the black vector at
the bottom center represents the knight's lance,
and the brown zigzag at the lower left evokes
the mythical beast. The dizzying upward and
downward sweep of the painting's forms, the
insistently diagonal orientation of the lines, and
the strength of the colors combine to create a
powerful, explosive image of apocalyptic change.
Eventually, Kandinsky eliminated all literal nar-
rative clues, evoking spiritual states with color
and with increasingly geometric, pure form.

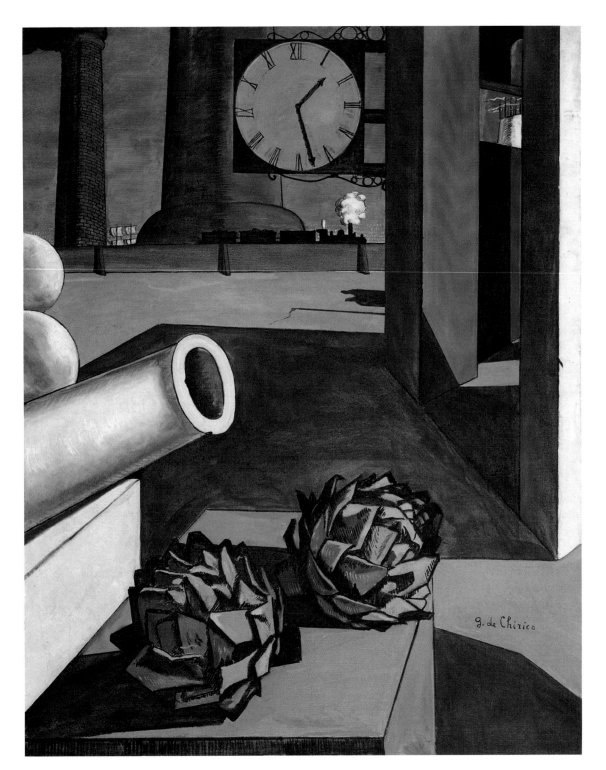

Giorgio de Chirico
Italian; 1888–1978

The Philosopher's Conquest, 1914
Oil on canvas
125.1 x 99.1 cm (49 ¼ x 39 in.)
Joseph Winterbotham Collection, 1939.405

Giorgio de Chirico's paintings capture momentary spatial and temporal dislocations. For de Chirico, such moments triggered a sense of clairvoyance and wholeness of vision, which he hoped to convey in his art. De Chirico's works, somewhat outside the mainstream movements and styles of his time, profoundly affected the Surrealists, who attempted to portray dreams and images of the subconscious (see pp. 136, 138). His reputation was established by his early works, painted when he was in his twenties and thirties, such as *The Philosopher's Conquest.*

The strangeness of this image, with its oversized, isolated objects set around a plaza empty of everything but shadows, creates a psychic unease in the viewer. What are we to make of the lush artichokes beneath the green barrel, their spherical shapes echoing the cannonballs? What does the clock signify, the cold sunlight, the menacing shadows? De Chirico meant these objects to be elements of a puzzle, a dream, which the viewer must solve or ponder. His matter-of-fact rendering, flat application of bright colors without nuance or personal touch, and clear treatment of the parts only serve to render the mysteriousness of the whole more enigmatic.

Amedeo Modigliani
Italian; 1884–1920

Jacques and Berthe Lipchitz, 1916
Oil on canvas
80.7 x 54 cm (31¾ x 21¼ in.)
Helen Birch Bartlett Memorial Collection,
1926.221

In a short life marked by alcoholism, drug abuse, and carousing, Amedeo Modigliani managed to create an accomplished body of work. He matured first as a sculptor, but he eventually shifted to painting. He was above all an elegant draftsman, with a particular feeling for the human figure.

Modigliani's art was mildly influenced by Cubism, from which he derived a simplicity of shape and contour and a freedom with anatomical detail. While his favorite subject was the female nude, he also painted many portraits. This depiction of the sculptor Jacques Lipchitz and his bride, Berthe Kitrosser, was commissioned by Lipchitz on the occasion of their wedding as a way of helping the troubled Modigliani financially. While Modigliani and Lipchitz were not close friends, the Lithuanian-born sculptor and Italian artist shared their Jewish backgrounds and émigré status in Paris.

The double portrait, according to Lipchitz, took two days. During the first, Modigliani made about twenty drawings, of which nine have been identified; during the second, he executed the painting. While Modigliani's portrayal of Berthe is graceful, gentle, and warm, his depiction of her husband is more complex, with its tight and pinched rendition of his face. Perhaps because he was unhappy with his likeness, Lipchitz traded the portrait to his dealer after Modigliani died in 1920.

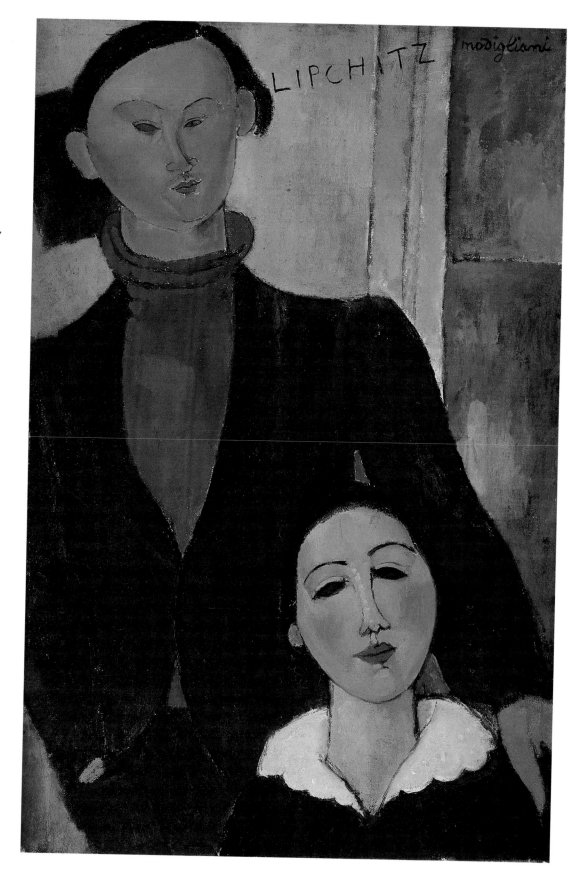

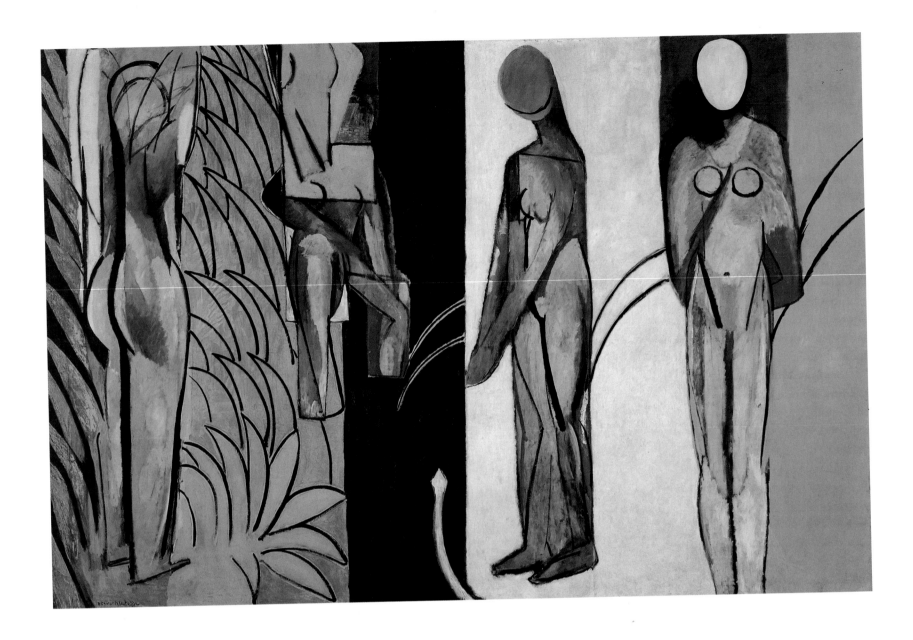

Henri Matisse

French; 1869–1954

Bathers by a River, 1909, 1913, and 1916
Oil on canvas
259.7 x 389.9 cm (102 ¼ x 153 ½ in.)
Charles H. and Mary F. S. Worcester Collection,
1953.158

Henri Matisse considered *Bathers by a River* one of his most significant paintings. The work was commissioned in 1909 by the Russian collector Sergei Shchukin, who wanted three murals to decorate the staircase of his Moscow mansion. In each of the paintings, Matisse varied the subject of the female nude in a pastoral setting. Shchukin decided to purchase only two of the works, *Dance II* and *Music* (both now in the State Hermitage Museum, St. Petersburg).

Matisse returned to *Bathers by a River* in 1913, when he was particularly influenced by Cubism (see p. 111). He reduced his original five bathers to four, simplifying these into columnar forms, with faceless, ovoid heads. In 1916, the final year of work on the picture, Matisse transformed the background into four vertical bands, and turned the formerly blue river into a thick, black stripe bisecting the canvas. One bather wades into the water, oblivious to the white serpent lurking below her. With its restricted palette and severely abstracted forms — the rigid, predominantly gray figures appear more stonelike than fleshlike — *Bathers by a River* is far removed from *Dance II* and *Music*, both of which convey a graceful, hedonistic lyricism. The sobriety and hint of danger in *Bathers by a River* may in part reflect the artist's reaction to the terrible, war-torn period during which he completed it.

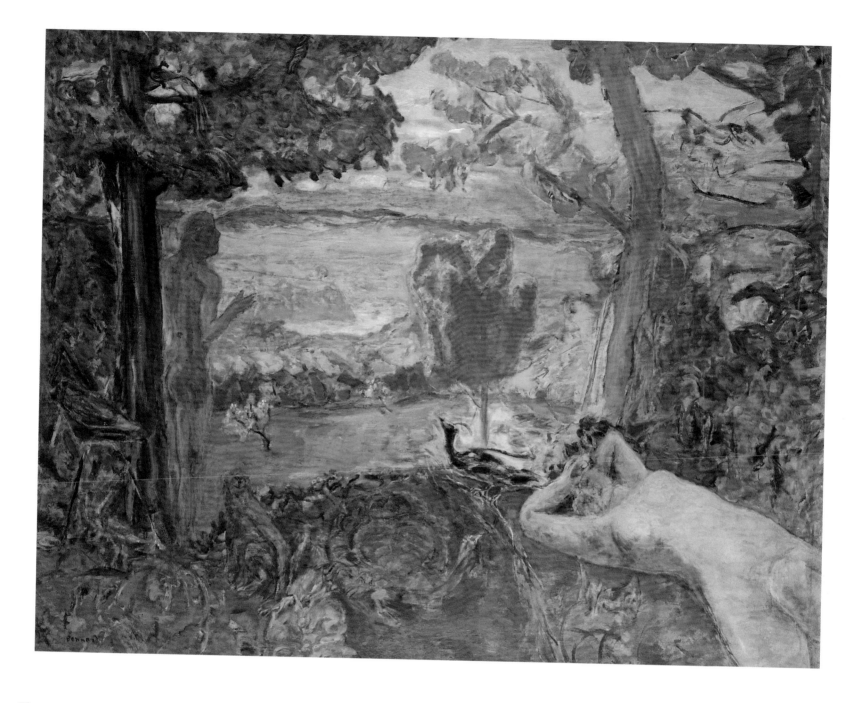

Pierre Bonnard

French; 1867–1947

Earthly Paradise, 1916–20
Oil on canvas
130 x 160 cm (51¼ x 63 in.)
Estate of Joanne Toor Cummings; Bette and
Neison Harris and Searle Family Trust endow-
ments; through prior gifts of Mrs. Henry Woods,
1996.47

Following a period of producing lithographs,
paintings, and posters of Parisian scenes in the
style of Edouard Vuillard and Henri de

Toulouse-Lautrec, Pierre Bonnard virtually
reinvented his art around 1905. The artist's new
emphasis on large-scale, expansive composi-
tions; bold forms; and above all brilliant colors
shows his awareness of the work of modernists
Henri Matisse and Pablo Picasso, as does his
focus on Arcadian landscapes, a theme he had
not previously explored.

Earthly Paradise exhibits Bonnard's daring
investigations into light, color, and space. Here
the artist used foliage to create a proscenium-
like arch for a drama involving a rigid, brooding
Adam and a recumbent, languorous Eve. The

contrast Bonnard set up between the two figures
seems to follow a tradition according to which
the female, seen as essentially sexual, is con-
nected with nature, while the male, seen as
essentially intellectual, is able to transcend the
earthly. Heightening the image's ambiguity is a
panoply of animals, including birds, a monkey,
rabbits, and of course a serpent — here reduced
to a garden snake. The melancholic scene, pre-
sented as a paradise that is less than Edenic,
may reflect the artist's response to the destruc-
tion of Europe during World War I, which was
raging when he began the painting.

Fernand Léger
French; 1881–1955

The Railway Crossing (Preliminary Version),
1919
Oil on canvas
54.1 x 65.7 cm (21 5/16 x 25 7/8 in.)
Joseph Winterbotham Collection, gift of Mrs.
Patrick Hill in memory of Rue Winterbotham
Carpenter, 1953.341

Fernand Léger first saw the work of Georges Braque and Pablo Picasso at the Paris gallery of Daniel-Henry Kahnweiler (see p. 111) and, in about 1909, began to paint in a Cubist style. His Cubist abstractions are more colorful and curvilinear than the angular forms and subdued tones of works by Braque and Picasso. An artist with far-ranging interests and talents, Léger later became a designer for theater, opera, and ballet, as well as a book illustrator, filmmaker, muralist, ceramist, and teacher.

Typically, Léger would develop a major composition by preparing studies in a variety of media. *The Railway Crossing* is an oil study for *The Level Crossing* (1919; Basel, Switzerland, pri-

vate collection), a reference to a railroad or street safety barrier. Like many of his contemporaries, Léger was fascinated by the machine age: References to mechanical and industrial elements pervade works such as *The Railway Crossing*. In the midst of a complex scaffolding of cylinders and beams, an arrow appears on a brightly outlined signboard. A network of solid volumes and flat forms seems to circulate within the shallow space, just as pistons move within a motor. The precise definition of his forms and brilliance of his colors express Léger's belief that the machine is one of the triumphs of modern civilization.

Piet Mondrian (Pieter Cornelis Mondriaan)

Dutch; 1872–1944

Lozenge Composition with Yellow, Black, Blue, Red, and Gray, 1921
Oil on canvas
60 x 60 cm (23 ⅝ x 23 ⅝ in.)
Gift of Edgar Kaufmann, Jr., 1957.307

Although Piet Mondrian's abstractions may seem far removed from nature, his basic vision is rooted in landscape, especially the flat geography of his native Holland. Beginning with re-alistic landscapes, over time he reduced natural forms to their simplest linear and colored equivalents in order to suggest their unity and order. Finally, he eliminated natural forms altogether, developing a pure visual language of verticals, horizontals, and primary colors that he believed expressed universal forces.

In *Lozenge Composition with Yellow, Black, Blue, Red, and Gray*, Mondrian turned a square canvas on edge to create a dynamic relationship between the composition and the diagonals of the edges. The Art Institute's painting is the fifth of the artist's sixteen diamond-shaped works.

Deceptively simple, his paintings reveal an exacting attention to subtle relations between lines, shapes, and colors. Mondrian hoped that his art would point the way to a utopian future in which the principles of universal harmony would be embodied in all facets of life and art. This goal was first formulated in Holland around 1916–17 by Mondrian and a small group of like-minded artists and architects. Collectively referred to as the De Stijl movement, their ideas have been extraordinarily influential on all aspects of modern design, from architecture and fashion to household objects.

Henri Matisse
French; 1869–1954

Interior at Nice, 1919 or 1920
Oil on canvas
132.1 x 88.9 cm (52 x 35 in.)
Gift of Mrs. Gilbert W. Chapman, 1956.339

Henri Matisse painted *Interior at Nice* in the Hôtel Méditerranée, a Rococo-style building he later fondly termed "faked, absurd, delicious!" It was the setting for many images he created of young women in the warm, silvery light of the Mediterranean. Present in many of these paintings are pink-tiled floors, a skirted dressing table with an oval mirror, a shuttered French window and its balcony, and patterned wallpaper. The Art Institute's variation on this theme is large and intricately composed, with a high viewpoint and a plunging, wide-angled perspective. The empty, shell-shaped chair in the foreground echoes the oval mirror, the flowers, and the scalloped motif at the top of the window. The picture on the wall duplicates the form of the woman on the balcony. All attention converges on this woman, who, her back to the sea, returns the observer's gaze.

Pinks, honeyed grays, silvery blues, and smoky corals all create a gently pulsating atmosphere of light and radiant warmth. The overpainting and loose, fluid brush strokes make the artist's process—his painterly choices—palpable to the viewer. These visible marks fix the momentary act of painting, just as the painting fixes on canvas the fleeting atmosphere of an afternoon in Nice. Matisse attempted here a kind of deliberate impressionism in which spontaneity is staged, atmospheric effects are carefully plotted, and a dramatic moment is knowingly enacted. The effect is emotionally fresh, yet formally perfect.

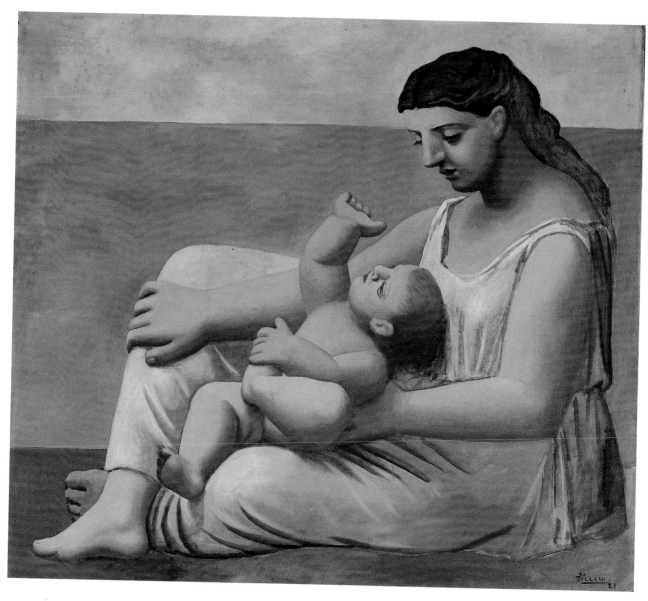

Pablo Picasso

Spanish; 1881–1973

Mother and Child (with fragment), 1921
Oil on canvas
142.9 x 172.7 cm (56 ¼ x 68 in.); fragment:
143.4 x 44.3 cm (56 ½ x 17 ½ in.)
Gift of Maymar Corporation, Mrs. Maurice L.
Rothschild, Mr. and Mrs. Chauncey McCormick;
Mary and Leigh Block Charitable Fund; Ada
Turnbull Hertle Endowment; through prior gift
of Mr. and Mrs. Edwin E. Hokin, 1954.270; frag-
ment: gift of Pablo Picasso, 1968.100

The extraordinary energy and creativity of Pablo
Picasso could not be contained by one style. In
1917 he was asked to go to Rome to design sets
and costumes for a ballet troupe. Deeply im-
pressed by the ancient and Renaissance art of
that city, he entered what is called his Classical
Period, during which he experimented with the
forms and styles of antiquity, from Etruscan
painting and Greek vases to Roman sculpture.

Between 1921 and 1923, Picasso produced at
least twelve variations on the mother-and-child
theme, all of which feature images of women
that are majestic in proportion and feeling. In
the Art Institute's work, an infant reclines on
his mother's lap and reaches up to touch her.
The mother, dressed in a simple gown with
Grecian folds, gazes intently at her child. Behind
them stretches a simplified background of sand,
water, and sky. Picasso's treatment of the mother
and child is not sentimental, but the relation-
ship of the figures expresses a serenity and sta-
bility that characterized his life at this time:
Picasso's first child, Paolo, was born in 1918 and
became a frequent subject for the artist.

Mother and Child was once longer, but
Picasso cut a portion from the painting's left
side. This fragment, which eventually entered
the museum's collection, depicts a seated male
nude. Originally, the figure's extended hand
dangled a fish over the child; Picasso painted
over this part of the composition when he re-
moved the left-hand section. While Picasso's
reasons for reworking the painting are unknown,
it is possible that he considered the figure on
the left superfluous to the central composition.

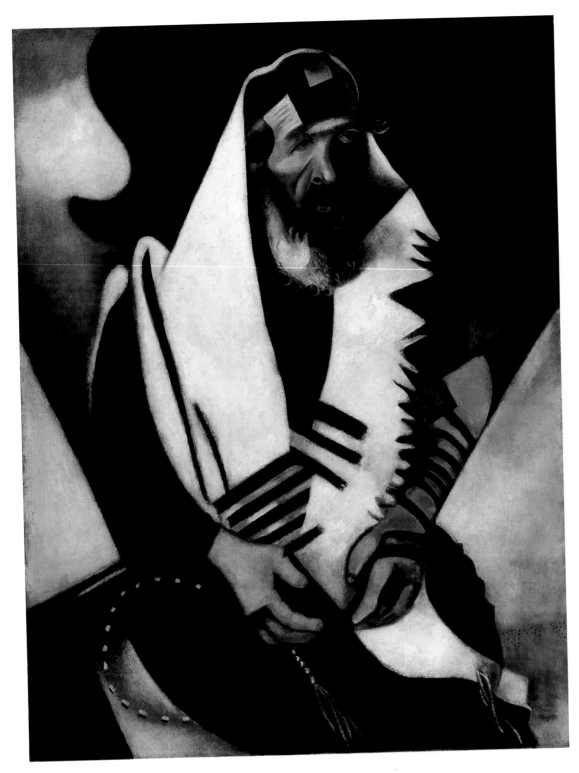

Marc Chagall
French, born Belarus; 1887–1985

The Praying Jew, 1923
Oil on canvas
116.8 x 84.9 cm (46 x 35 3/16 in.)
Joseph Winterbotham Collection, 1937.188

Living into his nineties, Marc Chagall had a prolific career that spanned more than eight decades of the twentieth century. Chagall's work often reflects influences of the contemporary movements he encountered in France and Germany: Fauvism, Cubism, Expressionism, and Surrealism. Yet his style was always distinctly his own. His fantastic and at times whimsical subjects and decorative lyricism reveal his love of Russian folk art and his roots in Hasidic Judaism.

It was not unusual for Chagall to paint variants or replicas of paintings he loved. The Art Institute's *Praying Jew* is one of three versions of this composition (the first version is in a Swiss private collection; a second is in the Museo d'arte moderna, Venice). He painted the original canvas in 1914 in his native Vitebsk (present-day Belarus). It accompanied him when he returned to Paris in 1923, and, before it left his possession, he painted the two other versions, which differ only in small details. In his autobiography, Chagall related how he paid an old beggar to put on his father's prayer clothes and pose for him. He limited his palette to black, white, and flesh tones, befitting the solemnity of the subject. The striking patterns, abstract background, and slightly distorted features of the old man show Chagall's absorption of modern tendencies, especially of Cubism. This moving portrayal stands out among Chagall's works for the simplicity of its execution and its particularly personal origins.

Joan Miró

Spanish; 1893–1983

The Policeman, 1925
Oil on canvas
248 x 194.9 cm (97 x 77 ¾ in.)
Gift of Claire Zeisler, 1991.1499

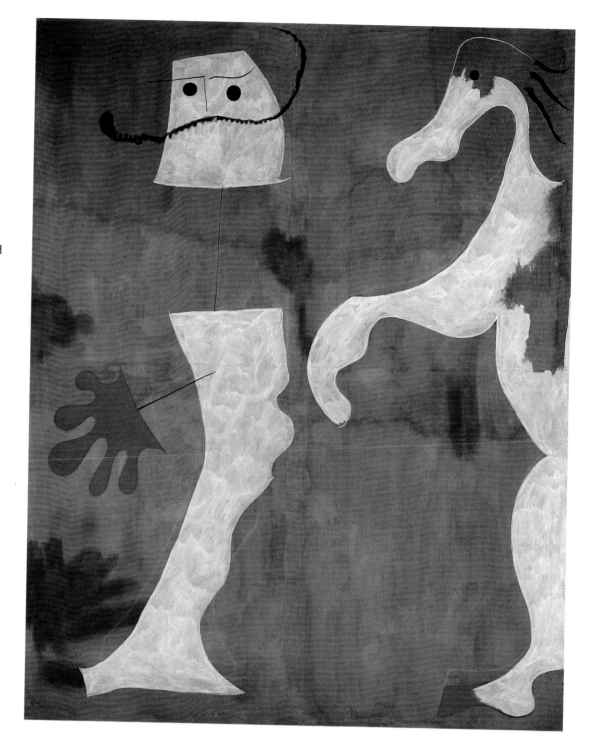

Soon after Catalan artist Joan Miró moved to Paris from his native Barcelona in 1920, he met avant-garde painters and writers who advocated delving into dreams and the subconscious in order to express a truer, greater realm of existence. To release images of this higher reality, the Surrealists ("sur" is French for "above"), as the artists and writers around the poet André Breton called themselves, embraced a spontaneous approach to their working method, a process of free association that they termed automatism.

Miró's experiments with automatism between 1925 and 1927 unleashed his imagination. "Even a few casual wipes in cleaning my brush," he exclaimed, "may suggest the beginning of a picture." The evocative Dream Paintings, as the works of this time have come to be known, straddle abstraction and representation to both haunting and hilarious effect. In *The Policeman*, a large composition from this group, two biomorphic, white shapes spring to life as a policeman and a horse, their forms defined by thinly applied paint against a splotchy, horizonless, ocher field. The policeman's features are defined with economy and wit: black circles demarcate the eyes; thin lines indicate the figure's eyebrows, nose, neck, and arm; a wavy line of black brush strokes becomes a flamboyant moustache. Rendered in a festive red, the hand at the end of his arm resembles a clown's glove. All of these details suggest that the painting's true subject is a circus clown impersonating a law-enforcement officer. The circus theme allowed Miró to ponder the irrational and improbable with delight and a simplicity of means, resulting in childlike qualities that belie a high level of sophistication.

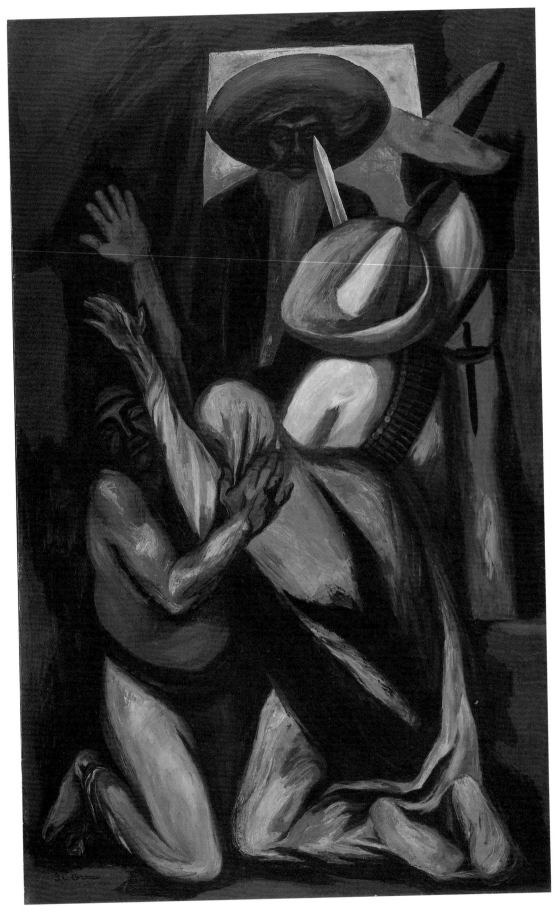

José Clemente Orozco
Mexican; 1883–1949

Zapata, 1930
Oil on canvas
178.4 x 122.6 cm (70 ¼ x 48 ¼ in.)
Gift of the Joseph Winterbotham Collection,
1941.35

José Clemente Orozco was a leader of the Mexican mural movement of the 1920s and 1930s, which was inspired by the Mexican Revolution of 1910–20. After an uproar over the murals depicting mass slaughter and up-heaval that he created for the Escuela Nacional Preparatoria in Mexico City, Orozco decided to seek work in the United States. It was during this self-imposed exile that he painted *Zapata*.

Emiliano Zapata was a revolutionary leader who struggled to return the enormous land holdings of the wealthy to Mexico's peasant population. After his death by ambush in 1919, he became a national hero. Framed here against a patch of bright sky glimpsed through the open doorway of a peasant hut, the specterlike figure of Zapata appears. Solemn and unmoved, he seems to stare beyond the drama before him of the two kneeling figures who, with outstretched arms, implore the soldiers to spare their lives. Such menacing details as the exaggerated peaks of the sombreros, the ammunition, and the weapons—especially the knife aimed at the eye of Zapata—symbolize the danger of the fight in which the revolutionaries engaged and the eventual deadly outcome for Zapata himself. The painting's dark reds, browns, and blacks evoke both the land that is being fought over and the bloodletting of the Mexican people. Orozco was ambivalent about the revolution; his vision of class struggle as inevitable, eternal, and hopeless explains the compassion, defiance, and despair expressed in this painting.

Georgia O'Keeffe
American; 1887–1986

Black Cross, New Mexico, 1929
Oil on canvas
99.2 x 76.3 cm (39 x 30 1/16 in.)
The Art Institute of Chicago Purchase Fund,
1943.95

Georgia O'Keeffe differed from other American pioneers of modernism in that she was trained entirely in the United States (including a brief period at The School of The Art Institute of Chicago). O'Keeffe first exhibited her work in 1916 at 291, the New York gallery established by photographer Alfred Stieglitz that was a forum for avant-garde European and American art. O'Keeffe soon joined the roster of American artists who became known as the Stieglitz Circle (O'Keeffe and Stieglitz were married in 1924). O'Keeffe lived to the age of ninety-eight, and, in spite of failing eyesight, worked almost until the end of her life. She is best known for her paintings of flowers and plants, enlarged beyond life-size and precisely painted with bold colors, as well as for her spare and dramatic images inspired by the landscape of the Southwest.

Black Cross, New Mexico dates from O'Keeffe's first visit to Taos, New Mexico, in the summer of 1929. She said that she saw many such crosses, spread "like a thin, dark veil of the Catholic Church . . . over the New Mexico landscape." The large, black shape in this canvas is probably one of the Penitente crosses, "large enough to crucify a man," that O'Keeffe described as having encountered during an evening walk in the hills. She painted the cross against the Taos mountains, with a vivid sunset below the object's horizontal arm. The somber cross—greatly enlarged so that even the nail heads are visible—adds an insistent abstraction to the scene. The power of an image such as this lies in the way O'Keeffe connected abstracted forms to nature and infused her natural forms with abstract and spiritual qualities.

Ivan Albright
American; 1897–1983

*Into the World There Came a Soul Called Ida
(The Lord in His Heaven and I in My Room
Below),* 1929–30
Oil on canvas
142.9 x 119.2 cm (56 ¼ x 46 ¹⁵/₁₆ in.)
Gift of Ivan Albright, 1977.34

Ivan Albright was born and lived most of his life
in Chicago. The Art Institute holds the largest
collection of any museum of paintings by this
artist. While Albright's unique style has been
called Magic Realism, it defies categorization.
His painstaking creative process, driven by his
need to meticulously record detail, involved de-
signing sets for his paintings and creating stud-
ies of models and props—even making diagram-
matic plans for colors. Albright's desire to pres-
ent the minutest subtleties of human flesh or
the tiniest elements of a still life often required
that he spend years on a single painting. His ex-
perience as a medical illustrator during World
War I is often cited as a determinant of his
later, haunting portrayals of aging and decay.

 Into the World There Came a Soul Called Ida
was begun in 1929 after Ida Rogers, then about
twenty years old, answered Albright's adver-
tisement for a model. Ida was an attractive,
young wife and mother, whom Albright trans-
formed into a sorrowful, older woman sitting in
her dressing room, her flesh drooping and the
objects surrounding her worn and bare. With
characteristic precision, the artist delineated
even the single hairs in the comb on the table.
The material lightness and precarious place-
ment of her possessions on the dressing table
and floor seem to symbolize the vulnerability of
the sitter. Ida gazes forlornly and poignantly
into the mirror and, with all the dignity she can
muster, powders her aging flesh.

Grant Wood

American; 1891–1942

American Gothic, 1930
Oil on beaverboard
74.3 x 62.4 cm (29 ¼ x 24 ⁹/₁₆ in.)
Friends of American Art Collection, 1930.934

Grant Wood's *American Gothic* caused a sensation in 1930, when it was exhibited for the first time at The Art Institute of Chicago and awarded a prize of three hundred dollars. Newspapers across the country carried the story, and the picture of the farm couple posed with a pitchfork before a white house brought instant fame to the artist. The Iowa native, then in his late thirties, had been enchanted by a simple Gothic Revival cottage he had seen in the small, southern Iowa town of Eldon. Wood envisioned a painting in which, as he put it, "American Gothic people . . . stand in front of a house of this type." He asked his dentist and his sister to pose as a farmer and his spinster daughter. The highly detailed, polished style and rigid, frontal arrangement of the two figures were inspired by Flemish Renaissance art, which Wood was able to study during three trips to Europe between 1920 and 1926. After returning to Iowa, he became increasingly appreciative of the traditions and culture of the Midwest, which he chose to celebrate in such works as this.

One of America's most famous paintings, *American Gothic* has become part of our popular culture, with the couple having been the subject of endless parodies. Wood was accused of satirizing in this work the intolerance and rigidity brought about by the insular nature of rural life—an accusation he denied. Instead, in *American Gothic* he created an image that epitomizes the Puritan ethic, virtues, and dignity that he believed defined the midwestern character.

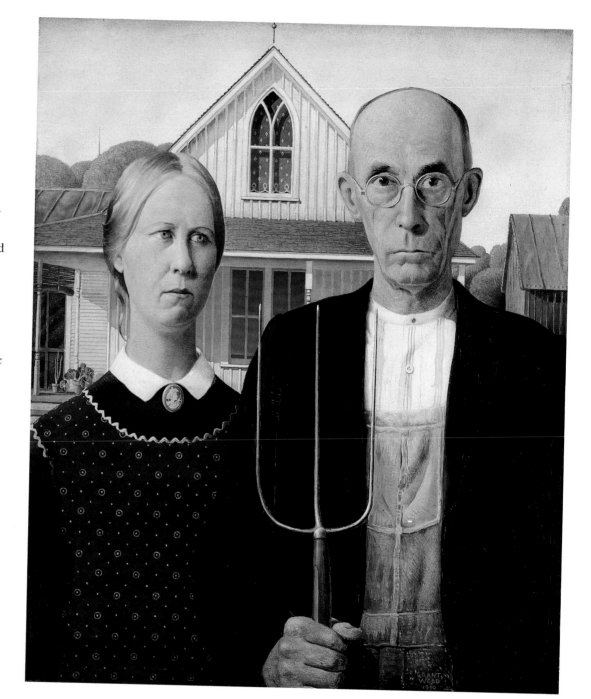

Arthur Dove
American; 1880–1946

Silver Sun, 1929
Oil and metallic paint on canvas
55.3 x 74.9 cm (21 ¾ x 29 ½ in.)
Gift of Georgia O'Keeffe for the Alfred Stieglitz
Collection, 1949.531

In 1912 Arthur Dove made news in New York City and Chicago when he exhibited ten pastels that were the first abstract works by an American to be seen by the public. Beginning with themes from nature, Dove had simplified and rearranged them, creating patterns, rhythms, and color harmonies that demonstrated how artists could dispense with representational subjects in order to communicate through form and color alone. From then on, Dove dedicated himself to exploring how he might depart from illusionism without abandoning nature.

Silver Sun reveals with particular clarity Dove's method of recasting nature into art. The artist's sense of wonder at the force and beauty of the world is apparent, but so is his control over his artistic means and, ultimately, over our aesthetic experience. Dove imparted a meta-physical radiance through expanding rings of blue and green, and through his use of glowing metallic-silver paint. He simplified, adjusted, and accented the landscape until the pulsating image no longer represented the thing seen but rather conveys feeling, impact, and meaning.

Dove remained committed to a personal vision. Nevertheless, he was well informed about current art trends, and a web of interconnections link his work to that of other artists. For example *Silver Sun* relates to the art of two of Dove's friends, painter Georgia O'Keeffe (see p. 129) and photographer Alfred Stieglitz: they, like Dove, sometimes depicted transcendent skies in order to communicate a vision of the wholeness of nature.

Charles Demuth

American; 1883–1935

And the Home of the Brave, 1931
Oil on composition board
74.8 x 59.7 cm (29 7/16 x 23 ½ in.)
Gift of Georgia O'Keeffe, 1948.650

Charles Demuth's still lifes and architectural studies displays astonishing technical skill and testify to the refinement with which he manipulated abstract design. In his paintings of the early 1930s, Demuth often interpreted the architecture in his hometown of Lancaster, Pennsylvania. Obviously not a literal representation of Lancaster, *And the Home of the Brave*—with its compressed and discontinuous space, emphasis on two-dimensional design, and rearrangement of observed facts into a new pictorial reality—is derived from Cubism. The accent on American urban and commercial forms acknowledges Demuth's native land: specifically, the double water towers at the apex of the composition are adapted from those atop a Lancaster cigar factory, while the number seventy-two at the lower edge of the painting refers to a state highway—the Manheim Pike— running north from town.

The ambiguous title of the work, *And the Home of the Brave*, is characteristic of Demuth's ironic temperament. Like other American artists and intellectuals of the early twentieth century, Demuth was simultaneously attracted to the vitality of contemporary civilization and the beauty and power of the machine, but conflicted about the inhuman aspects and utilitarian coarseness of the expanding industrial landscape of the United States.

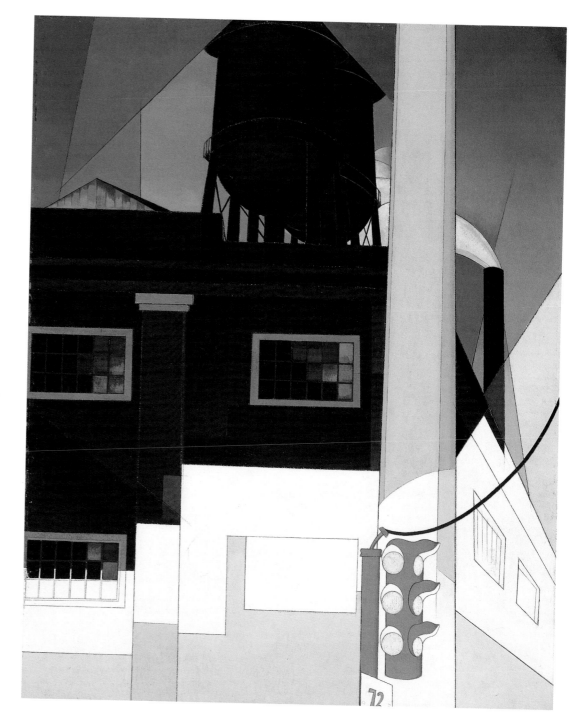

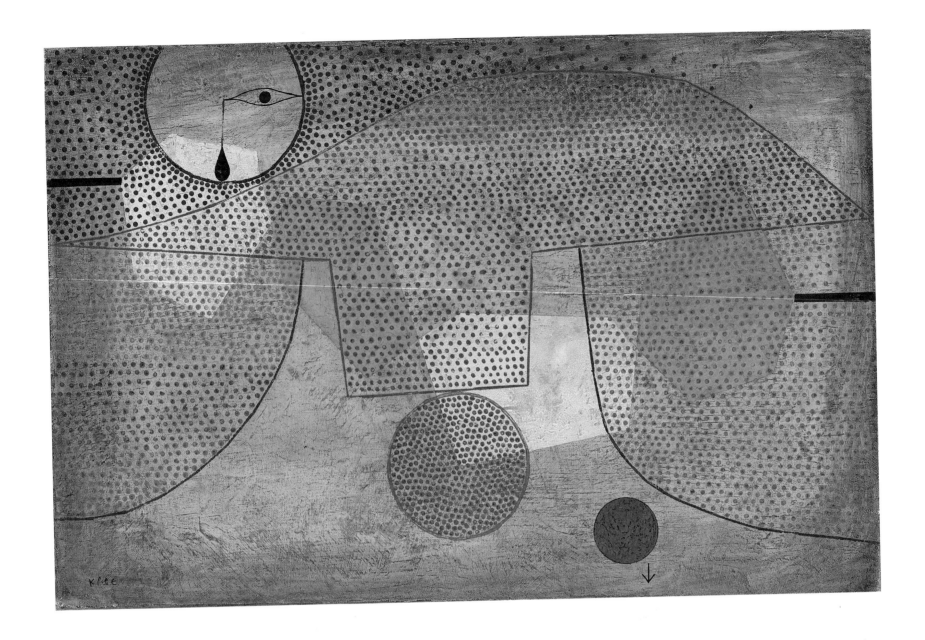

Paul Klee

German, born Switzerland; 1879–1940

Sunset, 1930
Oil on canvas
46.2 x 70.2 cm (18 ⅛ x 27 ⅝ in.)
Gift of Mary and Leigh B. Block, 1981.13

The imaginative and prolific Paul Klee worked in many media and styles, each of which he made unmistakably his own. After World War I, he was invited to join the faculty of the Bauhaus, the famed art school in Dessau, Germany. Klee resigned his position in 1931 and left Germany for good in 1933, after the Nazis came to power.

He spent his remaining years in his native Switzerland, struggling against an incurable skin disease that took his life in 1940. Klee's art—inventive, mystical, and technically masterful—and his great teaching skills made him one of the twentieth century's most important artists.

Sunset, like much of Klee's work, is small in scale and deceptively simple. His interest in primitive art and in the art of children, which he believed to be closer to the sources of creativity and to truthful expression than the conventional art of adults, is apparent in the composition's seeming straightforwardness. Over a neutral, loosely painted background,

Klee applied small dots of pigment to create an overall pattern of abstract shapes. An odd, schematic face in the upper left balances the small, red sun in the lower right; a quirky little arrow (a favorite device of Klee's to indicate lines of force) traces the sun's descent in the sky. Although hardly a conventional depiction of a sunset, Klee's composition evokes essential landscape elements—sky, water, horizon. As in all his work, using understatement, brevity, and wit, Klee created a microcosm that magically embodies life's great forces.

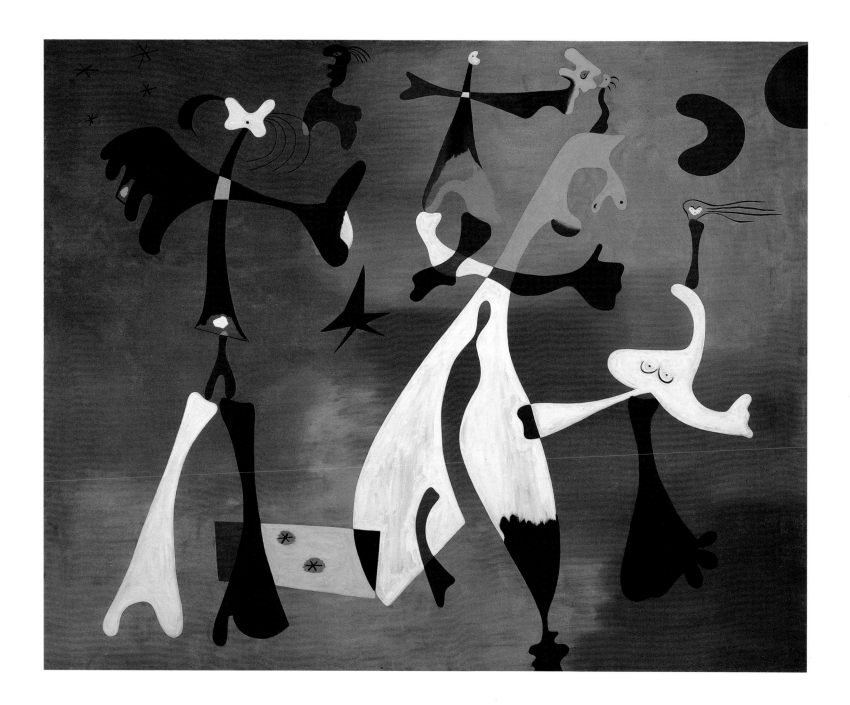

Joan Miró

Spanish; 1893–1983

Personages with Star, 1933
Oil on canvas
198.1 x 246.4 cm (78 x 97 in.)
Gift of Mr. and Mrs. Maurice E. Culberg, 1952.512

Gentle and poetic by nature, Joan Miró pursued his own course throughout his long career, from its early Cubist beginnings to the Surrealism (see p. 127) that characterizes his mature style.

Miró's particular brand of fantasy is often light-hearted, even whimsical; with dreamlike images, he attempted to capture expressions of the subconscious, rather than perceptions of the objective world. He rejected the notion that he ever painted an abstraction, maintaining instead that every element in his art is a sign of something that truly exists. Thus, one can "read" or decipher the artist's iconography, since certain symbols, such as the stars seen here, are frequently repeated and have constant referents.

Personages with Star is one of four cartoons for tapestries commissioned by the Paris collector Marie Cuttoli in 1933 to be fabricated at the famous French Aubusson tapestry works. At least one and possibly two tapestries were actually manufactured, one of which was definitely based on the Art Institute's painting. In this composition, figures gesture boldly and cavort among the stars. Playful and joyous, they seem to celebrate life on a cosmic plane.

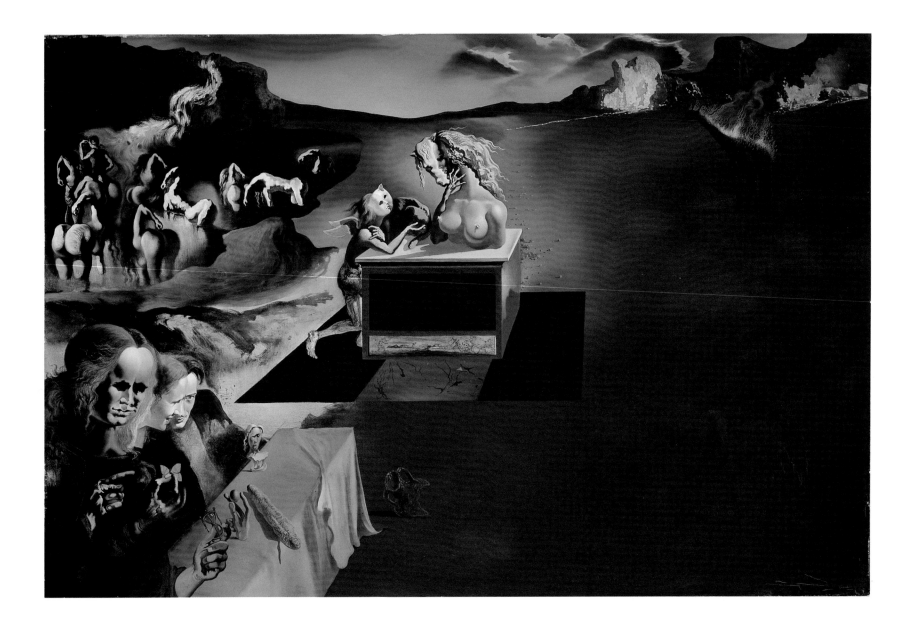

Salvador Dalí

Spanish; 1904–1989

Inventions of the Monsters, 1937
Oil on canvas
51.4 x 78.1 cm (20 ¼ x 30 ¾ in.)
Joseph Winterbotham Collection, 1943.798

Salvador Dalí, Surrealism's most publicized practitioner, created often-monstrous visions of a world turned inside out, which he made more compelling through his extraordinary technical skills. These qualities can be seen in his 1937 *Inventions of the Monsters*. After the Art Institute acquired the work, Dalí wrote to the museum:

[T]he apparition of monsters presages the outbreak of war. The canvas was painted . . . near Vienna a few months before the Anschluss and has a prophetic character. Horse women equal maternal river monsters. Flaming giraffe equals masculine apocalyptic monster. Cat angel equals divine heterosexual monster. Hourglass equals metaphysical monster. Gala and Dalí equal sentimental monster. . . .

While the artist's description is as enigmatic as the painting, it does help to decipher this bizarre but haunting work. Indeed, the specter of World War II loomed large after the Anschluss, Germany's annexation of Austria in March 1938. The painting is rife with threats of danger, from the menacing fire in the distance to the sibylline figure who holds an hourglass and gazes at a butterfly, both memento mori, or symbolic reminders of the transience of life. In their midst sit Dalí and his wife, Gala, the artist's muse, collaborator, and emotional anchor for much of his creative life. With his native Catalonia embroiled in the Spanish civil war, Dalí must have felt great anxiety as he surveyed a world without safe haven, a world that was indeed the invention of monsters.

Max Beckmann

German; 1884–1950

Self–Portrait, 1937
Oil on canvas
192.5 x 89 cm (76 x 35 in.)
Gift of Lotta Hess Ackerman and Philip E.
Ringer, 1955.822

Max Beckmann had a predilection for portraits
and, particularly, for self-portraits. He also fa-
vored such subjects as theatrical events, cos-
tume parties, carnivals, masked balls, and
grotesque charades; he himself wrote several
plays in the early 1920s. It seems, therefore, in
character that he presented himself in this
painting with so many aspects of the stage—
a masklike face, an evening-dress costume, a
theatrical pose.

This *Self-Portrait* was painted in Berlin in
1937, just before the German painter and his
wife were forced to flee because of the Nazis' in-
tensifying attack on artists, whose works were
labeled as "degenerate." Beckmann portrayed
himself here on the staircase of a hotel lobby.
Despite the elegance of his appearance and his
surroundings, he appears tense and isolated.
This is expressed in the position and size of his
body, filling the composition and pressing for-
ward toward the left, front edge of the picture
as if trapped; by his pale, inscrutable face, which
is withdrawn from us in half shadow; and by his
separation from the two figures in animated con-
versation, who are discernible behind a potted
plant on the landing. Beckmann's large, flat-
tened hands, inert against his black tuxedo,
imply the sense of helplessness and impending
doom he felt as a painter in Germany at this
time. This powerful image underscores the fact
that even the artist, as an observer of and com-
mentator on world events, is not immune from
them.

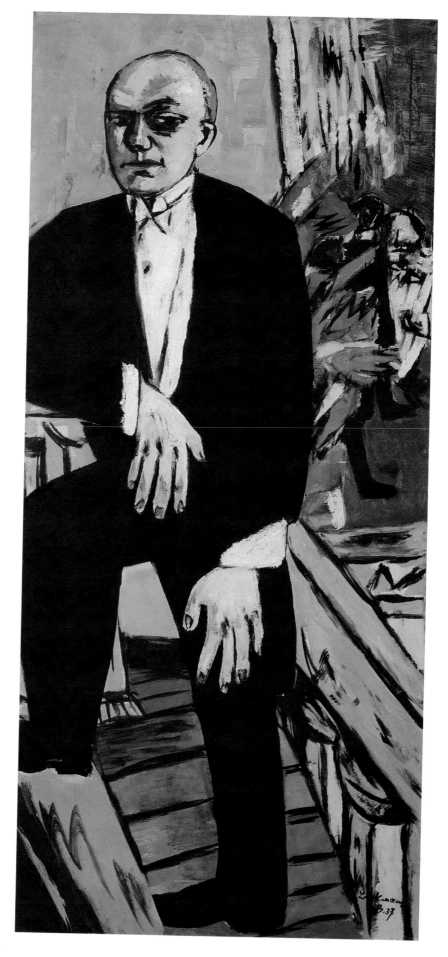

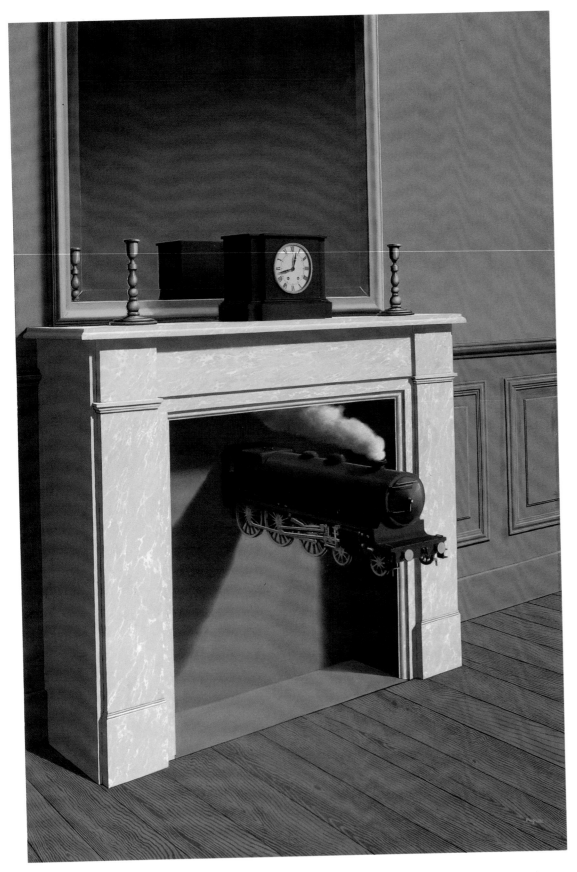

René Magritte

Belgian; 1898–1967

Time Transfixed, 1938
Oil on canvas
147 x 98.7 cm (57 ⅞ x 37 ⅞ in.)
Joseph Winterbotham Collection, 1970.426

Although conservative in his lifestyle, René Magritte developed an individual and eccentric manner of painting that evokes the world of the supernatural. Magritte eschewed the trance state sought by other members of the Surrealist group in their efforts to tap into the undercurrents of the subconscious mind. Rather, his precise, magical realism explored the poetry of shadows, the surprising affinities and disparities between people and things, and the profound absurdity of life. Magritte's personal brand of Surrealism was fashioned from commonplace objects whose altered sizes and surprising juxtapositions (inspired in part by Giorgio de Chirico's combination of disparate objects [see p. 118]) create an atmosphere of mystery and wonder.

In *Time Transfixed*, a metamorphosis has occurred: into the deep stillness of a sparsely furnished room, a tiny locomotive chugs incongruously out of the fireplace, emerging from the vent customarily used for a stovepipe. As the clock on the mantelpiece indicates, the time is precisely 12:43. Small in scale, the engine—its smoke efficiently and neatly disappearing up the chimney—represents no physical threat. It does, however, challenge the viewer's sense of order and notion of reality. The spectator is arrested by the very unexpectedness of the vision—unsure whether it is comic, fearsome, or miraculous—and time is indeed transfixed.

Matta (Roberto Matta Echuarren)

French; born Chile 1911 or 1912

The Earth is a Man, 1942
Oil on canvas
182.9 x 243.8 cm (72 x 96 in.)
Gift of Mr. and Mrs. Joseph Randall Shapiro
(after her death, dedicated to the memory of
Jory Shapiro by her husband), 1992.168

In 1937 the Chilean-born Matta left architecture, the field in which he had trained, for painting and became the youngest member of the Surrealist group. Matta's large, apocalyptic *The Earth is a Man* is the culmination of a project he

began in 1936 with a screenplay of the same title, written in tribute to the slain Spanish poet Federico García Lorca. Reflecting the play's threatening imagery and shifting perspectives, *The Earth is a Man* also elaborates upon previous compositions Matta called "Inscapes" or "Psychological Morphologies," in which turbulent forms serve as visual analogues for states of consciousness.

In this powerful, enigmatic work, forces of brilliant light seem to battle those of darkness, suggesting the chaos of both the creation and destruction of the world. Matta spilled, brushed, and wiped on vaporous washes of paint to ren-

der the invisible waves of energy that shape and dissolve a molten, primordial terrain. The painting's visual intensity evokes the tumultuous eruption of a volcano, such as one Matta had witnessed in Mexico in 1941. Exhibited shortly after its completion in New York City, where the artist had emigrated at the onset of World War II, the mural-sized canvas, with its abstract and visionary qualities, enthralled and influenced a new generation of American artists, who would come to be known as the Abstract Expressionists (see pp. 143, 148, 149).

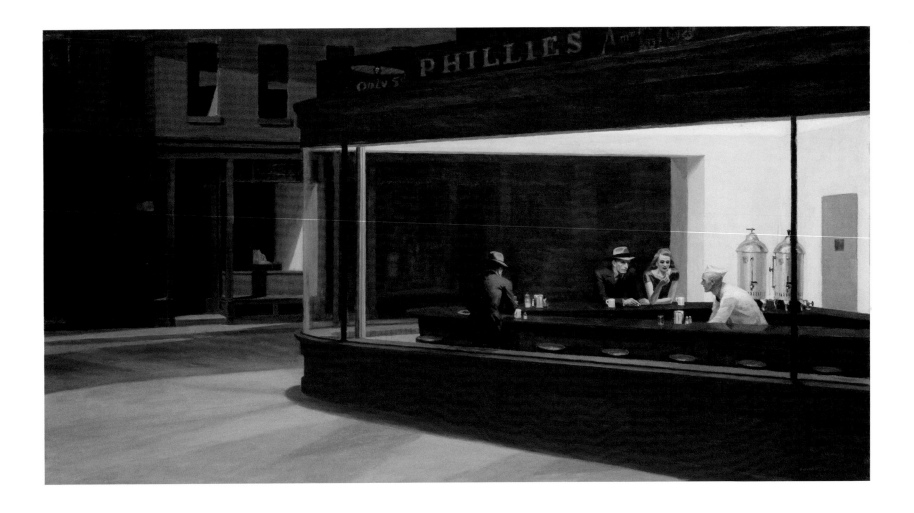

Edward Hopper
American; 1882–1967

Nighthawks, 1942
Oil on canvas
84.1 x 152.4 cm (33 ⅛ x 60 in.)
Friends of American Art Collection, 1942.51

In paintings of city streets, interiors, architectural exteriors, country roads, and the Atlantic coastline, Edward Hopper presented with clarity and forcefulness familiar aspects of American life, using a factual approach and dramatic lighting. The all-night diner in Hopper's *Nighthawks* has become one of the most famous images of twentieth-century American art. Hopper said the work was inspired by a "restaurant on New York's Greenwich Avenue where two streets meet." As is true of most of his paintings, the image is a composite, not a literal translation of a place: he simplified the scene and enlarged the restaurant.

The diner, an oasis of light on a dark corner, draws the viewer toward it. By eliminating any reference to an entrance, Hopper forced the viewer to observe the three customers and

waiter through the window. Sealed off by a seamless wedge of glass and lit by an eerie glow, the four anonymous, uncommunicative figures appear as separate from one another as they are from a passerby, evoking myriad questions about their lives that cannot be answered.

Hopper always maintained that he did not infuse his paintings with symbols of human isolation and urban emptiness. By leaving interpretation up to the viewer, however, he invited such speculation. The artist summed up the essential ambiguity of his urban images when he said, "*Nighthawks* seems to be the way I think of a night street. I didn't see it as particularly lonely Unconsciously, probably, I was painting the loneliness of a large city."

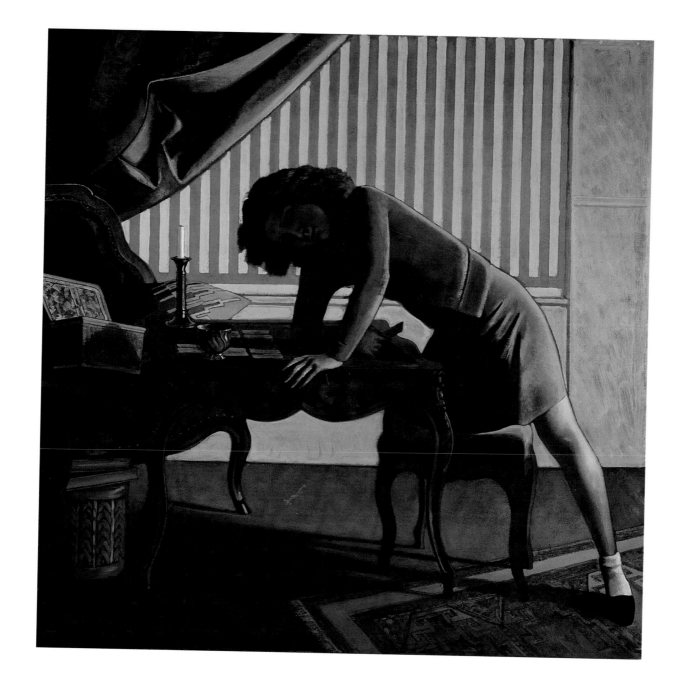

Balthus (Count Balthasar Klossowski de Rola)

French; born 1908

Solitaire, 1943
Oil on canvas
161.3 x 163.5 cm (63 ½ x 64 ⅜ in.)
Joseph Winterbotham Collection, 1964.177

A reclusive artist who rarely allows himself to be photographed or interviewed, Balthus was born into an educated, artistic, but impoverished family of Polish aristocrats who had fled political and economic turmoil to settle in Paris. He received little formal schooling; this permitted him to develop a deeply personal artistic vision, aided by copying Old Master paintings in museums in Paris and churches in Italy. In 1933 Balthus began producing work in his characteristic style. His erotically charged paintings—with their solidly modeled figures, especially young girls lost in reveries, placed in modestly decorated interior spaces—caused a scandal when first exhibited.

Balthus spent most of World War II in Switzerland, where in 1943 he painted one of his masterpieces, *Solitaire.* The composition shows an adolescent girl playing the card game solitaire. The striking posture of the figure—taut and contemplative as she bends over the table—is one Balthus had used in a number of earlier works. The counterpoint created by the insistent verticals of the patterned wallpaper against the diagonal of the girl's back, and by the mysterious expression of her shadowed face in contrast to the strong, raking light that defines her delicate, long fingers and her left leg, produce an unsettling emotional tenor. This tension has been alternatively interpreted as an adolescent's repressed sexual energy, and as a metaphor for the restlessness of refugees such as Balthus, waiting out World War II.

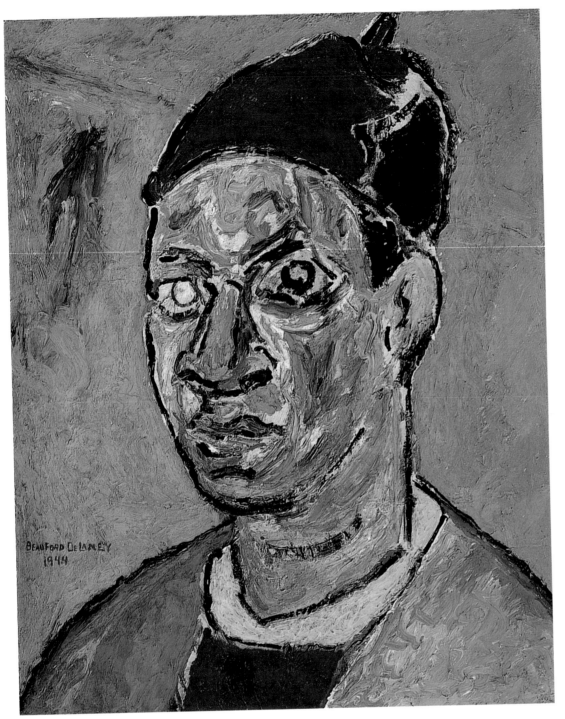

Beauford Delaney
American; 1901–1979

Self-Portrait, 1944
Oil on canvas
68.6 x 57.2 cm (27 x 22 ½ in.)
Restricted gift of Alexander C. and Tillie S. Speyer Foundation; Samuel A. Marx Endowment, 1991.27

The son of an itinerant Tennessee preacher, Beauford Delaney studied art in Boston before settling in New York City in 1929. Supporting himself as a bellboy and janitor, he began to produce a compelling and unconventional body of work. Initially, he concentrated on painting portraits, including those of prominent African Americans of his day. By the 1940s, his subjects had expanded to street scenes of his Greenwich Village neighborhood and experiments in abstraction dominated by thickly impastoed, swirling rhythms.

In the Art Institute's *Self-Portrait* of 1944, Delaney freely and liberally applied reds, blues, and yellows tinged with green, revealing his increasing interest in expressionism and abstraction. Representative elements—the artist's face, jacket, sweater, and trademark knit hat—are broken down into sections of color; these vivid, richly textured areas seem barely contained within their black outlines. Dominating the bright, thick patches of color is Delaney's intense gaze. His piercing look, coupled with brushwork that at times feels almost tortured, suggests profound discomfort and inner struggle.

In 1953 Delaney traveled to Paris, where he settled permanently. By 1960 museums and galleries throughout Europe were showing his abstract works. Recognition came more slowly in his native land, where Delaney, and a number of other African American abstractionists, were excluded until recently from histories and exhibitions of American modernism.

Jackson Pollock
American; 1912–1956

The Key, 1946
Oil on canvas
149.9 x 215.9 cm (59 x 85 in.)
Through prior gift of Mr. and Mrs. Edward Morris, 1987.261

Born in Cody, Wyoming, Jackson Pollock moved to New York in 1930. *The Key* belongs to Pollock's early Accabonac Creek series, named for a stream near the farmhouse that he and his wife, the painter Lee Krasner, purchased in East Hampton, Long Island, in late 1945. Pollock used an upstairs bedroom as a makeshift studio, painting *The Key* on a canvas spread on the wooden floor. In fact the impress of the floorboards is still visible across the canvas.

Strongly influenced by psychoanalysis and the Surrealist practice of automatism (see p. 127), Pollock's method allowed him to release and capitalize upon his particularly intense, restless energy. The painting's swarm of vibrantly colored, totemic shapes and fragments seems barely contained within the frame. Technically unorthodox, Pollock applied pigment to the canvas not only with brushes but also with trowels; he squeezed paint directly from tubes to create *The Key*'s vestigial figures, triangles, and arcs; and he left many areas of the canvas bare.

Works such as *The Key* played a pivotal role in the development of Pollock's art. The swirls of roughly applied pigment in the upper-right corner would evolve within a year into the "all-over" abstractions of his famous "drip" paintings. In these daring works, the process of painting became primary, expressing the power of spontaneous action and chance effects. Thus, Pollock broke with existing conventions, offering his peers and subsequent generations of artists entirely new realms of creative possibilities.

Arshile Gorky

American, born Armenia; 1904–1948

The Plow and the Song, 1946
Oil on canvas
128.9 x 153 cm (50 ¾ x 60 ¼ in.)
Mr. and Mrs. Lewis Larned Coburn Fund,
1963.208

Arshile Gorky's unsettled childhood in Armenia (he moved to the United States in 1920) would be followed by tragedy in later years. A fire in 1946 destroyed much of the work in his Connecticut studio. He survived a serious cancer operation, only to suffer an automobile accident in 1948 that left his painting arm paralyzed. In that same year, the artist took his life.

Always interested in avant-garde European art, Gorky experimented with a variety of styles. Young artists such as Gorky working in New York City were particularly stimulated by the European Surrealists, many of whom moved to the city before and during World War II and whose circle Gorky joined. The 1940s, especially between 1944 and 1947, marked the creation of Gorky's most important work, produced in a kind of stream-of-consciousness, or "automatic"

manner of painting. *The Plow and the Song* reflects the artist's indebtedness to the lyrical Surrealism of Joan Miró (see pp. 127, 135), but the sketchy handling of paint, translucent color, and tumbling pile of forms are hallmarks of Gorky's mature work. A delicate line darts like a needle, stitching together the fragments of the image into a cohesive whole. Deeply earthbound and yet lyrical and poetic, the painting is at once a still life, a landscape, and a fantasy.

Jean Dubuffet

French; 1901–1985

Supervielle, Large Banner Portrait, 1945
Oil and mixed media on canvas
130.2 x 97.2 cm (51 ¼ x 38 ¼ in.)
Gift of Mr. and Mrs. Maurice E. Culberg,
1950.1367

In 1923 Jean Dubuffet encountered a book by
the Swiss physician Hans Prinzhorn, *Bildnerei
der Geisteskranken (The Art of the Insane)*
(Berlin, 1923). Prinzhorn pointed out the con-
nections between primitive art, the drawings
of children, and images produced by the men-
tally ill, suggesting an underlying creative im-
pulse in man that can be easily destroyed by the
refinement and demands of "high culture." Art
Brut (raw art), as Dubuffet called this kind of
work, had a great impact on him and became a
lifelong interest.

In his early compositions, Dubuffet painted
with simple, childish scrawls, with no hint of
perspective or modeling. As his work evolved,
he built coarse surfaces from such unorthodox
materials as gravel, sand, chalk, and string.
After scandalizing the Paris art world with his
deliberately ugly images, in the 1940s Dubuffet
did a number of portraits of artists and intellec-
tuals he knew. Jules Supervielle, a poet and
playwright from South America, is the subject
of the Art Institute's painting. Worked into a
thick, impasto background that resembles
scorched earth, the image of the writer is most
unflattering. The artist achieved the outline of
the head with whitish pigment that he ladled on
and scraped off. He sketched in Supervielle's
jowly chin and withered cheeks with crude,
black lines. In this series of portraits, Dubuffet
depicted oversized heads and accentuated cer-
tain physical features, such as Supervielle's
long, pointed nose, in part to deflate the preten-
sions of the intellectual elite.

Jacob Lawrence
American; born 1917

The Wedding, 1948
Tempera on board
50.8 x 61 cm (20 x 24 in.)
Gift of Mary P. Hines in memory of her mother,
Frances W. Pick, 1993.258

"I paint the things I have experienced," Jacob Lawrence stated. Raised in Harlem, Lawrence studied at various federally funded, community cultural centers and art workshops, where his talent was quickly recognized. The young artist soon applied his bold, unique style to the creation of narrative cycles devoted to African

American history, leaders, and life. His sixty-panel *Migration* series (1940–41), depicting the resettlement of blacks from the rural South to the industrial North in the first half of the twentieth century, debuted in 1941 at the prestigious Downtown Gallery, New York. This exhibition made the artist, then only in his early twenties, one of the first African Americans to be represented by a New York gallery. The cycle was acquired later by The Museum of Modern Art, New York, and the Phillips Collection, Washington, D.C.

In addition to his series, Lawrence has also executed individual genre scenes, such as *The Wedding*, throughout his long career. With its

bright, flat colors, bold patterning, and economical, yet suggestive, forms, this vibrant 1948 composition shows a bride and groom, flanked by two attendants, standing before a stern-faced minister. This arrangement makes the viewer, like the attendants, a participant in a major life event. Befitting both the solemnity and joy of a wedding, the composition combines the symmetrical rigidity of the standing figures with a riotous profusion of intensely colored stained-glass panels and flowers. *The Wedding* demonstrates well what one writer described as Lawrence's unwavering commitment "to make his subject a testament, an expression of his belief in [humanity's] continuing strength."

Peter Blume

American, born Russia; 1906–1992

The Rock, 1944–48
Oil on canvas
146.4 x 188.9 cm (57 ⅝ x 74 ⅜ in.)
Gift of Edgar Kaufmann, Jr., 1956.338

Unlike the Surrealism practiced by many Europeans, with its preponderance of sexual motifs and dreamlike images, the unique brand of Surrealism of Peter Blume, one of the first American artists to embrace the movement, was based on the juxtaposition of disjunctive and unrelated objects and figures, all rendered in an accomplished and painstaking technique that echoes northern European painting of the fifteenth and sixteenth centuries. Blume typically labored tirelessly over his paintings, creating many sketches, which explains the relative rarity of large-scale works by the artist.

Although Blume's deeply personal iconography eludes clear interpretation, images of decay and rebirth occur again and again, especially in response to the aftermath of World War II. In *The Rock,* a group of men and women, perhaps representing humankind, is shown in the process of rebuilding civilization out of its own destruction. They labor at the task of cutting the stone for the new structures that are to be raised on the rubble of the old. Looming above the figures is a monumental rock, scarred and blasted, yet enduring, itself a symbol of humanity's tenacity and capacity to survive. At the left rises a scaffold, a clear indication of hope in the future. Interestingly, the building under construction represents Frank Lloyd Wright's famous Falling Water residence of 1936, which the original owners of *The Rock,* Liliane and Edgar Kaufmann, commissioned; their son, Edgar Kaufmann, Jr., donated the painting to the Art Institute in 1956.

Willem de Kooning

American, born the Netherlands; 1904–1997

Excavation, 1950
Oil on canvas
206.2 x 257.3 cm (81 3/16 x 101 5/16 in.)
Mr. and Mrs. Frank G. Logan Purchase Prize;
Gift of Mr. and Mrs. Noah Goldowsky and Edgar
Kaufmann, Jr., 1952.1

Willem de Kooning belonged to a group of artists in New York City whose work took shape in the 1940s and 1950s with such vitality and originality that, for the first time, the United States was regarded as a major source of mod-ern art. Each member of the group, called the Abstract Expressionists or the New York School, had his or her own characteristic imagery, but all shared an interest in the nature of the creative process and the role of the subconscious in it.

By 1950, when he executed this painting, the Dutch-born de Kooning had developed his personal style, with its expressive brushwork and distinctive organization of space into loose, sliding planes with open contours. In *Excavation* coarse and wispy black lines appear to define anatomical parts—bird and fish shapes, human noses, eyes, teeth, jaws, necks. The forms seem to writhe in a joyous, almost orgiastic, dance across the surface, while flashes of red, blue, yellow, and pink punctuate the composition. Aptly named, *Excavation* ac-knowledges the months de Kooning spent building up and scraping down the canvas's paint layers. Now recognized as a great work, the painting inspired much debate among Chicagoans when it was acquired by the mu-seum in 1952, revealing that the public was not yet prepared for such a bold, monumental statement of abstract art.

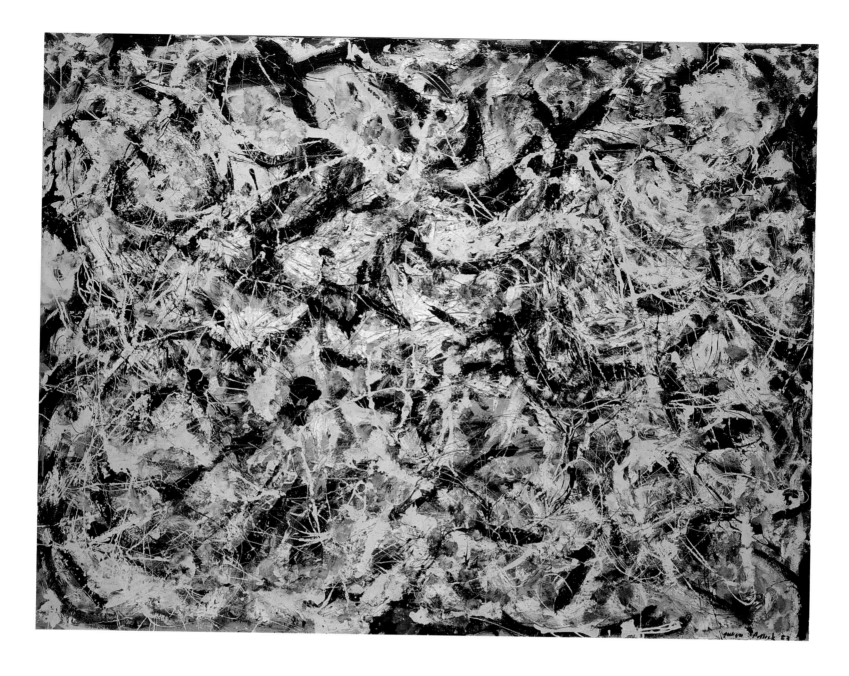

Jackson Pollock
American; 1912–1956

Greyed Rainbow, 1953
Oil on canvas
182.9 x 244.2 cm (72 x 96 ⅛ in.)
Gift of the Society for Contemporary Art,
1955.494

Following the lead of the Surrealists, many of whom were living in New York City during World War II, Jackson Pollock began to experiment with automatic painting, allowing accident and intuition to play a role in determining his compositions (see p. 143). The network of drips, splatters, and lines that animates the surfaces of his compositions was meant to reveal the artist's subconscious mood and led to the term Action Painting. As Pollock abandoned figuration altogether, his art began to emphasize even more the expressive power of the artist's gestures, materials, and tools (he often used sticks, trowels, and palette knives instead of brushes). He challenged the concept of easel painting by working on large canvases placed either on the floor or fixed to a wall. With no apparent beginning or end, top or bottom, his paintings imply an extension beyond the edges of the canvas and are thus no longer separate and self-contained objects. Rather, they engulf the spectator and his or her space.

In *Greyed Rainbow,* a work from Pollock's last years, the viewer is swept into the illusion of a shallow field in which splashes of black and white coil and intertwine, retract and expand in a dizzying fashion. From this turmoil, delicate colors emerge in the lower third of the composition, much as a rainbow peeks through storm clouds, contributing to this painting's particularly lyrical feeling.

Mark Rothko
American, born Russia; 1903–1970

Untitled (Purple, White, and Red), 1953
Oil on canvas
197.5 x 207.6 cm (77 ¾ x 81 ¾ in.)
Bequest of Sigmund E. Edelstone, 1983.509

Like a number of New York artists in the 1940s and 1950s, Mark Rothko became deeply interested in ancient myths and various religious practices. Initially, he filled his compositions with figurative content influenced by Surrealism, but, toward the end of the 1940s, he began to dematerialize his canvases into the veils of shimmering color for which he was to become well known. By directly staining the fabric of the canvas with many thin washes of pigment and by paying particular attention to the edges where the fields of color interact, he achieved the effect of light radiating from the image itself. This technique suited Rothko's metaphysical aim: to offer painting as a doorway into purely spiritual realms and to make it as immaterial and evocative as music.

Untitled (Purple, White, and Red) follows the characteristic format of Rothko's mature work, according to which three stacked rectangles of color appear to float within the boundaries of the canvas. Although Rothko limited his palette, he did not use color in an overtly symbolic way. Rather, he meant to draw the viewer into a state in which a multitude of associations and meanings can flourish. For many the planes of color might suggest luminous mists hovering over a landscape; for others the muted, mysterious atmosphere could lead to a state of spiritual reflection. The painting's large scale, sensuous palette, and sense of spatial expansion immerse the viewer in an all-encompassing visual experience.

Francis Bacon

English, born Ireland; 1909–1992

Figure with Meat, 1954
Oil on canvas
129.9 x 121.9 cm (51 ⅛ x 48 in.)
Harriott A. Fox Fund, 1956.1201

Surrealism was an early influence on the self-taught painter Francis Bacon, but philosophical and literary sources provided more significant stimuli, especially the bleak visions of Friedrich Nietzsche and T. S. Eliot. Like many of the generation that lived through the rise of fascism and World War II, Bacon came to believe that life is meaningless and that each person must confront the void of meaning in order to wrest any significance out of existence. In his powerful, nihilistic works, tortured and deformed figures become players in dark dramas for which there appear to be no resolution.

Bacon often referred in his paintings to the history of art, interpreting borrowed images through his own tormented vision. *Figure with Meat* is part of a series he devoted to Diego Velázquez's *Portrait of Pope Innocent X* (c. 1650–51; Rome, Galleria Doria-Pamphili). Here he transformed the Spanish Baroque artist's elegant portrayal here into a nightmarish image, in which the blurred figure of the pope, seen as if through a veil, seems trapped in a glass-box torture chamber, his mouth open in a silent scream. Instead of the noble drapery that frames Velázquez's pope, Bacon framed his figure with two sides of beef, quoting the work of the seventeenth-century Dutch artist Rembrandt van Rijn and of the twentieth-century Russian artist Chaim Soutine, both of whom painted brutal and haunting images of raw meat. The painting's masterful execution and monumental concept add to its profoundly disturbing effect.

Joan Mitchell
American; 1926–1992

City Landscape, 1955
Oil on canvas
201.9 x 201.9 cm (79 ½ x 79 ½ in.)
Gift of the Society for Contemporary American
Art, 1958.193

Joan Mitchell's large, airy paintings have always been anchored in landscape and in the particularities of place. Born and raised in Chicago (her mother was Marion Strobel, coeditor of the pioneering *Poetry* magazine), Mitchell settled in New York City in 1950, just as the first generation of Abstract Expressionists was emerging. The gestural brushwork of Willem de Kooning (see p. 148) particularly impressed her. Soon Mitchell was painting big, light-filled abstractions animated by loosely applied skeins of bright color, work infused with the energy and excitement of a large metropolis.

In the Art Institute's composition, a tangle of pale pink, scarlet, mustard, sienna, and black hues at the center threatens to coagulate or erupt. The painting's title, *City Landscape*, suggests that this ganglia of pigments is meant to evoke the nerves or arteries of a city. Stabilizing this energized center are the white, roughly rectangular forms of fore- and background, modulated with touches of gray and violet, which resemble blocks of buildings that channel the street activity surging between and around them.

The sense of spontaneity conveyed in *City Landscape* belies Mitchell's painting methods. Unlike many of her contemporaries who were dubbed Action Painters, because their work literally seems to have recorded their energetic movements as they painted, Mitchell worked slowly and deliberately. "I paint a little," she said. "Then I sit and look at the painting, sometimes for hours. Eventually, the painting tells me what to do."

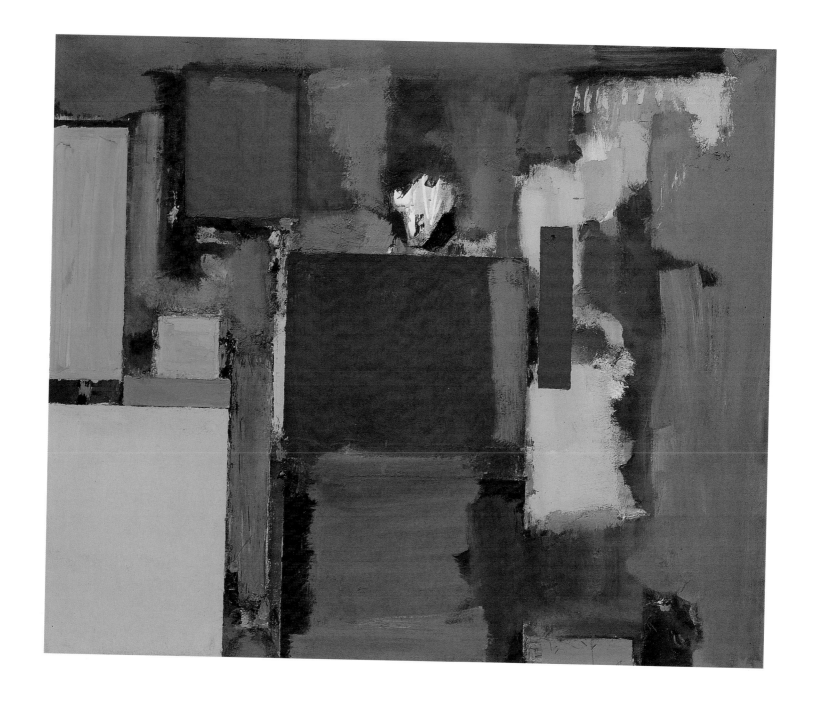

Hans Hofmann

American, born Germany; 1880–1966

The Golden Wall, 1961
Oil on canvas
151 x 182 cm (59 ½ x 71 ⅞ in.)
Mr. and Mrs. Frank G. Logan Prize Fund,
1962.775

The German-born painter Hans Hofmann was as much revered for his gifts as a teacher as for his brilliantly colored, richly painted canvases. In Munich during World War I, he operated his own art school. He came to the United States in 1930 to teach in California; in 1932 he settled in New York City, where he opened another art school. Hofmann subsequently founded a summer program in Provincetown, Massachusetts, in 1934. Truly creative expression, Hofmann believed, emerges from the translation of subjective states into "pure" form. This teaching influenced a generation of American abstract artists.

The chief distinguishing characteristic of Hofmann's art is the opulence of his painted surfaces. His work became increasingly abstract over his career, culminating in paintings that combine flat, floating rectangles with expressionistic brushwork. *The Golden Wall* for example unites various brightly hued rectangles against a ground that is primarily orange, red, and yellow. The rectangles emphasize the two-dimensionality or wall-like aspect of the canvas, while the more loosely brushed areas demonstrate the illusionistic, space-creating capabilities of painting. The true subject of *The Golden Wall* is the sensuousness of the paint itself— thick or thin, opaque or scumbled, but always left in its purest, most color-saturated state.

Clyfford Still

American; 1904–1980

Untitled, 1958
Oil on canvas
292.2 x 406.4 cm (114 ¼ x 160 in.)
Mr. and Mrs. Frank G. Logan prize fund; Roy J.
and Frances R. Friedman Endowment; through
prior gift of Mrs. Henry C. Woods; gift of Lannan
Foundation, 1997.164

Like many of the Abstract Expressionists with
whom he is linked, Clyfford Still wished his art
to express a sense of the sublime, or, as he put
it, "to achieve a purpose beyond vanity, ambition,
or remembrance." To reach this liberating spiri-
tual state, Still gradually stripped his art of figu-
rative referents and geometric forms until, by
the late 1940s, color became his primary vehicle
of expression. (He also resisted naming his
paintings, believing that the associations sug-
gested by titles might limit the spectator's free-
dom to experience his art fully.)

The result, as seen in the Art Institute's
monumental painting, was a radically new con-
ception of pictorial space: that of sheer ex-
panses of color. The viewer feels overwhelmed
by a seemingly boundless realm of pigment, a
sense of the infinite that is reinforced by the ap-
parently arbitrary cropping at the edges of the
canvas. Heavily impastoed, darkly drenched
fields of color cascade in jagged configurations,
separated here and there by areas of bare can-
vas, white paint, or slashes of bright hues. These
matte encrustations of paint have the huge scale
and weight of landscape forms — crags and
fissures, mountains and valleys — while their
upward expansion suggests transcendence.
The artist, however, disavowed all associations
for his work. "I never wanted . . . images to be-
come shapes," he proclaimed. "I wanted . . . all
[color, texture, image] to fuse together into a
living spirit."

Gerhard Richter
German; born 1932

Woman Descending the Staircase, 1965
Oil on canvas
200.7 x 129.5 cm (79 x 51 in.)
Roy J. and Frances R. Friedman Endowment; gift
of Lannan Foundation, 1997.176

Throughout his career, Gerhard Richter has alternated between figuration and abstraction, maintaining his characteristic emotional reserve and consummate skill in both modes. *Woman Descending the Staircase* is one of Richter's Photo Paintings, the earliest phase in his important body of figurative works. In these the artist enlarged and transferred onto canvas ordinary, found photographs, such as personal snapshots or images drawn from the media, which he occasionally highlighted with a tint of color. He then blurred the image, sometimes by dragging a dry brush over wet pigment, which allowed his forms to remain elusive. In this painting of an unknown, glamorously dressed woman descending a set of stairs, the blurring suggests floating motion, as if the artist has captured his model in mid-air. The work's glossy, silver-blue brushwork suits the elegance of the subject, with her glistening evening gown and diaphanous scarf.

The composition's subject and title evoke Marcel Duchamp's *Nude Descending a Staircase* (1912; Philadelphia Museum of Art). When it was exhibited at the 1913 Armory Show, this radical abstraction of a female figure shocked Americans accustomed to artistic conventions of female beauty. Rather than honoring this talisman of modernism, Richter invoked the reference as a kind of protest. He objected to Duchamp's painting because he "could never accept that it had put [an end], once and for all, to a certain kind of painting." Indeed, in the Art Institute's work, Richter deliberately fashioned a hauntingly beautiful, if nostalgic, image. The very beauty of his subject and his painting makes it an allegory for the desirability of representation.

Roy Lichtenstein
American; 1923–1997

Brushstroke with Spatter, 1966
Oil and magna on canvas
172.7 x 203.2 cm (68 x 80 in.)
Barbara Neff Smith and Solomon Byron Smith
Purchase Fund, 1966.3

The artists who participated in the Pop Art movement elevated commonplace, everyday aspects of modern industrial society to the status of "high art," and interpreted them with wit, detachment, and objectivity (see also p. 158). One of the early leaders of the movement, which reached its zenith in the 1960s, was Roy Lichtenstein. Lichtenstein's paintings of comic-strip and advertising scenes on themes of love and war and his series on great works of art— from Greek temples to the work of Picasso— all express his fascination with the mass reproduction of images.

In *Brushstroke with Spatter*, Lichtenstein parodied Abstract Expressionism, the style with which he began his career. The individual brush strokes and accidental splatters of paint elevated by Abstract Expressionists as full of individual emotion and content, are presented here as if they were magnified details from a commercial photographic reproduction of a painting by the likes of Jackson Pollock (see pp. 143, 149). By using a background of enlarged Ben Day dots (invented to add tone to a mechanically printed image) and outlining the smoothly rendered strokes and splatters in black, the artist removed all records of his own hand from this work. Lichtenstein thereby withdrew any reference to his art as an expression of himself and called into question such issues as the meaning of the creative process, of reproduction, and of the work of art itself.

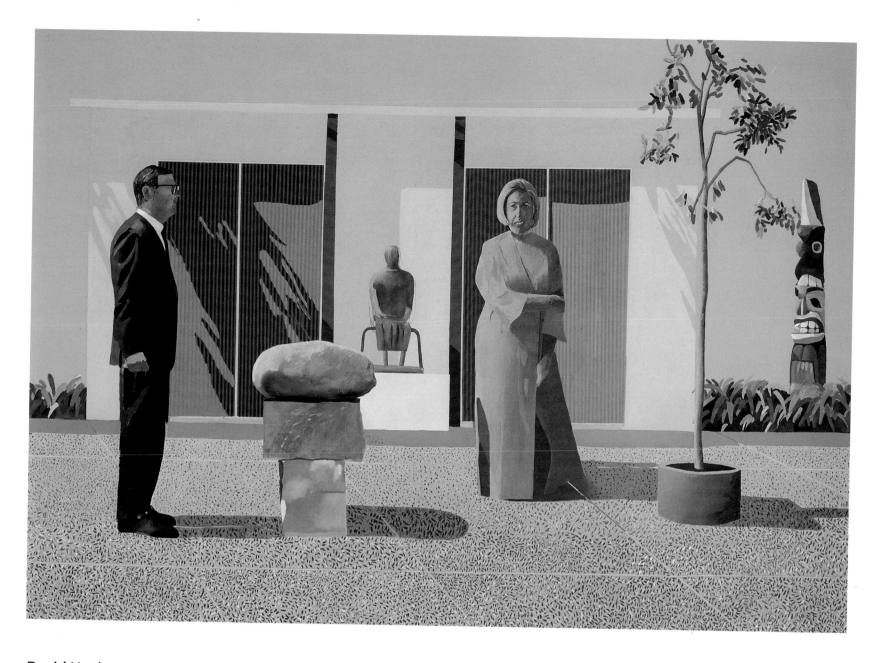

David Hockney
English; born 1937

American Collectors, 1968
Acrylic on canvas
213.4 x 304.8 cm (83 ⅞ x 120 in.)
Restricted gift of Mr. and Mrs. Frederic G. Pick,
1984.182

As a painter, printmaker, set designer, and photographer, David Hockney is one of the most versatile and inventive artists of the postwar era. He was born and trained in art in England, and lived in London, Paris, and New York before settling in Los Angeles in 1964. For the last quarter century, his canvases have reflected the sun-washed flatness and bright colors of the southern California landscape.

In the late 1960s, Hockney painted a number of double portraits of friends and associates, including *American Collectors*. This not entirely flattering portrait depicts Los Angeles patrons Fred and Marcia Weisman, who amassed a significant collection of contemporary art. Standing straight and still in a stage-like pictorial space, the two figures and the objects around them are struck by a brilliant, raking light that flattens and abstracts them. While their placement in the composition seems stilted and arbitrary, it is actually quite revealing. The collectors are situated on a ter-

razzo deck, where some of their art collection is displayed. With his formal suit, rigid pose, and clenched fist, Fred Weisman echoes the intense William Turnbull sculpture in front of him. The manner in which Marcia Weisman holds her arms is similar to the Henry Moore sculpture behind her, in the center of the composition, and the expression on her face is mirrored by the totem pole at the far right. By depicting the Weismans almost as if they were sculptures themselves, Hockney asks us to consider the relationship between these two individuals, as well as that between the couple and the art with which they chose to surround themselves.

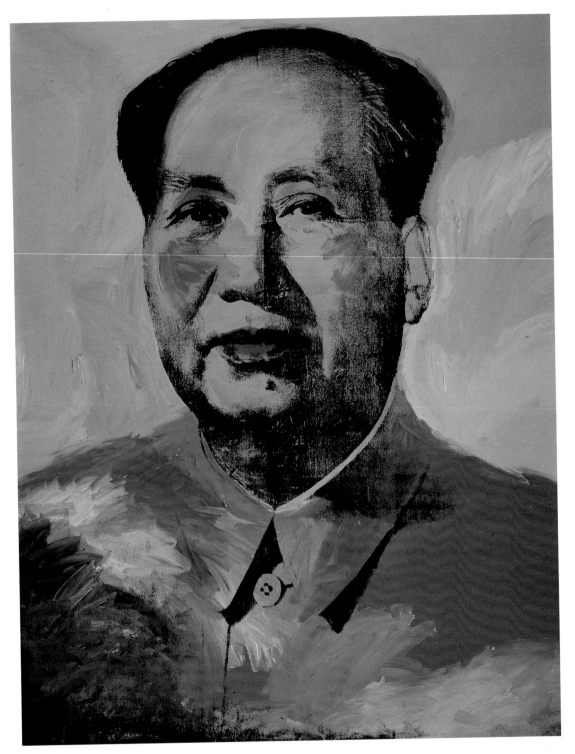

Andy Warhol
American; 1928–1987

Mao, 1973
Acrylic and silkscreen on canvas
448.3 x 346.7 cm (176 ½ x 136 ½ in.)
Mr. and Mrs. Frank G. Logan Prize, Wilson L. Mead funds, 1974.230

The artist, filmmaker, writer, and public personality Andy Warhol was the most influential figure of the Pop Art movement. Embracing popular culture, Warhol based his early paintings on images appropriated from the media and advertising: the faces of celebrities and universally recognized products such as Campbell's soup cans and Coca-Cola bottles. He used commercially produced photo silkscreens and printer's inks to transfer enlarged images to canvas. This mechanical process allowed him to mass-produce his art just like a manufacturer, which gave his New York studio its name: The Factory.

In the early 1970s, when Communist China renewed relations with the West, Warhol, a basically apolitical artist, cast his cool, ironic light on the cult of celebrity surrounding the totalitarian leader Mao Zedong (1893–1976). Nearly fifteen feet in height, this enormous *Mao*, from a 1973 series, mirrors the huge, propagandistic images of the ruler that were pervasive throughout China. The Mao portraits are among the first of Warhol's works to feature a somewhat painterly style. The pigments brushed freely over the surface of the Art Institute's canvas evoke the gestural handling of the Abstract Expressionists, whose subjective approach Pop artists rejected with their popular imagery and commercial methods. The colors added to Mao's face function in several ways: as make-up, they suggest the artifice necessary to maintain the vitality of the aging commander in the public's eye; as graffiti, they signal protest against the totalitarianism Mao epitomized.

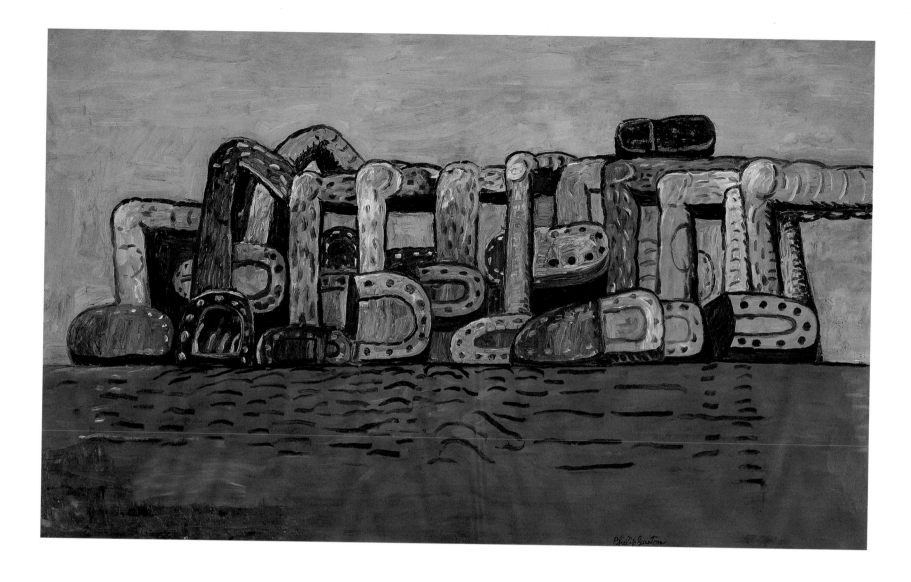

Philip Guston

American, born Canada; 1913–1980

Green Sea, 1976
Oil on canvas
177.8 x 295.9 cm (70 x 116 ⅙ in.)
Restricted gift of Mrs. Frederic G. Pick; Grant J. Pick, Charles H. and Mary F. S. Worcester, and Twentieth-Century Discretionary funds; anonymous gift, 1985.1118

In the late 1960s, Philip Guston, acclaimed for his luminous, delicately worked canvases in an Abstract Expressionist style, shocked his followers by abandoning abstraction and introducing broadly rendered, cartoonish figures and objects into his compositions. In part this change in style signaled the artist's return to figurative painting, which he had practiced with critical success in the 1930s and 1940s. In this new phase of his career, Guston created an unusual repertory of images that includes spindly, pink legs; odd, broadly defined shoes; the stylized face of his wife; the hoods of Ku Klux Klansmen; and the artist's self-portrait, a stubbly, one-eyed head often confronting an empty bottle, in reference to his alcoholism.

Green Sea is one of a series of paintings Guston executed in 1976, featuring a tangle of disembodied legs, bent at the knees, wearing flat, ungainly shoes, and grouped on the horizon of a deep green sea against a salmon-colored sky. While this particular image, repeated in increasingly abstract terms in subsequent paintings, recalls the composition of bunched brush strokes characteristic of Guston's earliest abstract works, its meaning eludes us. The knobby knees seem to suggest, in their knotted huddle, an adolescent awkwardness and insecurity, which makes the image at once funny and poignant.

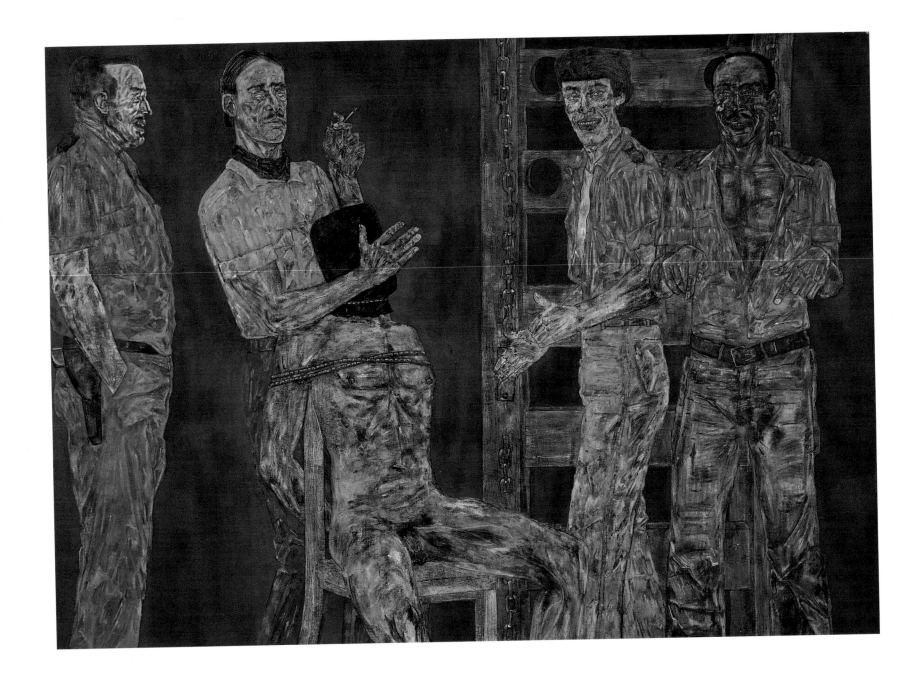

Leon Golub

American; born 1922

Interrogation II, 1981
Acrylic on canvas
304.8 x 426.7 cm (120 x 168 in.)
Gift of the Society for Contemporary Art,
1983.264

Leon Golub's often harrowing paintings are the expression of his commitment to the possibility that art can effect social and political change. In the 1960s and early 1970s, Golub's political activism and his pursuit of a painterly, figurative style ran counter to the prevailing Pop Art and Minimalist movements. It was not until the 1980s, with a renewed interest in figuration, that Golub's monumental canvases finally received critical and popular attention.

Interrogation II, one of three depictions of brutal torture sessions that Golub painted in 1981, shows four mercenaries and their naked, hooded victim, who is bound to a chair. A grayish-black torture rack provides the only interruption to the intense, red-oxide color field which creates a symbolically bloody backdrop for the heinous activity. The rawness of the action is reinforced by Golub's technique of scraping the applied paint down to the tooth of the canvas. Themes of atrocities are not uncommon in the history of art. Yet how different *Interrogation II* is for example from Edouard Manet's *Mocking of Christ* (p. 48), in which Christ's tormentors seem distracted from their awful duty by the simple humanity of Jesus. In contrast Golub's perpetrators seem ruthless and determined. An image of cruel intensity, the Art Institute's composition is made even more disturbing by the torturers' grinning faces and the direct eye contact they make with the viewer, drawing one into uncomfortable complicity with their terrible acts.

Anselm Kiefer
German; born 1945

The Order of the Angels, 1983–84
Oil, acrylic, emulsion, shellac, and straw on canvas with cardboard and lead
330 x 555 cm (129 ⅞ x 218 ½ in.)
Restricted gift of Nathan Manilow Foundation;
Lewis and Susan Manilow, Samuel A. Marx
funds, 1985.243

One of the most important artists to emerge in the 1980s, Anselm Kiefer is known for his spectacular, large-scale paintings rich with expressive power and complex meanings. Born in Germany at the end of World War II, he has concerned himself with themes of nationalism and imperialism, destruction and resurrection, mythology and the occult. Using a wealth of literary, historic, and symbolic references, he intends his art to play a crucial role in transmitting and clarifying the historical record and in making liberation and redemption possible.

To carry the weight of his message, Kiefer evolved a truly original technique, loading his work with such materials as straw, lead, pieces of clay, photographs, and blistering the surfaces with heat. In *The Order of the Angels*, he created a devastated, postwar landscape visited by a miracle. Based on writings attributed to the early sixteenth-century theologian Pseudo-Dionysius the Arcopagite (whose name is inscribed at the upper left) on celestial hierarchies, Kiefer represented Dionysius's nine categories of angels in labels at the upper right. Lead strips connect each name to a corresponding numbered rock in the landscape below, suggesting that the landscape itself is imbued with a higher spirit. Kiefer explained the presence of a large snake at the center of the painting as a reference to a tradition that identifies snakes, like angels, as existing between man and God. The symbol of the serpent could also suggest the animal's ability to shed its skin; in this way, the artist perhaps expressed a desire for his homeland to shed its recent past and move toward rebirth.

Sigmar Polke
German; born 1941

Raised Chair with Geese, 1987–88
Artificial resin and acrylic on various fabrics
290 x 290 cm (114 ¼ x 114 ¼ in.)
Restricted gift in memory of Marshall Frankel;
Wilson L. Mead Endowment, 1990.81

Sigmar Polke was born in 1941 in Silesia, which, after World War II, became part of East Germany. After moving to West Germany in the 1960s, he began to produce an iconoclastic body of work in which he incorporated his responses both to contemporary art and to life in his bifurcated country.

Between 1984 and 1988, Polke executed five paintings featuring the central image of a watchtower. The last of the series, the Art Institute's composition has a disjunctive quality, created partly by the artist's decision to superimpose multiple images on a surface covered with diverse fabrics: a bright-pink, quilted textile; striped awning material; and black cloth.

The images intensify the work's unsettling character. The raised chair of the title (*Hochsitz* in German) can indicate a type of elevated seat frequently used in the German countryside as a lookout for hunting fowl, a reference underscored by a gaggle of geese in the painting's left-hand corner. The designs on the black fabric evoke the pleasures of leisure time at a beach and provide an association to another kind of raised chair, that of a lifeguard. But, more ominously, *Hochsitz* is related also to guard towers, prisons, concentration camps, and walled countries. Polke is one of a number of German artists who, in creating works of such tension and paradox as *Raised Chair with Geese*, have sought to confront and come to terms with the collective trauma that characterizes the history of their nation in the twentieth century.

Chuck Close

American; born 1940

Alex, 1991
Oil on canvas
254 x 213.4 cm (100 x 84 in.)
William H. Bartels and Max V. Kohnstamm prize funds; Katharine Kuh and Marguerita S. Ritman estates; gift of Lannan Foundation, 1997.165

Since the late 1960s, Chuck Close has used the human face as a vehicle to investigate illusionism and the process of making art. While in his recent work he is less focused on creating an exact likeness than on exploring formal issues such as line and color — which lends a sense of abstraction to the resulting images — his portraits, such as *Alex*, are not without human expression and complexity.

Close projects photographs of family and friends onto canvases inscribed with a grid, each section of which he then fills in with pigment. His early portraits are comprised of countless black-and-white dots, airbrushed with painstaking exactitude. In 1989 the artist suffered a collapsed spinal artery, which severely limited his mobility and confined him to a wheelchair. With great determination and courage, Close regained his former control of his medium, as this monumental 1991 portrait of his friend the artist Alex Katz demonstrates.

Since the early 1990s, Close's dots have been replaced by larger, more freeform shapes. Here Katz's head flickers in and out of focus, registering both as a photographic image and as a shimmering, abstract design. The various improvisational marks on the mosaiclike surface — diamonds, Xs, and crosses — infuse the image with an edgy, nervous quality. Although Close tries to present his subjects objectively, he admits that "information about character is there anyway, if people want to look for it." "Faces," he concludes, "are road maps of a life."

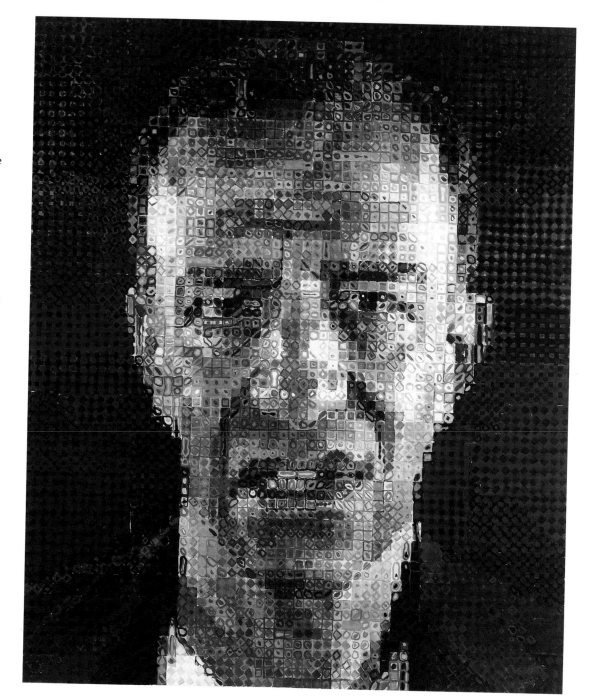

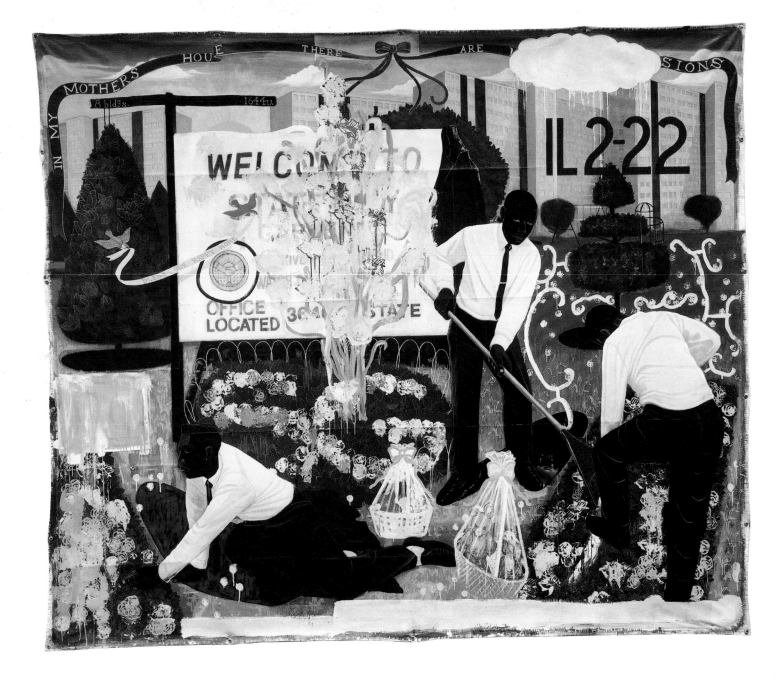

Kerry James Marshall

American; born 1955

Many Mansions, 1994
Acrylic and collage on canvas
289.6 x 343 cm (114 x 135 in.)
Max V. Kohnstamm Fund, 1995.147

Kerry James Marshall has made African American life the main subject of his art. This large, riveting composition is part of a series Marshall titled *Garden Projects* after he became intrigued by the use of the word "garden" in the names of many of the housing developments of Los Angeles and of Chicago, the city in which the artist lives and works. Marshall, who grew up in urban housing projects, hoped to challenge stereotypes of public housing with the series. As he observed, "All we hear of is the incredible poverty, abuse, violence, and misery that exist there, but [there] is also a great deal of hopefulness, joy, pleasure, and fun."

In this work, three men wearing dress shirts and ties beautify their harsh surroundings with a profusion of flowers, under the looming towers of the immense Stateway Gardens development. Given this austere setting, the painting is filled with ironic symbols of happiness and beauty: In front of a weathered "Welcome" sign, two bluebirds carry a streamer that reads "Bless Our Happy Home." At the upper right is a playground; in the immediate foreground, Easter baskets herald springtime, with its sense of promise and hope. Framing the whole is a red ribbon with the words: "In My Mother's House There Are Many Mansions." Feminizing a well-known phrase from the Book of John (14:2), the message may refer to the warmth and caring that can exist in communities of all kinds, including government housing projects.

Lucian Freud

English; born Germany 1922

Sunny Morning—Eight Legs, 1997
Oil on canvas
234 x 132.1 cm (92 ⅛ x 52 in.)
Joseph Winterbotham Collection, 1997.561

In his art, Lucian Freud has subjected the human face and figure to intense, uncompromising scrutiny for over fifty years. *Sunny Morning— Eight Legs*, a monumental, recent work, confronts us with a bizarre set of models, arranged on top of and under a sheet-draped bed in the artist's London studio. With his head thrown back, his upper torso twisted, and his bent legs stretched awkwardly, the male nude seems a study in tension, and even discomfort, in contrast to the easy tenderness with which he holds the sleeping dog. From beneath the bed emerges a pair of legs that echoes but reverses those of the reclining man; the inclusion of the lower pair imparts a tone of perversion or even violence. Suffusing the entire painting is a clear, unforgiving yellow daylight that pours in from the rear window.

To execute *Sunny Morning*, Freud swept his hog-hair brushes across the surface with vigor, building form out of thickly textured layers of paint. Employing a mostly neutral palette, tinged with the red of arteries and the blue of veins, he seems to have molded human flesh with his brush much as a sculptor works with clay. The model's exposed genitalia; his almost pleading expression; the precipitous, downward angle of the floor, accentuated by the second pair of legs; the heavy, falling linen; and the precariousness of the dog's delicate frame as it nestles against the large, naked man all combine to present a disturbing and painful image of vulnerability.

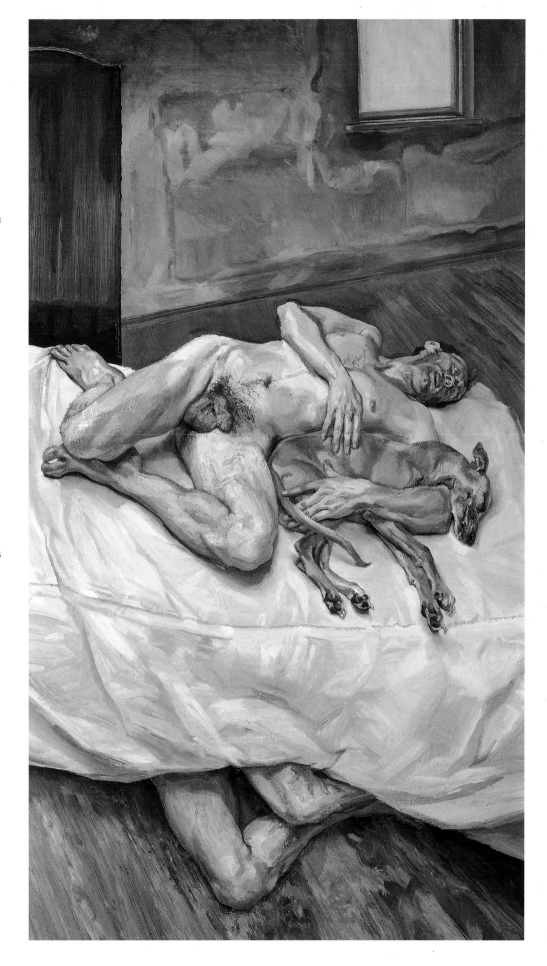

Index of Artists